THE

Ladies' Room

READER

The *Ultimate* Women's *Trivia* Book

ALICIA ALVREZ

CONARI PRESS

Berkeley, California

Conari Press books are distributed by Publishers Group West.

ISBN: 1-57324-557-7 PB
ISBN: 1-57324-561-5 HC

COVER DESIGN: AME BEANLAND
COVER AND INTERIOR ILLUSTRATIONS: MARTHA NEWTON FURMON
INTERIOR DESIGN AND COMPOSITION: ELLEN KWAN

Library of Congress Cataloging-in-Publication Data

Alvrez, Alicia.
 The ladies room reader : the ultimate women's trivia book / Alicia Alvrez.
 p. cm.
ISBN 1-57324-557-7
1. Women—Miscellanea. I. Title.
HQ1233 .A68 2000
305.4—dc21 00-009566

Printed in the United States of America on recycled paper.
01 02 03 PHOENIX 10 9 8 7 6 5 4 3 2

THE LADIES' ROOM READER

WELCOME TO THE WORLD OF WOMEN

Women—what we love, what we hate, how often we like to have sex, and how much we chat on the phone.... It's all here in this very first compendium of things feminine. I have perused hundreds of books, magazines, and Web sites for the most fun facts about females available anywhere. Open and enjoy! Soon you too can impress your friends with minutia such as:

* Who really invented the bra;

* What extra appendages had Ann Boleyn, one of the wives of Henry VIII;

* What Mae West said on the death of Marilyn Monroe;

* How many hours the men in our lives spend on housework and childcare;

* How many of us leave messages on our answering machines for our pets;

* Who coined the term bug for a computer problem; and

* How many pounds of lipstick we wear in our lifetimes.

May *The Ladies' Room Reader* bring a smile to your lips as well as a deeper appreciation for the amazing creatures we women are.

—*Alicia Alvrez*

1

Women Get Malled

I Shop Therefore I Am

*S*hopping has been a love of women for millennia. Ovid, who lived around the first century A.D., once declared, "Women are always buying something."

Why do women love to shop? Anthropologists tell us that it's a leftover habit from our hunter-gatherer days. Since humans first roamed the Earth, women were the ones close to home, gathering the nuts and berries, and we still like to do it.

Both men and women cite price and quality as reasons for where they shop, but the similarities stop there. Sixty-seven percent of women say they enjoy shopping, whereas only 37 percent of men do. And stores with a wide selection tend to be uncomfortable for men; they don't want too many choices. Women, on the other hand, overwhelmingly love having a wide variety to select from.

Studies also confirm that women are affected by the environment in which they shop more than men, perhaps because they spend more time there. Women need space to move from aisle to aisle without feeling cramped. At makeup counters, for instance, women tend to gravitate to the corner,

where they can wrap themselves around the counter and avoid being bumped. We hate stuff we have to bend over for, not because we aren't willing to bend, but because we are afraid of getting bumped into from behind.

At the Mall

* When asked whether they would rather have sex or go shopping, 57 percent of woman choose the mall.

* Seventy-two percent of women say they shop for recreation. We head for a department store about 16 times a year and spend about 4 hours a month at the mall (down from 8 hours ten years ago). A typical visit lasts an hour, and we come home with our wallets about $35 lighter.

* "**SHOPPING is** the female version of church—it's **SPIRITUAL**." —*Joan Baez*

* The United States has more malls than any other country on Earth—42,048 at last count.

Our love affair with malls appears to be waning, however. We're going there less and spending less time when we're there. Online shopping and not enough time have both been cited as reasons, along with the theory that malls have become too similar and lack novelty. To lure us back, mall owners are adding schools, libraries, police substations,

museums, and churches. I guess they figure if you have to be there for some other reason, you might drop a few dollars at a store at the same time.

 Someone asked people the following question: If you were given $500, what amount would they spend on clothes. Women said $278, compared to $202 for men.

A recent survey of female shoppers found women to be much less brand-conscious than in previous decades, and researchers chalk up the huge difference to women's entrance into the workforce and the sense of self-esteem work gives us. "For women today," said Laurie Ashcraft, coauthor of the study, "status comes from within, rather than without." We are also more interested, Ashcraft discovered, in wellness than in how we look.

Inside Our Closets

The International Mass Retailing Association tells us that the average American has in her or his house 23 batteries, 2.9 televisions, 15 sweatshirts, and 12 kinds of snack foods.

One-quarter of women admit to switching sizes of two-piece outfits, such as bathing suits, to get a better fit when their tops and bottoms are different sizes. And one-tenth of us own up to having bought

something with the expressed intention of wearing it to an event and then returning it to the store—and few of us feel guilty about it.

If we pick up a basket at a housewares store, there's a 75 percent chance we will buy something (as opposed to 34 percent for basketless folks).

About half of us say we search for a bargain when shopping, and 41 percent believe the biggest financial mistake they have made is paying too much for something.

Buying something new is a happiness booster for almost everyone, but we tend to do it when we are already in a celebratory mood. Sorry retailers, but when women are feeling bad, they are much more likely to call someone than to go shopping to cheer up. However, 57 percent of us (as compared to 27 percent of men) say we shop to relieve stress.

Half of us begin Christmas shopping right after Thanksgiving, with only 9 percent of women waiting till the last minute (as opposed to about one-quarter of all men).

Surveys tell us we spend more time shopping per week— 6 hours—than playing with our kids, reading, or gardening.

Gift Symbology

Looking to give a gift with meaning? According to the fascinating book, *The Language of Gifts,* virtually anything one could buy is loaded with symbolism. Here, for instance, are ideas specifically for women:

❀ **Baskets:** Women's domain; fertility; wholeness and togetherness

❀ **Brooms:** Female magic; domesticity; the contributions of wise women

❀ **Shells:** The womb; fertility; resurrection

❀ **Camellia:** A unique woman; loveliness; excellence

❀ **Vulture:** Exemplary motherhood

❀ **Unicorn:** Femininity; purity; goodness

❀ **The Number 4:** Womanhood; root of all things; security; potential

More than 515 million pairs of jeans are sold in the United States each year, and the average household has 14 pairs.

Men so hate shopping that one survey found that their stress levels while shopping were "equivalent to emergency situations experienced by fighter pilots or policemen going into dangerous situations." And virtually all women polled who took their male partners shopping with them regretted that move.

Women still do most of the grocery shopping for the family (70 percent)—although increasingly more men are taking on this task (17 percent; the remaining percent are the couples shoppers)—and we shop on average 3.4 times per week. (Poor advance planning, I guess.)

Only 31 percent of shoppers have a list (which is probably why they have to go more than once a week, in this list-writer's opinion). But far more women carry lists than men. Even with a list, we're not particularly disciplined. Statisticians say that two-thirds of what we buy are impulse items. (So the less we go to the store, the more money we save.)

Women tend to nosh on food illegally at the grocery more than men, to sneak into the express line with more items than allowed, and to read the magazines while we wait.

FRIDAY is the busiest day at the grocery store, with Saturday and Thursday tied for second.

The demand for cold cereal continues to skyrocket (no time to cook), which is why there are now more than 125 brands on the average store shelf, up from 65 only ten years ago.

Before supermarkets, you had to go to the fish store for fish, the bread store for bread, and so on. Then someone had the bright idea of putting everything together in one spot. (Just who that was is open to discussion; several chains maintain that they were the first.) But supermarket shopping didn't take off until one Sylvan Goldman invented the shopping cart. This Oklahoman noticed that as soon as a woman's little hand-held basket was full, she would check out. So he had an employee design a rolling cart to accommodate more stuff. But the carts just sat there—no one knew what to do with them. So Goldman hired a bunch of his employees' wives to come in and push them around until the other housewives got the idea.

Supermarket Sweepstakes, OR *The Science of Conning the Maximum Dollars Out of Your Purse*

$ The average time spent in the grocery store is 40 minutes. And those clever marketers have discovered that for every minute you stay in the store past that, you spend an additional $2.

$ To encourage you to spend more time and therefore more money, the music played in supermarkets tends to have only 60 beats per minute, which makes you move much more slowly than music with a faster beat. It can make the average cart dollar figure rise by almost 40 percent.

$ The practice of charging very little for something—say 49 cents a pound for chicken—is called a loss leader. The store is willing to lose money on that item because it figures it will more than make up for it by luring you in. It's based on the fact that most people will not drive from store to store to pick up only the bargains but will buy whatever they need and want from one store. So the loss leader ensures you come to *that* particular store.

$ You know all those folks cooking items for you to sample at the end of the aisles? Such giveaways really work—the vast majority of people who try an item then purchase it.

$ There is a science to the placement of items on the grocery store shelves. Clever supermarket owners have figured out that for the average "eye height" of women, the best placement of items is between 51 and 53 inches from the ground. That's where they'll put the high-ticket items. The bargains will be above and below that so you have to hunt to find them.

$ Staples are scattered throughout the store so that you have to walk through all the aisles to find them.

$ What's the largest piece of real estate on grocery store shelves? PET FOOD.

$ Stores encourage a certain flow—you come in a particular door and move through the store in a particular pattern up and down the aisles. The stores do this, at least in part, because it's been discovered that as you turn into a particular aisle, your eyes will naturally go to the items on the opposite side of the aisle from your turn. That's where they will put items that they really want you to buy, often in attractive displays that tempt you to pick up something special. The same is true for those shelves on the ends. Because they are so visible, more expensive items are also placed here.

$ Have you ever wondered why the canned soup is not shelved in alphabetical order, which would make it so much simpler to find? That's because researchers have figured out that in the search for the kind you want, you end up buying several cans of other varieties and therefore buy more— 6 percent more, to be precise.

$ You know when you come across those sale items that say "limit 4"? Is the store really worried

about running out? Of course not; it's a technique to get you to buy a bunch of something that perhaps you wouldn't have bought at all. Studies have shown that we are more likely to purchase something if it says it has a limit, and even more likely when it says "limit 4" than only "limit 2."

$ It's true—candy and other kid items are placed at kid eye level, which is about knee level on an adult.

$ According to a study by the *Journal of Family and Consumer Sciences*, 1 in every 10 grocery store purchases is for an item that we never use.

$ The mark-up on food is, in general, really low per item. The store makes its profit on volume; hence all their tricks to increase the amount we buy.

We hate to go grocery shopping. In a 1991 study by the University of Maryland, folks were asked to rank 22 ordinary activities. Grocery shopping ranked 21, just above cleaning the house.

What do we particularly hate? Expiration dates that we can't see, followed by meat that looks old, long lines, bad produce, and impolite employees.

You know all those new products that you see for a while on grocery store shelves only to disappear as soon as you develop a hankering for them? That's because not enough people wanted them to warrant

the store real estate. Food manufacturers lose about $20 billion annually to items that don't catch on.

Here's a little secret supermarket owners don't like to talk about—not only do they charge us for food, but they also charge food manufacturers for shelf space. That's right—companies have to pay for the real estate they take up, which makes launching a new product that much more expensive.

No matter the occasion, a recent poll shows that the gift preferred by most adults is … money, regardless of educational status, age, or income. Over 66 percent of those surveyed chose money over all items. Young women also liked jewelry quite a lot, but they too preferred money.

Retailers have discovered that today's consumer is highly cost-conscious and goes through five steps before purchasing something:

1. **Evaluate Need:** We have less time than ever before, so we want to shop faster and less. We don't want something unless we need it.

2. **Search:** Depending on the item, we like help, but only 18 percent of women (compared to 25 percent of men) use some kind of electronic device—Internet, infomercial, TV—to help in the search.

3. Check Out Alternatives: For items such as TVs as well as clothing, we want high quality in the price range we expect to pay, rather than necessarily the lowest price.

4. Purchase: Women prefer stores that feel safe and appear clean; men prefer places that are the most convenient.

5. Experience Satisfaction: For both men and women, the key factor in satisfaction is ease— that they can get the goods, price, and information they want and, if something isn't right, a quick replacement or fix.

When women shop for cars, they want safety and reliability first. For men, that's further down on the list of priorities.

The world's largest department store is the Macy's in New York City. It has 2.15 million square feet!

Women's love of shopping provides quite a temptation to shoplift—women's sticky fingers outdo men's 5 to 1.

Manufacturers of certain background music systems for chain stores admit that they put subaudible messages—messages that can't be heard, but work subconsciously—in the stores' music. They claim that at least 120 stores are using such systems—not to influence purchases, but to prevent shoplifting.

One manufacturer, Proactive Systems, claims that messages such as, **"Don't steal,"** reduce shoplifting by as much as 65 percent. No stores except one, Jay Jacobs, will own up to using such devices. Jay Jacobs is a chain geared to teenage girls, and a visit to one of their stores revealed rock music with no audible messages.

Thirty-four percent of shoppers never read labels. However, women read them much more than men, and those who read tend to buy. Reading takes time, however—approximately 11–16 seconds for the label of a beauty product that we purchase—and if there is not enough space for us to feel comfortable, we will spend only 2 seconds and not buy.

According to Simmons Research, 73 percent of women say that the men in their lives influence their purchasing decisions, whereas only 9 percent of men say women affect their choices. But while women tend to consult men, they don't take men's opinions too seriously, except in one category—car buying. Here the man's opinion is weighted very heavily by the woman in his life.

One-quarter of U.S. households are now made up of a single person. Collectively this group has a tremendous amount of buying power—they have more to spend because they don't have kids—and demographers are finding out some surprising differ-

ences among them. For instance, middle-aged single women tend to spend more on cars than single men, while single men spend more heavily on clothes. Single women spend half as much as single men on restaurant meals. (Presumably they cook more at home and are dating men who pick up the dinner tab.) Not surprisingly, they also buy more fruits and vegetables than their male counterparts, but also consume more sweets, fats, and oils. Single women in general are spending more money than they used to; they now spend just as much as men, an average of $25,500 per year (the average for all households is $32,277). That's not necessarily good news; these women are spending, on average, 93 percent of their income, whereas men, who still get paid more, are spending only 73 percent and saving the rest. Women often spend more because they want to live somewhere safe and are less likely to buy a fixer-upper house.

Credit cards didn't come into widespread use until 1958, when the country went on a spending spree that is yet to end. The price of a pair of Levis at the time? $3.75.

We tend to think of prices going UP, **UP**, **UP** over time, but as new technology is introduced, items

are often very expensive initially but then prices drop. Witness the refrigerator. In 1965, an 8.3 cubic foot model cost $635; in 1985 you could get a 17.2 cubic foot model for the same price.

Women Changing the World

Because women are the shoppers in this culture, as our roles in society have changed, so too have the products and stores we use. For instance:

* Grocery store coupons are virtually a thing of the past—fewer than 3 percent are now redeemed. We're too busy to clip.

* In the 1950s, 75 percent of American households had sewing machines. Now it's less than 5 percent. **NO TIME**.

* Hardware stores—traditional male provinces— have almost completely disappeared in favor of places like Home Depot, which sell home, not hardware—women's space. As Paco Underhill says in *Why We Buy*, "The retail hardware industry has gone from an 'Erector set' mentality to a 'Let's play house' approach." They hire women to explain how to do things and have how-to videos and free installations to encourage confidence in their female customers. Designer names that sell to women—like Martha Stewart and Ralph Lauren— now make paint. Who for? Women, of course.

And the hardware is now displayed *in situ,* where you can see what the cabinets will look like with the tile flooring and fixtures, rather than just hanging on racks. Again, this is to encourage women to imagine what their homes could look like with such improvements.

In the 1980s, a "Dear Abby" column set off a furor in the female shopping world. It claimed that security people watch through two-way cameras and peepholes as we try on clothes. While Abby responded that such a belief was "full of beans," the rumor took hold nonetheless. Women were horrified at the idea of men looking at them while changing. A Connecticut state senator went so far as to introduce "Peeping Tom" legislation banning such practices in his state, even though he had no evidence it was happening. The author of *Bigger Secrets,* William Poundstone went to a variety of stores to find signs of peeping and queried a number of people who had worked as security people in department stores. He concluded that it was an unsubstantiated rumor; the security folks told him the most they do is make sure you have the same number of items coming out as going in.

At least in the 1970s, more women met prospective mates in the shopping mall than in singles bars.

Who are the **BIGGEST** spenders in the country? Folks who live on Long Island. They spend an average of $44,217 on goods and services. The study was done in the mid-1990s; done today, my hunch is that San Jose, which ranked third in this survey, would now be on top.

WHERE *Does* THE MONEY GO?

What, on average, do we spend annually in various categories?

$$$$$ Restaurants: $1,835

$$$$ Clothes: $1,831

$$$$ Entertainment: $1,693

$$$ Charities: $1,224

$$ Alcohol: $324

$ Books, magazines, newspapers: $185

The Gender of Shopping

The foremost expert in the science of shopping is Paco Underhill, who has done research for corporations from Starbucks to Estée Lauder and has written a fascinating book on the topic, *Why We Buy.* Here are some of the most interesting tidbits he and his team have discovered about the differences in the shopping habits of men and women:

❁ If a man tries on an article of clothing, chances are 65 percent that he will buy it; only 25 percent of women trying something on actually purchase it. We're choosy; the act of finding just the right thing is important to us.

❁ Eighty-six percent of women check price tags, compared to 72 percent of men. According to Underhill, not looking at the price "is almost a measure of his virility.... Stores that sell prom gowns depend on this. Generally, when Dad's along, the girl will get a pricier frock than if just Mom was there with her."

❁ Even when shopping with women, men tend to be the ones who pull out their wallets. That's because while a man tends to abhor shopping, he loves to pay. Says Underhill, "It allows him to feel in charge even when he isn't."

❁ Gender division of labor still rules in shopping habits—men tend to be the purchasers of items that go outside the home (grills, mowers), and women buy for the inside of the house.

❁ When buying computers, cell phones, and other electronics, men are more likely to read the brochures and leave without talking to a sales-person. Women tend to speak to sales personnel, preferring to get their information from a person

rather than a piece of paper. Both require several
trips to the store for a technological purchase,
with women averaging one more than men.

❀ Electronics purchases differ in one other way—
here men are the browsers, women are the "get
the right thing and get out" types. Women are in
the electronics store to buy, not to moon over the
latest scanner. Ditto for Web buying. Internet
sites are discovering that women log on, go to
their destination, and purchase; men are the ones
who flit from here to there.

❀ The more time you spend in a store, the more
likely it is you will buy something. Women
spend very different amounts of time, depending
on who they're with. Here's average shopping
times at a housewares chain that Underhill's
company clocked:

Woman alone: 5 minutes, 2 seconds (accomplish task, get out)

Woman with kids: 7 minutes, 19 seconds
(distracted by kids)

Woman with female friend: 8 minutes,
15 seconds (having a fun time consulting
one another)

Woman with man: 4 minutes, 41 seconds
(oh, boy, got to hurry or he is going to freak).

2

Painted Ladies

Cosmetics and Clothing Uncovered

The most expensive dress ever sold at an auction was Princess Diana's blue silk and velvet gown that she wore to dance with John Travolta at the White House in 1985. It went for $200,000, which was donated to AIDS charities.

When women began to wear pants in the 1950s, it was considered "naughty" to be seen in ones that fastened in the front; proper women's pants had side fastenings only.

Consider what life would have been like if you lived in fifteenth-century Florence, where it was illegal for women of the lower class to wear buttons of certain shapes and substances.

Alice Roosevelt Longworth, daughter of Teddy Roosevelt, is the only president's daughter to have a color named after her. Alice blue is a pale greenish-blue color. Apparently she wore such a color early in her father's presidency, and the name stuck.

Russia's Elizabeth I, who lived in the 1700s, rivals the very best twentieth-century clothes horse. She owned 15,000 dresses, many of which she actually wore because she had the habit of changing her ball gown two and three times per evening.

Have you ever found sand in the pockets of your brand-new jeans? No, someone has not worn them

to the beach before you purchased them. It's pumice sand; stonewashed jeans are rubbed against pumice stone to give them their unique look, and the pumice sometimes crumbles and hides in the pants' pockets.

Big noses are beautiful, believe the San Blas women of Panama. They even paint black lines down the middle of their noses to make them look bigger.

Mad for Makeup

❀ Dermatologists tell us that the average woman uses 20 beauty products and grooming devices in her morning routine. Young women are twice as likely to use foundation and blush than older women, but about half of women of all ages use facial moisturizer.

❀ American women spend over $5 billion a year on cosmetics and at beauty parlors.

❀ The art of wearing makeup goes back 8,000 years. In ancient Egypt the favorite eye shadow color was green, and lipstick was blue-black. (Cleopatra painted her lower lids green and her upper ones blue-black.) It was also considered *en vogue* to dye your fingers and feet with

magic eyes

henna, turning them reddish orange. The Egyptians also popularized eye glitter, mixing their eye shadow with crushed iridescent beetle shells.

❀ Fifty-three percent of women wear makeup every day, and most of those spend 15 minutes applying it. Our favorite beauty aids, in order of popularity: **mascara, blush, lipstick, eye shadow.** And 28 percent of women open their mouths wide when applying mascara, but most of us aren't aware of what faces we make.

❀ The folks at L'Oréal claim the average woman brushes her eyelashes over 300 times with mascara every morning.

❀ Three out of four women admit to putting on makeup in the car, but only, they swear, at red lights or when stopped in traffic.

❀ Fifty-eight percent of American women color their nails (and 6 percent of straight, rural men do too).

❀ Fingernail polish was invented in ancient China (c. 3000 B.C.) and was used to differentiate people of various ranks, with the royalty sporting red and black. Egyptians used nail color to indicate status as well. Red was for queens; women of lower status could only wear pale colors.

* Long fingernails for both men and women—up to 2 inches and longer—were considered the height of beauty and class in traditional Chinese culture, proving that you did not work with your hands. To keep the nails from breaking and tearing, they were often covered by gold or silver nail covers, which were worn constantly, even to bed.

* The ancients wore eye shadow because it was believed to prevent blindness, strengthen eyesight, and offer protection.

* Eyeliner was said to keep evil out.

* Lipstick was believed to guard against the entrance of evil spirits, to keep poisonous foods out, and to keep the soul from leaving the body through the breath.

* The average woman puts on 6 pounds of lipstick in her lifetime.

* A Girl Has to Make Do: Cleopatra lived before the age of lipstick, so she colored her lips with pomegranate seeds.

* Beauty standards change. In fifth-century China, women used to polish their teeth with a black dye made from the skin of eggplant. (Black was beautiful, I guess.)

❊ In India today, red teeth are popular with many traditional Hindu women.

❊ Makeup Pays: One of the richest women in the world is reputed to be Liliane Bettencourt, the heir to the L'Oréal fortune. Her net worth is somewhere around $8.5 billion.

❊ Given all the moisturizers in the world, it is that much more impressive that Oil of Olay has cornered almost one-third of the world's market. Like Avon products, it was originally sold door to door.

❊ Makeup use is on the upswing, after a decline of ten years from 1986 to 1996, when *au naturel* was in. Now vibrant colors have again made a comeback. Cosmetic manufacturers couldn't be happier. "When you start playing with colors, you change colors more often," said one.

SHE'S NOT DOING ANY TYPING

The longest fingernails in the United States belong to Frances Redmond, who has let them grow for the past twelve years. They are now more than 17 inches long.

Cosmetics queen Helena Rubenstein put some of her fortune to good use. She gave painter Marc Chagall and his wife the money to escape from the Nazis and then supported them until they got established in New York.

Beauty mogul Elizabeth Arden's real name was Florence Nightingale Graham. And, yes, she did flirt with becoming a nurse before turning to cosmetics, where she made a fortune.

Mabel Williams was a woman whose brother had a mail-order catalog. One day she mixed up some eye makeup for herself out of black pigment and petroleum jelly. Her brother decided to offer it in his catalog, where it quickly became one of his bestselling items. He was marketing it under the name Lash-Brow-Line, but to thank his sister for his great success, he changed it to Maybelline, now one of the largest cosmetic companies in the world.

Women in Japan are still not supposed to wear pantsuits to important business functions.

Over 25 percent of U.S. fashion dollars are spent on clothes that are size 16 or larger.

Women of the Mughal court in India changed several times a day and never wore the same outfit twice. Their discarded clothing was given to their slaves.

Nipple piercing was a hot fad among women in the 1800s.

Perhaps this honor should go to the ladies in Europe who, after reading Ben Franklin's instructions on how to make a lightning rod in his 1753 edition of *Poor Richard's Almanack*, began to wear them on their hats. Complete with grounding wire, of course.

Underwear Uncovered

- Fifty-one percent of women surveyed report wearing briefs, 40.5 percent favor bikinis, 4.6 percent like thongs, and 4 percent of women don't wear any.

- The lower your income, the more likely you are to don a thong.

- The original names for what is now considered lingerie were "white work," "white sewing," or "the under wardrobe." The word *underwear* wasn't used until 1879.

- Underwear has been around since about 2000 B.C. Men wore loincloths under their clothes, whereas women sported short skirts. By A.D. 200, Romans of both sexes were wearing loincloths very similar to today's briefs.

- Isabella was the daughter of King Phillip of Spain, who was having trouble controlling the seaport of

Ostend. In support, Isabella vowed not to change her underwear until Ostend was back in Spanish possession. The siege lasted **THREE YEARS!** (There is no word as to whether Isabella kept her vow.)

ॐ Imelda Marcos is known for her huge shoe collection, but she actually was a bigger consumer of underwear. When she and her husband fled the Philippines, there were 500 black bras (including a bulletproof one), 200 girdles, and 1,000 pairs of unopened pantyhose in her closet.

The White House Undercover

Ladies garments seem to have trouble staying in place in the White House. While we all know about Monica, here are four tales from *Wild Women in the White House* that you might not have heard of before:

✳ During a reception for FDR, a foreign diplomat's wife's drawers suddenly dropped. The doorman plucked them up, folded them like a tea towel, and whisked them out of sight.

✳ At an LBJ ball, a lively dancer wasn't as lucky. Feeling her petticoat heading to the floor, the

woman in question kicked it under the piano. Unfortunately for the damsel, a quick-eyed man snatched up the offending undergarment, loudly asked whom it might belong to, and placed it on top of the piano. Needless to say, it remained unclaimed.

✳ JFK's bedroom antics were well known, but not well enough known, apparently, to his chambermaid, who once found a black lacy item in the president's bed and returned it to Jackie. "Not my size," she drawled to her husband as she handed it to him.

✳ Nancy Reagan was meeting one day with a member of the White House Preservation committee. Standing to shake the honored guest's hand, she looked down to discover her skirt had fallen to her feet. "This is one meeting you'll never forget," she proclaimed to her embarrassed guest.

The first designer to achieve the kind of fame that today's top *couture* creators do was a Frenchwoman named Rose Bertin, who lived in the early 1770s. She was commissioned by Empress Maria Theresa to make over the wardrobe of her daughter, Marie Antoinette, whose fashion sense, thought Maman, wasn't up to snuff. Bertin became the French queen's chief designer, and some people say that it was Marie's lust for fashion, coupled with Rose Bertin's huge price tags, that really led to the

call for her beheading. Bertin survived the French Revolution by escaping ultimately to England, and went on to design clothes for royalty around the world. Her fame caused other French designers to begin to put their names on the clothes they created, and designer labels were off and running.

GET IN THE GAME

If you want a designer creation but can't afford the price tag, check out *styleshop.com* and *inshop.com*. They are two Internet sites that offer the skinny on sample sales, where top designers sell off their creations at rock-bottom prices. The sites also offer the lowdown on markdowns at chains such as Express and Ann Taylor.

Nightgowns were first introduced in the late sixteenth century. They were long, loose wool or velvet gowns for both men and women, designed to keep you warm, a welcome respite from all the tight corsets and powdered wigs that were worn in the day. It wasn't until one and a half centuries later that women's nightgowns began to diverge significantly from men's. They began to be made in flimsier fabrics to emphasize a woman's shapeliness. They were meant to be worn not just to bed but for lounging around beforehand. That's where the word *negligee* comes from. It is Latin for "to neglect" or "not to pick up."

How do today's girdles work? By spreading your fat out over a wider surface area, thereby making it look less bulky. Before the advent of Lycra, girdles would displace fat, moving it above or below the girdle. Lycra, however, has the ability to conform to any woman's body shape, evening and smoothing out fleshy areas with no bumps.

Diamonds Are a Girl's Best Friend

❖ Seven out of every ten women wear some jewelry every day, and 27 percent wear at least five pieces at any given time (earrings count as two, unless of course you have multiple piercings, in which case the number skyrockets).

❖ The Duchess of Windsor's jewelry collection netted $53 million when it was sold at auction in 1987.

❖ Jewelry has been made since 3500 B.C.; it first surfaced among the high-class rulers of Sumer. A sign of rank, it was worn only by royalty and priests. The mummy of a Sumarian queen, Puabi, gives us some idea of what these royal ladies wore: Puabi was found adorned in a robe of gold and silver that was covered in lapis lazuli. Her arms were covered in gold bracelets, and she had three gold crowns on her head, each one nesting

into the next. She was wearing dangling gold earrings, and around her neck were three necklaces of semi-precious stones. Every finger wore at least one ring. Massive amounts of other jewelry were uncovered in her tomb.

❖ Brooches were first worn by the warrior class medieval Irish, who encrusted them with jewels as part of their luxurious dress.

❖ Various kinds of jewelry have different symbolic meanings: Plato spoke of a golden chain that links heaven and earth; ever since, a gold chain has stood for the link between opposites. Later, Socrates spoke of a silver and diamond chain that binds the practice of justice with happiness, which helped chains used in jewelry begin to stand for happiness.

❖ Rings, because they are circles, stand for unity and eternity. They also denote a desire for reconciliation and wholeness.

❖ When necklaces are worn low around the heart, they increase heartful feelings and attract love. Since necklaces are merely big rings, the ring symbology also attaches to them.

❖ Gold and silver have particular meanings too. Gold stands for the masculine principle—wealth, power, and success. Gold chains were thought to keep one healthy and live longer, while jewelry made of gold nuggets is said to keep money flowing into your life. Silver represents the feminine side—magnetic, receptive, intuitive. It is said to be calming and soothing, and to promote balance and wholeness.

The Ears Have It

Originally, earrings were worn to guard ears from illness. They were also believed, particularly diamond earrings, to help eyesight. Around this same time, the cure for a headache was believed to be wearing one silver and one gold earring.

Mirror, Mirror

In ancient China, the mirror stood for the queen and was a sign of harmony and a happy marriage. In the Middle Ages, monks who were scribes used to take breaks to gaze into a mirror, which they felt had the spiritual power to strengthen their eyes.

What kind of clothes make the man? According to 52 percent of women surveyed, blue jeans and a casual shirt.

Why do we stop wearing a particular article of clothing? Thirty-nine percent of us report it's because

it doesn't fit anymore, not because it's gone out of style. Another 25 percent of us have to throw it away because it is stained or worn out, and 30 percent report it's because we have nowhere to wear it.

The Proper Support

❧ Rumor has it that the bra was invented by Otto Titzling. Funny, but not true. Actually the idea goes back to the ancient Greeks, who wore them much as we now do sports bras. The ancient Chinese had the concept as well. Theirs was like an apron, supposedly conceived of by a concubine in the eighth century. In modern times, devices that could be considered bras were patented as early as 1893. But generally speaking, the modern bra is credited to be the brainchild of one Mary Phelps Jacobs; before that, Western women wore corsets. Around the beginning of the twentieth century, this New York socialite wanted to wear a thin gown one day, but her corset showed. So she took some ribbon and handkerchiefs, and *voilà*. Clever Mary even patented her invention in 1914. She had been making them for free for

friends who requested them, but when she got a dollar in the mail asking her to send one of her **"CONTRAPTIONS,"** she decided to go commercial. Unfortunately, she never got what she deserved for her brainchild. She sold her patent for $1,500 to the Warner Brothers Corset Company. It has since been valued at having been worth $15 million at the time.

❧ Why do we call it a bra? That too was Mary Phelps Jacobs' idea. She had moved to France in the 1930s and liked the sound of the word *brassiere*. It was being used in France to mean "a harness, leading strings or the shoulder straps of a rucksack," according to *Larousse's French Dictionary*, but it soon caught on for this article of clothing. By 1935, it had been shortened to *bra*.

❧ A bra is designed for 6 months of use.

❧ Jean Harlow was the first actress to regularly appear braless on screen.

❧ The *Times of London* reported that the firm Triumph International Japan invented a bra that lets its wearer know of any incoming missiles. Called the **"ARMAGEDDON bra,"** it was designed in 1999 to take advan-

tage of the doomsday prophecy craze sweeping Japan. It has a sensor on the strap and a control box. Unfortunately, it doesn't work all that well under clothes; to be most effective, it must be worn on the outside. No word on how many women have taken advantage of this newest spin on bust control.

- The average bra size is 36C, up from 34B ten years ago (the aging population, experts tell us, get larger as the decades go on). Those in the know say that 85 percent of us are wearing the wrong bra size.

- Maybe It's Not Your Magnetic Personality: Women visitors to San Quentin prison in Marin County, California, must go through a metal detector before entering that is so sensitive that it even picks up the metal in their underwire bras.

- Metal underwiring can be dangerous. A woman in England was struck by lightning as she walked in a rainstorm and was killed. A burn mark on her chest led investigators to conclude that it was the metal in her bra that had attracted the lightning to her.

- In London, a student at the Royal College of Design invented a bra that has sensors that send a call into the local police station when the wearer's

heart rate accelerates to panic level, indicating a possible attack on the woman. It also indicates the bra's location.

- Next time you are in Hollywood, check out Frederick's Bra Museum. (Yes, **THAT** Frederick's.)

- The bestselling bra in the world is the Wonderbra; more than 30,000 per week fly off shelves in England alone.

- The most expensive bra in the world was made by Victoria's Secret. It is encrusted with diamonds and is valued at $3 million.

Forty-seven percent of women claim to dress to be noticed; the rest of us don't want to attract attention with our clothes.

Ninety-six percent of women carry some kind of purse, and it weighs, on average, between 3 and 5 pounds.

Where did the notion of pink for girls and blue for boys come from? Ancient people believed that boys were more valuable than girls, and that therefore evil spirits would be after the boys. It was thought that blue, the color of heaven, would ward off such spirits. Girls didn't need protection because no spirits would want them. In later centuries, the sexism of such a practice became embarrassing and girls were assigned a color in compensation.

In Burma, long necks are so prized that young girls of the Paguan tribe wear tight metal necklaces to lengthen their necks.

Hair-Raising Facts

* The Upjohn Hair Information Center, which studies such things, informs us that the average woman spends 36 minutes per day on her hair, and brushes, combs, or checks her hair around 5 times a day.

* Women overwhelmingly prefer to wash their hair the first thing in the shower, with only 16 percent waiting till the end, versus 35 percent of men.

* Hair grows an average of 1/100 of an inch a day.

* When she was a child star, Shirley Temple's mother would make sure that her hair was set with precisely 56 curls every day.

* None other than the FDA informs us that 2 out of every 5 women in the United States color their hair. The average age at which we begin that task is 36. The most common natural hair color is dark brown.

* How much hair do you lose a day? Male or female, the answer is anywhere from 25 to 125 strands. Unless you're balding, these are replaced by the body.

39

❀ Blonde was so **IN** during the Italian Renaissance that no proper aristocratic woman was caught dead as a brunette. Instead, upper-class ladies spent hour after hour dying and then burnishing their hair to a harsh metallic shine. During the same time, it was *de rigeur* for such gentlewomen to shave their hair back several inches from their natural hairlines.

❀ Britain's Elizabeth I, who owned over 3,000 dresses, was completely bald after losing her hair to smallpox at age 29. That's why she always wore a wig, which started a wig craze that lasted for centuries among the aristocracy. By the eighteenth century, British ladies' wigs were as much as 4 feet high and contained such items as plates of fruit, stuffed birds, miniature gardens, and model ships. Dusted with flour and coated with lard, these wigs were worn for months at a time and tended to attract mice and insects (ugh!). In 1795, the government imposed a hair-powder tax, and the trend quickly ended.

❀ In France around the same time, women's head-dresses got so high that the castle doorways had to be raised so that the ladies of the court could enter without having to duck. Canes for both women and men were also an eighteenth-century French fashion craze. Those designed for women

often had music boxes, pictures, or perfume bottles secreted inside.

✽ A completely bald pate was the height of beauty for Egyptian women of 1500 B.C. Since razors had not yet been invented, the women would pluck every hair off their heads (!) with gold tweezers and then polish their heads to a shine.

✽ Between 1992 and 1996, First Lady Hillary Clinton had, according to those who keep track of such things, 320 different hairstyles, all of them up for public scrutiny. Someone even created a Web site, now apparently defunct, for comments on the 'dos.

✽ These ladies give new meaning to the word *cone-head:* Wealthy women in Egypt of 2500 B.C. would place cones of scented grease on top of their heads in the morning. As the day got warmer, the grease would melt and drip down their heads and bodies, bathing them (and their clothes) in an oily aroma.

The Woman Who Changed Hair-Story

Throughout history, men and women have changed their hair color with powders and dyes, including orange, blue, green, or flaming red. Safe commercial hair dyes, however, are relatively new. The first was created in 1909, but to early twentieth-century women, changing one's hair color was considered risqué. Then along came Clairol and a woman named Shirley Polykoff. Polykoff was an ad copywriter who came up with the famous lines for the Clairol campaign, "**Does She or Doesn't She?**" and, "**Only Her Hairdresser Knows for Sure.**" The publicity really caught fire when *Life* magazine refused to run the campaign, saying it was sexually suggestive. Clairol got the all-male censor panel to test it. What they discovered was that no woman thought it was suggestive and every man did. *Life* gave in, and by the end of the 1960s, 70 percent of women in the United States dyed their hair.

Fur coats are out for the animal rights crowd. And no wonder—it takes between 35 and 65 minks to make one coat, and 60 to 100 chinchillas!

All Buttoned Up

So why *do* women button their clothes from the left and men from the right? There is a reason. Historically men tended to dress themselves, and since most people are right-handed, it's easier to but-

ton yourself if you button from the right. Women, or at least upper-class women who set fashion trends, tended to be dressed by maids, so the buttons were placed to make it easier for their helpers. And centuries later, when presumably we all dress ourselves, we are still slaves to convention.

If the Shoe Fits

❋ The woman with the most shoes in the world—with more than 10,000 pairs—is Sonja Bara of Toronto. She may have had an unfair advantage over Imelda Marcos (who only had 1,060 pairs, although it was reported that she had 3,000). Bara's family firm sells shoes. She now has a shoe museum in Toronto that houses, among other pairs, John Lennon's Beatle boots and Queen Victoria's dancing shoes.

❋ In Roman times, what you wore on your feet told the world what your station in life was. High-born women usually wore closed red or white shoes, switching to green or yellow for special occasions. Lower-class females wore only undyed open leather sandals.

* High heels were originally worn only by men, beginning in the sixteenth century in France. The heel made it easier for one's boot to stay in the stirrup while riding. But it was Louis XIV who really launched the mania for high heels. He was very short and would add inches to his stature with his boots. The French courtiers would follow suit, making him shorter again. This battle continued until they all, men and women, were wearing astronomically high heels. By the eighteenth century, the style for men's footwear had descended, but women continued their elevation.

* According to *Harper's* Index, the average increase in the protrusion of a woman's buttocks is 25 percent when she wears high heels.

* "I don't know who invented the high heel, but all WOMEN OWE HIM A LOT." —*Marilyn Monroe*

* The American Academy of Orthopedic Surgeons wants us to know that 8 out of 10 women they surveyed said their shoes were painful, and 9 out of 10 women wear shoes that are too small. Hum, could there be a correlation?

* "If high heels were so wonderful, men would be wearing them." —*Sue Grafton*

* Our feet are getting **BIGGER**. In 1986, 12 percent of American women had shoe sizes 9 1/2

or larger. By 1998, 30.4 percent of all women's shoes sold were size 9 or above.

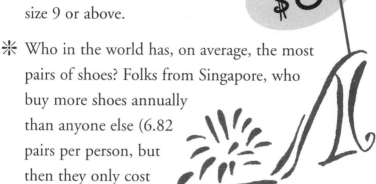

❋ Who in the world has, on average, the most pairs of shoes? Folks from Singapore, who buy more shoes annually than anyone else (6.82 pairs per person, but then they only cost about $5 a pair).

Philip the Fair, who ruled fourteenth-century France, tried to keep a lid on the garment industry. Married folks could have only 4 garments; unmarried, only 1 (unless they were castle-owning heiresses, in which case they could have, presumably, 4). For some reason, he did not try to control pairs of shoes, so soon the aristocracy vied for distinction among themselves via footwear. Soon royalty was wearing shoes with tips as long as 2 feet (commoners' were only half a foot). These proved treacherous during the battle of Nicopolis during the French Crusades of 1396. In order to run away, men had to cut off the tips of their shoes.

"To call a fashion wearable is the kiss of death. No new fashion worth its salt is ever wearable."

—*Eugenia Sheppard*

We have bicycles to thank for the introduction of shorter hemlines. In the 1890s, biking really took off as a form of exercise for ladies, but their long skirts kept getting caught in the pedals. So designers raised hems a couple of inches.

Bathing suits go back as far as the ancient Egyptians of around 1200 B.C., and bikinis are almost that old as well, give or take a few centuries. Women in bikinis appear on Roman mosaics done around A.D. 1. But they were not used for swimming. Rather, it appears, they were workout outfits, for women are depicted on mosaics wearing bikinis while carrying barbells.

Modern bikinis came into fashion just after WWII. It was 1946. The United States had just dropped an atomic bomb on Bikini Atoll, prompting tremendous media coverage, and French designer Louis Reard had just created an itsy-bitsy two-piece bathing suit. He wanted it to have a catchy name, as Charles Panati tells us in *Extraordinary Origins of Everyday Things:* "Reard, wishing his suit to command media attention, and believing the design was itself explosive, selected a name then on the public's lips."

Make Way for Models

❀ Supermodel Naomi Campbell will go down in fame as the model to wear the highest heels to

work. One day she was strutting down the runway in a pair of mock snakeskin shoes with 12-inch heels, which proved to be too high even for her. She fell off them, spraining her ankle. The shoes are now enshrined at the Victoria and Albert Museum.

❀ Claudia Schiffer has the distinction of being the supermodel who has been on the most magazine covers—**550**.

❀ Linda Evangelista, who, at 34, is the oldest working supermodel, once claimed that she spends all her free time coloring her hair. She's also renowned for the great line that sums up the supermodel life: "**We don't get out of bed for less than $10,000 a day.**"

❀ Who buys all those clothes the supermodels parade in? Only 1,000 or so women. The woman who purchases the most *haute couture* is Mouna al-Ayoub, the ex-wife of the consultant to the Saudi royal family. One recent purchase was a $160,000 dress.

❀ Model Suzanne Mizzi has the highest insured body in the world—$16.6 million. The policy costs her nearly $60,000 a year and specifies, among other things, that she must not get pregnant, go hot air ballooning, or engage in risky sexual behavior.

The Stocking Story

None of us born after the invention of nylons can ever know what a stir their introduction caused. Women had been wearing hot, heavy cotton and expensive, easily run silk stockings, so when the Du Pont company announced that it had invented a material for stockings that was indestructible (okay, a slight exaggeration), women everywhere took notice. By the time the first nylons shipped in May 1940, near-riots broke out in the stores that carried them. Demand continued to outstrip supply during the war, as women took great care with the few pairs they managed to find.

The very first Avon lady was the widow of a senator, Mrs. P. F. E. Albee. She was hired by the cosmetic company's owner David McConnell to go door to door selling cosmetics and training other women to do the same. The company was originally called the California Perfume Company, but McConnell, a lover of Shakespeare, changed it to honor the bard.

The Nose Knows

🌸 Perfume has been popular throughout history, often to cover up the lack of proper bathing. Nero, emperor of Rome, wins hands down as the purchaser of the most perfume. He once spent

the equivalent of $160,000 for rose perfume, petals, and oils for one party. And when his wife died, he used more perfume in the funeral procession than the yearly perfume output of Arabia.

❀ Legend has it that the secret to Cleopatra's irresistibility was her perfume. It was a special blend of rose, cardamom, and cinnamon oils.

❀ With all the different perfumes in the world, which is the most popular? Chanel No. 5. Created in the 1920s, it contains more than 80 different ingredients and still sells over 10 million bottles per year. There was no Chanel No. 4; Coco named it that because she loved the number 5. And she launched it, auspiciously, on 5/5/25.

❀ The perfume trade employs technicians who have such a refined sense of smell that they can distinguish among 19,000 odors at 20 levels of intensity.

Saint Audrey was an English princess who lived around A.D. 650 and whose birth name was Etherelda. When she was dying of a tumor in her neck, she proclaimed it was a punishment from God

for wearing necklaces in her youth. During the Middle Ages, the English would hold a festival on her feast day; female fairgoers would don cheap necklaces called "St. Audrey's Lace," which over time got abbreviated to 'Taudry Lace. And that's where the word *tawdry*, meaning cheap, comes from.

Fashion has always been with us—but not bathing. In ancient Mediterranean cultures, olive oil was used to clean the body because soap did not exist. During the Middle Ages, in parts of Central Europe it was believed that bathing more than once a year was dangerous. Even after soap began to be produced in Italy and Southern France, getting folks to use it throughout the continent was an uphill battle. For instance, the German Duchess of Julich was given a bar as a present in 1549. She was so insulted that she made the gift-giver leave her sight. And, in 1672, when an Italian soapmaker gave German Lady von Schleinitz some soap, he sent a note telling her how to use it and assuring her that it was only "a novelty," reports *The Browser's Book of Beginnings*.

The very first woman to wear pants in the United States was not Amelia Bloomer, but her friend Elizabeth Smith Miller. It was the 1840s. When Bloomer saw the pants on Miller, she realized their potential in liberating women from confining fashion, so she adopted them for herself. They became a symbol in the battle for women's right to vote, with Bloomer campaigning in a shirt and baggy pants. Soon the loose leggings and the garments worn under them were called "Bloomers." Pants really caught on, though, once bicycling came into fashion in the 1890s and, over time, *bloomers* became just another word for underwear.

Mary Walker, a Civil War physician, is the only woman ever to have won the Medal of Honor. During the war, through a special act of Congress, she was allowed to wear the uniform of her rank, first lieutenant. Once decommissioned, this diminutive dame refused to put on a dress ever again, preferring a frock coat, striped trousers, and a top hat. She even went so far as to tour the country, lecturing against women's clothing as not providing them sufficient protection. "If men were really what they profess to be," she proclaimed, "they would not compel women to dress so that the facilities for vice would always be so easy." Mary had

nothing to worry about—to be absolutely sure, not only did she wear pants, but she also often draped an American flag across her lap for good measure.

Another crusader in women's fashion around this time was Britain's Lady Harbertson, who founded the Rational Dress Society in 1880. She was against all corsets, bust supports, and hoop skirts, proclaiming that the weight of a woman's undergarments **"should not exceed 7 pounds."**

In the 1700s, there were no machines to make cloth; every single piece had to be spun by hand. This was considered "women's work" and consigned to an unmarried female in the family. Hence the word *spinster*.

Until the 1960s, both models and store mannequins were much rounder than they are today. We have Jackie Kennedy to blame for the change. Her thin fashion chic set off a trend that continues to this day. Store mannequins instantly lost 6 inches in the waist and 4 in the thighs. Researchers tell us in *Sexy Origins and Intimate Things,* that these store dummies "lost so much weight, so quickly ... that if they were real women they'd have been unable to menstruate or conceive children, and would have had a hard time keeping their bones from becoming brittle."

3

Of Cabbages and Queens

Feminine Food Fancies

_W_omen are more likely than men to ask for a doggie bag in a restaurant.

Housewife Debbie Fields started her famous cookie company because a man insulted her at a party in 1977. Trying to impress a snobbish client of her husband's, she said, in answer to what she did for a living, "Well, I'm still trying to get orientated." She reported what happened next in an article in _Redbook_: "He went to the shelf, practically threw a dictionary at me, and said, 'The word is _oriented_, not _orientated_. If you can't speak the English language, don't speak at all.'" On the spot, this young mother decided to open her own business, if only to prove to this man she was intelligent. When she sold her 800 stores to a large conglomerate in the 1990s, you can bet she was laughing all the way to the bank.

If you love clams, thank Ruth Alden Bass of the seaside town of Duxbury, Massachusetts. Ruth was just a starving colonist in the seventeenth century when she spied a pig rooting in the sand along the seashore. She followed suit and came up with a handful of clams. She decided that if pigs could eat them, so could she.

MEN ARE FROM McDONALD'S, WOMEN ARE FROM MARTHA STEWART-VILLE

According to a recent readership survey done by *Bon Appetit*,

❉ Seventy-five percent of women are concerned with how their table looks for a party, compared to 54 percent of men.

❉ Forty-one percent of women entertain at brunch or lunch; only 25 percent of men do.

❉ Women are half as likely to eat a fast-food breakfast in the car as are men.

❉ Women are twice as likely as men to use candles to set the ambience at a dinner party.

Researchers are discovering that increasingly we are eating on the run, not bothering with forks, spoons, plates, or a full meal. Rather, we are becoming a nation of snackers; only 24 percent of us sit down and have 3 meals a day. What are we noshing on? Microwave egg rolls, burritos, pizza, and bagels, among other hand-held items.

Given our propensity to eat on the go, food manufacturers are busily coming up with new hand-held items. What's on the food horizon? According to the *Futurist*, among other things, expect to see scrambled eggs on a stick (!) and a "conewich," bread that will hold its filling more neatly than

the sliced kind because it's shaped like
an ice cream cone.

WINNER OF THE GIVE ME A BREAK! AWARD
In a survey done by Kimberley-Clark, 45 percent of
women responding said they had a kitchen floor you
could eat off of.

Women now own 1 in every 3 restau-
rants in the United States—an increase of
41 percent between 1987 and 1992
alone. But we make less money at it than
men—on average, 37 percent less.

Women have suddenly become the
majority in a traditionally male job: bar-
tending. The Bureau of Labor Statistics
tells us that 70 percent of all bar-
tenders are now female, which is good
news because bartending tends to pay more than other
food service jobs.

In a trend that began in the early '90s, Americans
are eating much more spicy food, making the con-
sumption of spices go from 2 pounds per person to
2.7 pounds in 5 years.

Give Us Chocolate

♥ "Research tells us that 14 out of any 10 individu-
als like chocolate." —*Sandra Boynton*

♥ Actually, according to the American Dietetic Association, 40 percent of women crave chocolate.

♥ While study after study finds chocolate to be the number 1 food craving by women, no one has definitively proven why. Author Debra Waterhouse, who wrote a book on the subject, claims that it's because of chocolate's effects on brain chemicals and blood sugar levels. Chocolate has a balance of 50 percent fat (which is a mood elevator) and 40 percent sugar (a mood stabilizer and calm-enhancer).

♥ Rounding out the top 3 favorite foods of females are bread and ice cream. Contrast this with men: red meat, pizza, and potatoes.

♥ When 105-year-old artist Beatrice Wood was asked the secret of her longevity, she replied, **"Chocolate and young men."**

♥ Good news for chocoholics! A new study has found dark chocolate contains more antioxidants than do most vegetables and fruits. (If only it weren't so fat laden!)

♥ Chocolate originated in South America as a drink. The Spaniards got it from the Indians, but it spread to Europe in great profusion as part of the dowry of Spanish princess Maria Theresa, who moved to France to marry

Louis XIV. She couldn't live without the stuff, and soon, neither could the rest of the French.

♥ In villages in Central America during the eighteenth century, chocolate was believed to be the drink of the devil, and no one under 60 was allowed to imbibe under threat of excommunication.

♥ Emelyn Hartridge was a student at Vassar trying to make ends meet when she began to make fudge to sell to her classmates. Previously, fudge was seen only as a mistake in candymaking, either from overcooking fondant or undercooking caramel. Hartridge's candy proved so popular that Vassar put fudge kitchens in every dorm.

♥ "I don't love acting. **I LOVE CHOCOLATE.**"
—*Elizabeth Taylor*

♥ To improve her memory, Eleanor Roosevelt would eat 3 chocolate-covered garlic balls each morning on doctor's orders.

Love candy but hate the fat and calories? Tufts University's Diet and Nutrition Center to the rescue. They have analyzed all the popular candy brands and have created a list of the 6 kinds of least fattening candy. All of these are better for you than any other candy brand; the first 2 have no fat at all:

1. Life Savers

2. Good & Plenty

3. York Peppermint Pattie

4. Junior Mints

5. Sugar Daddy

6. Tootsie Roll

For the record, Tufts also analyzed the most fattening candy. Here goes, listed in order of most calories from fat:

1. Mr. Goodbar

2. Reese's Peanut Butter Cup

3. Hershey's Milk Chocolate

4. Almond Joy

5. Kit Kat

6. M&Ms Peanut

Tootsie Talk

* Tootsie Rolls were first created in 1896. The candy's inventor, Leo Hirschfield, gave them the nickname of his daughter, whose real name was Clara. Good thinking—chances are Clara Rolls would not have made it.

* Tootsie Roll Industries is run by a woman, Ellen Gordon, who likes employees to consider the company their family. Workers can eat as much candy as they want while working.

* If all the Tootsie Rolls eaten each year were stretched end to end in a line, it would go to the moon and back.

If you've been to England, chances are you've eaten a Sally Lunn, a kind of sweet tea cake served

with butter. It was named after an eighteenth-century baker in Bath who peddled her cakes on the street. Eventually tiring of the business, Sally sold the recipe to a man who was a very savvy marketer. He wrote a song about the tea cakes and used it to advertise his wares. Some believe this was the very first singing commercial.

How much do we each eat a year? Averaged out, it comes to one ton of food and drinks. The count includes: 116 pounds of beef, 100 pounds of vegetables, 117 pounds of potatoes; 80 pounds of fruit; and 286 eggs.

Beware of those cold cereals that are marketed to kids. On average, they contain 44 percent sugar, as compared to 10 percent for the "adult" cereals.

Eleanor Roosevelt held weekly Sunday evening salons in which the leading literati, artists, intellectuals, and politicos of the day mingled and held forth. She would always serve scrambled eggs, calling the menu "scrambled eggs with brains."

When poultry farmers discovered that people must prefer white meat to dark, they started breeding chickens with enormous breasts. What do they call such birds? Dolly Partons, of course.

But Not a Drop to Drink
We get a tremendous amount of water from the foods we eat. Following are some common foods and

their water content. Cucumbers and watermelon are not surprising, but how about steak?

❄ Cucumber: 96 percent

❄ Watermelon: 92 percent

❄ Milk: 87 percent

❄ Apple: 84 percent

❄ Potato: 78 percent

❄ Steak: 74 percent

❄ Cheese: 40 percent

❄ Bread: 35 percent

French actress Sarah Bernhardt was famous for stirring her bouillabaisse with a red-hot poker.

The daring danseuse of the early 1900s, Isadora Duncan, adored expensive foods such as asparagus, strawberries, champagne, and caviar. But she lacked the funds for such items and had to rely on the generosity of friends to provide such treats.

All about Alcohol

→ No Wimpy Umbrellas for Her: Haven't you always wondered where the term *cocktail* came from? Wonder no more. A barmaid in Elmsford, New York, by the name of Betsy Flanagan used to decorate her drinks with a rooster feather. One day a

customer asked for "one of those cock tails" and the name stuck—and spread.

→ How Do They Know This Stuff? There are approximately 250,000,000 bubbles in every bottle of champagne.

→ During the Roman Empire, women became infertile from drinking wine from containers that leaked lead.

→ The Russian court of Catherine I forbade men to get drunk at parties before 9 P.M., whereas women weren't allowed to be tipsy at all. The Queen's daughter Elizabeth and her friends got around the royal rule by dressing like men and holding transvestite balls.

→ "One more drink and I'd been under the host."
—*Dorothy Parker*

→ In her old drinking days, Elizabeth Taylor's favorite drink was a chocolate martini, which she and Rock Hudson concocted on the set of *Giant*.

→ Napoleon's wife, Empress Josephine, adored champagne—so much so that her bills for the bubbly became an issue in their divorce.

→ Queen Elizabeth I so loved vanilla that in her later years she would only consume food and drink laced with the stuff. (Yes, vanilla extract contains alcohol.)

→ John and Jackie Kennedy loved daiquiris so much that Jackie had the recipe taped to the wall of the kitchen in the White House.

→ The Manhattan—sweet vermouth and whiskey— was invented by Jennie Jerome. Jennie was a beautiful New York socialite in the 1870s who broke American men's hearts when she went off to England to marry a lord. Lord Churchill, that is; Jennie would become Winston Churchill's mother. (Ever the party girl, she actually gave birth to Winnie in a cloak closet; she went into labor during a fancy dress ball.)

→ "There comes a time in every woman's life when the only thing that helps is a glass of champagne." —*Bette Davis*

→ Marilyn Monroe agreed with Bette. Champagne was the only alcohol she would touch.

→ In ancient Greece and Rome, women weren't allowed to drink alcohol, except for *passum*, a sweet wine made from raisins. And they weren't fooling around; in the second century A.D., husbands were known to murder their wives if they were caught sneaking down to the wine cellar.

→ Beer has been made since 6000 B.C. (although it did go out of vogue for a while because the ancient Greeks thought it caused leprosy), and women made and sold most of it, at least in Mesopotamia. They drank their share of it too, even the priestesses at the temples. Until modern sanitation, beer was much safer than water, and in northern Europe it provided much of the nutrition in daily diets until as late as the seventeenth century.

→ If you drop a raisin into a glass of champagne, it will bob up and down continually—or at least until it gets too soggy.

Too Much of A Good Thing

A woman in Miami who thought she had cancer accidentally drank herself to death—not with alcohol, but with water. She was trying a water cleansing and was imbibing 4 gallons a day, which destroyed her body's chemical balance.

President Rutherford B. Hayes and his wife were teetotalers, much to the chagrin of White House visitors who called Mrs. Hayes *"Lemonade Lucy"* behind her back. She had instituted the mid-meal practice of serving Roman punch, a sherbet-like mixture of lemon juice, sugar, and egg whites, as a palate cleanser. Secretly a White House steward began spiking the guests' punch, much to their great pleasure,

and the course became known as "the Life-Saving Station." Lucy and Rutherford never found out.

We're still not eating what we should. Women consistently do not get enough iron and calcium, the latter because of our avoiding the high fat content in milk, cheese, and ice cream. We don't get enough fiber either—we average 13 grams, but we should be consuming 25. And we are still getting too much salt—an average of 3,100 milligrams, instead of 2,400.

VICARIOUS PLEASURE

Want to have the fun of eating without the calories? Rent one of these fabulous movies that feature women and food:

- *Babette's Feast*

- *Breakfast at Tiffany's*

- *The Cook, the Thief, his Wife, and her Lover*

- *Eat, Drink, Man, Woman*

- *Eating: A Very Serious Comedy about Women and Food*

- *Home for the Holidays*

- *Like Water for Chocolate*

- *Tampopo*

- *The Wedding Banquet*

The historian Pliny the Elder wrote that Cleopatra once bet Marc Antony that she could spent the equivalent of $2 million on one banquet. She did it by dissolving her huge pearl earring in a tumbler of very strong vinegar, and was about to throw the other earring in when the referee called her the winner. (Scientists now tell us that vinegar will not dissolve pearls, but it's a good story nonetheless.)

Those who control the cooking always have the opportunity to slip a little something extra into the stew. That's why, perhaps, the most famous poisoners of yore were women. And the most famous of all was the Roman royal Locusta, who poisoned the Emperor Claudius about 2,000 years ago, so that her son Nero could become emperor. Stories about what method she used vary; some say poisonous mushrooms, others, mushrooms laced with poison. Either way, she did accomplish her mission.

The first wife of Henri IV of France, Marguerite de Valois, is known for introducing the use of long-handled spoons at court to minimize spillage on the very high collars that were in fashion at the time.

The pretzel was invented in the Middle Ages by a monk in Italy as a reward to children for memorizing their prayers. The shape is supposed to be the shape children's arms take while praying.

THE FULLER BRUSH MAN HAD NOTHING ON THESE GALS

In 1926, the first automatic toaster for the home was developed. Though it sold for a very expensive $12.50, every home soon had one. Why? Because of Toastmaster's sales force—a bevy of ladies who went door to door carrying a loaf of bread under one arm and a Toastmaster under the other for handy demonstrations.

One Potato, Two Potato . . .

* The poor potato has come in for much maligning over the years. When it was first introduced into Europe from Latin America, it was thought to cause syphilis and leprosy.

* Where did we get the idea it was fattening? A potato actually has the same number of calories as an apple, and we'd have to consume 11 pounds of potatoes to put on 1 pound of fat. Now, once you put something on that potato or turn it into chips or french fries, that's a different story.

* Who invented potato chips? Several people make this claim to fame. One is black cook Mrs. Catherine A. Wicks, who is reputed to have introduced them in the 1850s at Moon's Clubhouse in Saratoga Lake, New York. Others

say it was a black male chef, Hyram S. Thomas Bennett; still others claim it was American Indian George Crum. In the Crum version of the tale, chips were originally his attempt to make very thin french fries for a finicky customer, but soon became an item in their own right.

* Whoever invented them, potato chips have become the country's most popular snack food. The average American consumes 7 pounds per year. We have them with lunch about 32 percent of the time and dinner 18 percent.

* Potato chip makers now use special potatoes, called chipping potatoes, to make their chips.

* Have you ever noticed green spots on your potato chips? It's not mold, but rather spots of chloro-phyll that are harmless to eat.

* Pre-Columbian housewives high in the Andean Mountains were the first creators of freeze-dried food. They would take potatoes that they grew in the valleys, carry them up to the highlands, and spread them out overnight to freeze. The next day, when the potatoes began to thaw in the sun, the women would stomp on them to squeeze out all the water. After 3 cycles of freez-ing and squeezing, the potatoes were ready to store for the winter.

Incan women were not the first females to use frost to their advantage. In 3000 B.C., Egyptian women actually figured out a way to make ice. As the sun set, they would place water in shallow clay containers on beds of straw. Because Egypt is so hot and dry, rapid evaporation of the water combined with a fast drop in temperature as night came on would cause the water to freeze. Perishable food was then stored on top of the ice so that it would last a bit longer in such a hot climate.

Ice is considered a food by both the U.S. and Canadian governments, and we consume more of it than bread—about 2 pounds per day per person. That of course includes the ice in ice cream.

Don't Mess with Her Meatloaf

Nancy Hart was a Georgia housewife who, during the Revolutionary War, had dinner on the table for herself and her children one day when British soldiers barged in. As they helped themselves unceremoniously to her dinner, she grabbed a gun, shot one soldier, and held the rest at bay until help arrived.

Catherine de Medici is credited with introducing Italian food to France in 1533 by bringing a bag of *fagoli* (Italian beans) in her dowry when she went off

to marry the future king of France. This was born the famous French bean dish, *cassoulet.* Catherine didn't stop there. She also introduced the French to peas, sorbet, and that most Gallic of entrees, *Canard a l'Orange.*

Ms. de Medici is also known in food history as the popularizer of the artichoke. She absolutely adored the vegetable, which caused countless number of French heads to turn, as artichokes were considered an aphrodisiac.

We All Scream for Ice Cream

❄ Sorbet and ice cream were invented by the Italians. During her month-long wedding celebration, Catherine de Medici's confectioners served a different flavored ice each day, as well as a semi-frozen dessert that was the precursor to modern ice cream.

❄ Dolly Madison is the person credited with popularizing ice cream in the United States. She was introduced to it by Thomas Jefferson, who had tasted it in France. When she became first lady, she served it often at White House dinners.

❄ Ice cream really broke through into mass consumption in the year 1946, when an average of 20 quarts per person was consumed. Today we're

up to 23 quarts per person each year, making the United States the ice cream capital of the world.

✳ During Victorian times, it was illegal in many parts of the United States to drink soda water on Sunday. Thus, folks were not allowed to consume ice cream sodas on that day. A druggist, upset with the loss of business, invented an ice cream dish without soda—ice cream with syrup poured on top. Because it could be consumed on Sunday, he named it that, which was eventually changed to *sundae*.

Getting Our Licks In

Women much prefer "exotic" ice cream flavors. Men tend to stick to vanilla. Despite women's wild influence, vanilla and chocolate account for 50 percent of all the ice cream consumed in the United States. Rounding out the top 10 nationally:

- Neapolitan
- Cookies 'n' Cream
- Butter Pecan
- Strawberry
- Chocolate Chip
- Mint Chocolate Chip
- Vanilla/Chocolate combination
- Marble Fudge

A Turkish princess whose name is lost in the annals of history is credited with introducing forks into Europe around A.D. 1000 when she married a Venetian nobleman. Her gift was not appreciated. One church father decreed, "God in His wisdom has provided man with natural forks—his fingers." The princess promptly died, and forks took another 300 years to reach common usage in Italy.

Marie Antoinette also lives on in food history—and not just for her cake remark. The queen was actually born in Austria. When she moved to France to marry Louis, she brought with her the recipe for what has now become a quintessentially French item—the croissant.

Marie Antoinette may not have said, **"LET THEM EAT CAKE,"** but food did lead to her eventual demise. Fleeing from revolutionaries, she got caught when she stopped to dine. And awaiting beheading, she was well fed in prison. According to visitor Benjamin Franklin, a staff of 13 prepared her dinner, consisting of "three soups, four entrees, three roast dishes, each of three pieces, four sweet courses, a plate of fancy cakes, three compotes, three dishes of fruit, three loaves of bread with butter, one bottle of Champagne, one small carafe of

Bordeaux, one of Malvoise, one of Maderia, and four cups of coffee." One can only hope she had guests.

Canned tomatoes were introduced into the United States in 1934 by divorcee Myrtle "Tillie" Ehrlich, who refused to hear from the Department of Agriculture that it couldn't be done. Tillie got a loan for $10,000 and proved them wrong. When she sold her thriving canning business 13 years later for $6 million, she laughed all the way to the bank!

The herb rosemary is a symbol of fidelity, which is why it used to be traditional in some parts of Europe for the bridesmaids to give the groom a bunch of rosemary sprigs on his wedding day. The English didn't follow this custom—it was said there that the woman rules the house where rosemary grows.

Villagers in rural Thailand believe that a baby sits inside a pregnant woman's stomach eating the food she eats. Because these villagers consume mostly rice, they believe children are made of rice.

Throughout Asia, there is a myth that rice sprang from the body of a beautiful maiden who was sacrificed in lieu of being raped by a god. Rice then grew out of her lifeless body.

Sweet Things

How many pet names and loving phrases for women are based on food? And why?

- Honey
- Honey bun
- Cream puff
- Cheesecake
- Muffin
- Dumpling
- Pumpkin
- Sweetie
- Sweetie pie
- Cutie pie
- Cookie
- Sweet cookie
- Cupcake
- Baby cakes
- Sugar
- Sugar buns
- Chick
- Peach
- Piece of cake
- Honey pot
- Hot tomato
- Hot tamale
- Tart
- Dish
- Sweet enough to eat

One Smart Cookie

One of Americans' favorite foods was created because a woman was too busy—chocolate chip cookies. It was 1933 and innkeeper Ruth Wakefield was running late on dinner preparations at her inn. To save

time, she decided that rather than melt chocolate before mixing it into her chocolate cookie batter, she would simply chop up the chocolate and let the bits melt as the cookies baked. The cookies were a grand hit with customers. The name of the inn? Toll House, of course.

Marie Callendar was a poverty-stricken woman when she began making pies at home during World War II. By 1986, when she sold out to Ramada Inn, her company had sales of $175 million.

Who Are These Women?

Sixty-three percent of women recently surveyed still make cookies from scratch, 38.6 percent still make their own pies (including the crust!), and 38.1 percent still make biscuits from scratch.

The first American cookbook was self-published in 1796 by Amelia Simmons, a self-proclaimed orphan, in an attempt to improve "the rising generation of females in America," particularly of orphans. "If orphans pay some attention to cooking, they will be welcome wherever they are, and may even attract husbands," opined the author of this popular tome, which went through four editions.

When carrots were introduced to England from Holland in the fifteenth century, British women would wear the tops in their hair.

Heiress Christina Onassis so loved Diet Coke that when she lived in France she had her jet fly in 100 bottles per week from the United States at a cost of $300 per bottle. Why didn't she get more at a time? her chief housekeeper was asked. "Because Madame doesn't want old Diet Coke," was the reply.

Bathing Beauties

Cleopatra is said to have bathed in donkey milk and Mary Queen of Scots in wine, while novelist George Sands preferred cow's milk (3 quarts) and honey (3 pounds).

If you are an average American, you will consume 35,000 cookies in your lifetime—and that figure includes all the folks like me who never touch one.

In ancient Greece, when you won an athletic event, you were presented with, not a bunch of flowers, but a bunch of celery!

Why do women crave pickles when they are pregnant? Experts say it's salt they are really after. Pregnant women need 40 percent more blood than normal to feed the placenta, and salt is a key ingredient in making blood. And the fetus is swimming in a salt and water solution. As for ice cream, almost all women crave that, pregnant or not.

Speaking of pickles, we Americans eat 8 1/2 pounds each annually. So says the Department of

Agriculture, which also reports that we prefer dill to sweet 2 to 1.

All about Oreos

❋ Invented in 1912, Oreos are the most popular cookie in the world. According to the New York Public Library Reference Desk, 1 dollar out of every 10 spent on groceries in the United States goes to buying these treats.

❋ Someone has tracked what we do with the *9 billion* Oreos that we collectively consume each year. Of the half of Americans who pull them apart, women tend to be twisters and men dunkers.

❋ Eighty-two percent of dunkers use milk, but 2 percent use peanut butter.

❋ If every Oreo were dunked in milk, 42 million more gallons of milk would have to be sold to cover the change.

❋ An Oreo has 90 ridges and takes 90 minutes to produce.

❋ Fifteen thousand grocery stores across the United States hold an Oreo stacking contest. Finalists go to Universal Studios for the national competition.

❋ The cookies used to come with crème and lemon fillings, but the lemon was quickly phased out.

✳ Enough crème is produced for Oreos each year to frost all the wedding cakes in the United States for 2 years.

✳ Exactly what is the crème made of anyway? Rumors abound that it is lard or Crisco, but those in the know tell us that it is made of sugar, vegetable shortening (which Crisco is too), vanilla, salt, and lecithin, in that order, with sugar outweighing the fat 2.38 to 1.

✳ Oreos have a new gimmick: If you buy Oreos Magic Dunkers, your milk will turn blue as you dunk (food coloring, of course). Will any adult want blue milk? Only time will tell.

It's true—women are far less likely to drink juice or milk straight out of the container. And women are less likely to reach for the salt shaker without tasting their food first.

Women eat 50 percent more cantaloupe than men. And if you ever wondered who was the market for canned fruit cocktail, wonder no more: It's men.

Seventy-eight percent of women say they love to cook. That number has been dropping since the mid-'70s, when, I guess, it became acceptable for women *not* to want to cook.

Two-thirds of women admit to having made something from a mix and passed it off as homemade.

Forty-six percent of women say their favorite room is their kitchen.

At a dinner party, what is the most popular topic of conversation for women? Food (ditto for men), followed by health, TV shows, and the news.

Much energy has been spent on discovering Coca-Cola's secret ingredient. According to *The Great American Bathroom Book*, there really is one (no, not cocaine, although that used to be included) that no one has ever uncovered. Its code name is 7X. Food detectives have discovered a document made by a flavoring supplier that seems to list the ingredients of Coke's "natural flavorings," the term on the label that covers 7X. (Why the guys on the line who actually make up 7X haven't been queried is beyond me.) Here it is: lemon oil, orange oil, lime oil, cassia or cinnamon oil, nutmeg oil, and neroli oil. There may be traces of coriander and lavender oil as well. It is the proportion of those oils that give Coke its distinguishing taste; Pepsi uses similar ingredients, with lemon oil more predominant than in Coke.

Taking on the Big Guy

Is the formula for Coke really a secret? That's unclear. Diva Brown, a woman from Atlanta where Coke was first developed, claimed that the inventor sold her the formula in 1888. She went on to market a variety of spin-offs with names like Better Cola, Celery-

Cola, My-Coca, and my favorite, Yum-Yum. She sold the secret to two men before she died in 1914, who began manufacturing cola as well. Their businesses went under, however, after Coca-Cola brought lawsuits against them.

According to the author of *Big Secrets*, 7-Up is the only leading carbonated drink whose formula is not a secret—carbonated water, sugar or corn syrup, citric acid, sodium citrate, lemon oil, and lime oil. When it was introduced in the 1930s, it also contained lithium, a common drug for depression, which must have come in handy for all those suffering from the Great Depression. Hence the 7; it stood for the seven ingredients. Soon, however, the lithium was removed, making its name no longer technically true.

The notion of the drive-in restaurant was conceived of in 1906 by a Boston socialite named Mrs. Jack Gardner as a way to entertain her bored friends. She and four carloads of the *crème de la crème* of Boston piled into cars and went to a posh hotel, where they forced waiters to serve them oysters in their cars. They ended up going to 10 restaurants in all, being served in the car for each of 10 courses.

What are the most common causes of indigestion, according to doctors? Not spicy foods, but citrus juices; chocolate (!); peppermint; alcohol; fatty foods such as cheese, goose, and duck; caffeine; and nicotine.

There really was an Aunt Jemima—sort of. The story goes like this: In 1893, the pancake mix was being featured at the Chicago World's Columbian Exposition. Executives of the Davis Milling Company convinced Nancy Green, a woman who worked as a cook for a judge's family in Kentucky, to come and pose as Aunt Jemima, whom they were already featuring on boxes to give the mix a more homey feel. By the time the fair was over, Ms. Green had personally dished up 1 million pancakes to hungry attendees. She continued to work as Aunt Jemima until her death at age 89.

Rock On, Kitchen Mama

These songs with feminine food themes come courtesy of *Goddess in the Kitchen* by Margie Lapanja.

* "Sugar Magnolia"

* "Strange Brew"

* "Cinnamon Girl"

* "Sweet Painted Lady"

* "Stir It Up"

* "Sweet Jane"

* "American Pie"

* "Sugar Pie Honey Bunch"

* "How Sweet It Is"

* "Bread 'n' Butter"

* "No Sugar Tonight"

* "Spoonful"

* "Honey Don't"

* "Sweet Melissa"

* "Cheeseburger in Paradise"

* "You Can Tune a Piano but You Can't Tuna Fish"

The custom of birthday cakes is an ancient one. It goes all the way back to Persia, where a sweet cake to commemorate one's birth was first introduced. Worshipers of Artemis would bake a cake of honey and flour on the sixth day of each month in honor of the goddess' birth. They even put lit candles on top just as we do. The practice died out eventually and was revived by the Germans during the Middle Ages, but only for children. The Germans were the first ones to add one candle for each year.

The tallest cake in the world was made by a woman named Beth Cornell and a team of helpers at the Shiwassee County Fairgrounds in Michigan in 1990. It had 100 tiers and was 101 feet tall.

In a U.S. poll taken in 1945 of best-known women, the fictional Betty Crocker ranked second, right after the president's wife.

Betty Crocker was invented in 1921 by what is now General Mills so that the company would have a signature on letters that answered the questions they were getting from housewives. They chose her last name in honor of a male executive who was retiring and her first name because someone liked it. The women who worked for the company competed in a penmanship contest to see whose handwriting would be chosen for Betty's signature. They are still using the signature of the secretary who won. It wasn't until 1936 that Betty had a face, and her visual image has kept transforming with the decades. She's been made over 8 times, getting younger the first 7 occasions. Her most recent facelift, done for her seventy-fifth anniversary, was designed to give her a less "**WASP-y**" look.

The Granny Smith apple is named for a real grandmother who lived in Australia in the 1800s. In 1860, a woman named Maria Smith emptied out a crate by the creek near her home. In the crate was an apple seed that sprouted into a tree, which produced a green apple that had never existed before. This tree is the mother of all the Granny Smith apple trees in the world. This was no ordinary granny, though. Ms. Smith was an orchardist experimenting with apple varieties, which is how she came to have that seed in the first place.

Nellie Melba was an opera singer with such an amazing voice that she inspired two well-known food items. The first is Peach Melba, created by the great French chef George Auguste Escoffier after he heard Nellie sing in *Lohengrin.* Carving a pair of swan wings out of ice, he placed ice cream between the wings and peaches on top and offered it to the grande dame. (The raspberry sauce that usually tops this dish he added later.) The other foodstuff doesn't have as romantic a story—nor taste as good. Rumor has it that a chef tried to serve thin, dry toast to Ms. Melba and she rejected it. But other guests adored it, as long as it was called Melba Toast. Melba was not her real name; that was Helen Mitchell. She took Melba from the place she was born—Melbourne, Australia.

HOT INDEED!

Nathan Handwerker was a struggling hot dog vendor with a great marketing sense who worked on Coney Island. One of his ideas for Nathan's franks was to give doctors free hot dogs if they would eat them in front of his stand—wearing their hospital whites, of course. He also had the bright idea to hire a beautiful young redhead, Clara Bowtinelli, to help serve. She didn't last long,

though. A talent scout eating a hot dog spied her, and off to Hollywood she went as Clara Bow, one of America's first movie stars. (Clara was quite a Hollywood character in her day, having affairs with Gary Cooper, Bela Lugosi, and John Gilbert, among many others. There were even rumors, apparently totally unfounded, that she slept with the entire USC football team.)

Got an important dinner to make? Call on Saint Martha, the patron of cooks, housewives, and waitresses. She was a happy homemaker before she began preaching and working miracles, and she's reputed to be helpful in all things domestic.

Strawberries were first eaten by the Romans, but they were not cultivated until the fourteenth century, when the Duchess of Burgundy, along with Charles V, ordered them grown in their gardens. Strawberries soon were eaten throughout Europe with a fascinating gender distinction in England: men ate them with wine, whereas women enjoyed them only with cream.

Andrea Halperin took her natural tendencies for eating healthy and recently created a grocery store in New York City that carries 7,000 items—all completely fat-free. There's everything from pastries to pizzas at F3 Fat Free Foods, with one notable item missing: peanut butter. She hasn't been able to locate

any that is nonfat. Business is booming, and she expects to have sales of $1.5 million in the first year. Plans to go online and to franchise the concept are in the works.

The next time you make your fresh brewed coffee at home, give a nod of thanks to Melitta Bentz. She was a housewife looking to improve the taste of coffee for her family when she invented the coffee filter in 1908. Somehow she had the bright idea to punch holes in a tin container, put in a circle of absorbent paper, and place it over a coffeepot. Now her name graces an entire coffee paraphernalia empire.

Guess where the most arguments take place in the average American's home? The kitchen.

Before Fannie Farmer wrote her famous cookbook, *The Boston Cooking School Cookbook* in 1896, there were no standard measurements in any recipes—just a "**pinch of this**" and a "**dollop of that.**" Fannie almost didn't write the book. She had plans of going to college, but when at age 17 she had a stroke that left her partially paralyzed, she couldn't attend. As she was recuperating, she turned to cooking, later attending cooking school. Despite

the fact she became the school's director, she had a hard time getting her book published. Little, Brown only agreed when she said she would pay for the 3,000-copy print run. Fannie had the last laugh though—her cookbook eventually sold 4 million copies, and a grateful Little, Brown ended up making a fortune.

The Fast-Food Fix

◆ We're consuming more fast food than ever, while telling ourselves that our choices are healthier than they used to be. Even if that is true, we're still usually opting for a fat-laden burger, with men making that choice 75 percent of the time, and women 65 percent. And despite the low cost, the higher our incomes the more we drive in. One-fourth of us with incomes over $65,000 eat at fast-food restaurants at least 11 times per month!

◆ When we do go to a fast-food restaurant, men and women tend to behave differently. Men alone generally pick a table up front, where they can survey the action. Women by themselves tend to pick one in the back where it is quieter and there is more privacy. But women don't like going into the restaurant alone. Solo females comprise a large percentage of those using the take-out window. They then eat in the parking lot.

◆ Where do fast-food chains go to test new items? Tulsa, Oklahoma, because of its demographics. Tulsans match the average fast-food goer's characteristics perfectly. They overwhelmingly drive to work. And they go to fast-food spots because they like the food; convenience, cost, and health concerns are all secondary issues. Who tests there? Arby's, McDonald's, Subway, Pizza Hut, Long John Silver's, among others.

We Americans spend about $14 billion a year on snack food, consuming an average of 21 pounds per person. But what we are choosing varies from region to region. Potato chip consumers tend to live in the Central Eastern United States; tortilla chip crunchers in the Southwest and Pacific. The mid-Atlantic states are the champion pretzel eaters; they consume twice the national average. And the South is the only place you can find serious pork rind lovers, although even there the average is one-third of a pound per year.

Increasingly we are ordering 1 or 2 appetizers in lieu of an entrée when we dine out. To compensate for lost revenue, restaurant owners are beginning to close the gap between the prices they charge for the two categories.

I have never understood the difference between French and Italian bread in the grocery store. Here's the answer, discovered in *How Does Aspirin Find a*

Headache? While sometimes the shapes are different, the actual difference is in the ingredients. French bread has shortening and sugar added to the flour, water, yeast, and salt; Italian bread does not. This makes French bread rise more, resulting in a bread lighter in consistency and texture than Italian.

It Just Keeps Going Round

Chances are you've seen the Internet story about the $250-dollar Neiman-Marcus cookie recipe. (If you haven't, it's a letter from a woman claiming to have accidentally paid $250 for Neiman-Marcus' special cookie recipe; she thought she was being charged $2.50. They wouldn't give her a refund, so to retaliate, she is letting as many people know the recipe as possible for free.) It's an urban legend, one of those stories that circulate so much that people believe it's true even though it never happened. What I recently discovered that I didn't know before, however, is that this version is just the latest one in a story that has been around since the 1940s. In the first version, it was a chocolate cake recipe that a woman paid $25 for. Later it became a $100 fudge recipe, a $1,000 Red Velvet cake recipe, and a $250 Mrs. Fields cookie recipe, among others. Mrs. Fields Cookies took so much flack that the company printed up

posters declaring it a hoax and hung them in every store. What I want to know is why this story? What does it tap, besides our love for chocolate, that it keeps resurfacing?

Women on the Domestic Arts

"I don't like to say that my kitchen is a religious place, but I would say that if I were a voodoo priestess, I would conduct my rituals there."
—*Pearl Bailey*

"It seems to me that our three basic needs—for food and security and love—are so mixed and mingled and entwined that we cannot straightly think of one without the others." —*M. F. K. Fisher*

"My idea of heaven is a great big baked potato and someone to share it with." —*Oprah Winfrey*

"There is nothing like soup. It is by nature eccentric: no two are ever alike, unless of course you get your soup from cans." —*Laurie Colwin*

"Cooking tip: Wrap turkey leftovers in aluminum foil and throw them out." —*Nicole Hollander*

"People who loathe the idea of a salad are very like those who claim not to like perfume: they just haven't met the right one." —*Miriam Polunin*

"The secret to making good bread is that there is no secret. Let your imagination help you break any rules you imagine exist to daunt you."
—*Jacqueline Deval*

"Asparagus should be sexy and almost fluid."
—**Diana Vreeland**

"I must divide Perfect Dinners into three categories . . . one person dining alone, usually upon a couch or a hillside; two people, of no matter what sex or age, dining in a good restaurant; six people, of no matter what sex or age, dining in a good home."—*M. F. K. Fisher*

"Roast Beef, Medium, is not only a food. It is a philosophy." —**Edna Ferber**

"One cannot think well, love well, sleep well, if one has not dined well." —*Virginia Woolf*

"In the childhood memories of every good cook, there's a large kitchen, a warm stove, a simmering pot, and a mom." —**Barbara Costikyan**

"How to eat [spinach] like a child: Divide into piles. Rearrange again into piles. After five or six maneuvers, sit back and say you are full."
—**Delia Ephron**

"The cherry tomato is a wonderful invention, producing, as it does, a satisfactorily explosive squish when bitten." —*Miss Manners*

"Everything you see I owe to spaghetti."
—*Sophia Loren*

"I like the philosophy of the sandwich, as it were. It typifies my attitude toward life, really. It's all there, it looks good, and you don't have to wash up afterwards." —*Molly Parkin*

"What is sauce for the goose may be sauce for the gander, but it is not necessarily sauce for the chicken, the turkey, or the guinea hen." —*Alice B. Toklas*

She Was a Wee Bit Hysterical, Wouldn't You Say?

A woman going to the grocery store in Arkansas one day happened to see another woman sitting in her car, eyes closed and hands held around the back of her head. Taking a cat nap, thought the shopper, who then went in to shop for the week's groceries. When she came back nearly an hour later, the woman was still there, in the same position. She approached the car gingerly and asked if the woman was all right. "No," came the reply. "I've been shot in the back of the head and I'm holding my brains in." Our shopper quickly called for the paramedics who uncovered the real truth. One of those cardboard and metal bread dough tins had exploded, covering the back of her head with dough.

The first diet cola, Diet-Rite, was introduced in 1962. By 1966, there were a whole slew of reduced-calorie products.

The world's largest lemon was grown by Australian Violet Philips. It weighed 5 pounds, 13 ounces.

By the way, lemons contain more sugar than strawberries.

Grapefruits were known as "The Forbidden Fruit" until the seventeenth century.

Eighteen percent of us read the nutritional analyses on bags of corn chips before buying them in a company cafeteria; only 2 percent of us do so at a local sandwich place.

Americans so love pizza that the equivalent of 350 slices is being consumed every second of the day.

I Always Wondered Who Ate Them
According to research, the average consumer of a frozen pizza is a parent between 35 and 44 who has three or more kids and lives in the South outside a pizza delivery area.

We Eat Anything When We Are Bored
There's been a lot of research on the relationship between food and mood. In a Canadian study, scientists found that we prefer sweet things when we are worried or bored; spicy foods when we are feeling friendly, confident, or happy; crunchy things when

we are amused or bored; salty items when we are anxious or bored; sour foods when sad; warm foods when we're happy and relaxed; and cold foods when we're happy or relaxed. And when we're feeling amorous, we want sour, spicy, or cold food.

M&Ms were supposedly developed so that soldiers in the field could eat candy without getting covered in chocolate. The colors of M&Ms have caused a number of controversies: the greens are believed by many to be aphrodisiacs; orange is said to increase breast size. The reds were thought to contain Red Dye No. 2, which was found to be carcinogenic. Although they were never made with No. 2, some people to this day throw them out. There was a great uproar in 1995 when blue replaced tan. But here's my favorite M&M color story: The band Van Halen so hated brown M&Ms that it was written into their contract that if they even saw one as they were about to play at a concert, they would leave.

That fast-food standard—a hamburger, soft drink, and fries—takes approximately 1,500 gallons of water to make. That of course includes the water needed to grow the potatoes and feed the cattle.

Watermelon is really a vegetable.

By Any Other Name
Names for popular foods vary from region to region in the United States. Here are a few:

↔ Frappe/milk shake/cabinet

↔ Hero/hoagie/grinder/sub

↔ Hot dog/frankfurter/frank/wiener/
red hot/steamer

↔ Cod/codfish/scrod/whitefish

↔ Crayfish/crawfish/crawdaddy/crawdad

Despite the Boston Tea Party, tea was not the number 1 beverage of colonists. Neither was coffee. Chocolate was in the nonalcoholic department. As far as alcohol was concerned, New Englanders preferred rum, whereas the middle colonists quaffed beer.

Tea wasn't even introduced in America until 1714, and housewives weren't quite sure what to do with it. Many would boil the leaves in water, then throw away the water and serve the leaves with sugar and lemon.

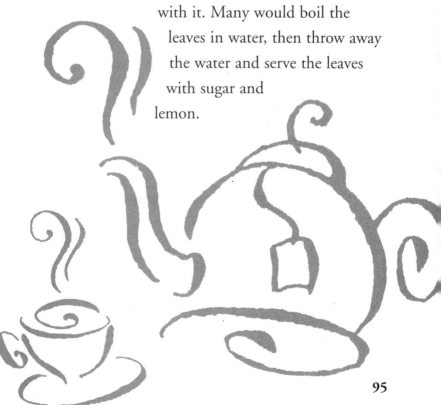

The old wives' tale is true. According to a study done by Michigan State University, those who eat apples daily get fewer respiratory infections than those who don't.

Popcorn, that movie staple, was actually banned in theaters during the 1920s because of noise.

We Americans eat 10 billion bowls of soup annually.

If you are pregnant, you should not eat feta, Brie, Camembert, queso blanco, Roquefort, or other blue cheeses. So says the FDA, because such soft cheeses may contain *Listeria*, which can be bad for an unborn baby.

Before the twentieth century, avocados weren't eaten by decent women because they were believed to enhance sexual prowess. Growers sponsored a PR campaign to sanitize this green fruit's reputation, which worked—avocados are now free from such taint.

4

Women in Bed

Connubial Conjugations and Other Erogenous Activities

According to Ann Landers, "Women complain about sex more often than men. Their gripes fall into two major categories: **1. NOT ENOUGH; 2. TOO MUCH.**"

Would you like to have sex more than three times a week? Yes, say 70 percent of men. No, say 46 percent of women.

Headaches used to be the main reason we didn't have sex. Now it's that we're just too tired.

The younger a woman is, the more she is likely to worry about losing her sex appeal. (The rest of us are too tired to care, I guess.)

Do you fantasize about someone else while having sex? No, say 63 percent of women polled. Yes, say 51 percent of men.

Seventy-five percent of women surveyed say that fantasy is part of their sex lives.

What are women's top five fantasies?

1. Sex with usual partner (not even on the male list)

2. Sex with a stranger

3. Sex with a former partner

4. Sex with a woman

5. Sex with someone of a different race

In general, say sexologists, women's fantasies are more romantic and atmospheric than men's. They often involve a developed story line, similar to a romance novel, with events leading up to the sexual encounter.

In survey after survey, sex is cited as Americans' favorite activity. However, at the same time, marriage and family therapists say one of the most common reasons couples seek help from them is lack of sexual desire.

A study showed that about 20 percent of the U.S. population has Inhibited Sexual Desire. Of that number two-thirds are women.

Technical Difficulties

An English woman phoned police after receiving two phone calls late one night. The first, she said, was an obscene crank call. But the second was the one that concerned her. She could hear a man's voice and her adult daughter crying out before the line went dead. The police rushed to the daughter's house and broke down the door. There was the daughter making love with her boyfriend, whose toe kept bumping the automatic dial button on the daughter's cell phone. The number programmed in? Her mother's, of course.

According to *Supermarket Business*, which should know, women are the purchasers of 60 percent of all condoms sold in grocery stores.

A condom manufacturer, who has a great interest in such things, tells us that on average, couples had sex 106 times in 1998, down from 112 times in 1997, and that couples living together had sex more often than married couples (about 40 more times a year).

Studies continue to confirm that men reach their sexual peak in their early twenties and then slowly decline, while women peak in their early thirties and stay that way until their early sixties.

Despite that, the older a woman gets, the less sex she has. Between 65 and 74, she has sex an average of 10 times a year, which drops to 2 times annually after age 75.

Over one-third of women over 80 are still having sex with a male partner. (But not often—see previous fact.)

In the 1970s a birth control campaign was waged in rural Egypt to get village women to begin taking birth control pills. It failed, because women took the pills, put them into lockets, and wore them around their necks rather than swallowing them.

What Lola Wants, Lola Gets

Throughout history, there have been women who have taken sexual freedom as their birthright and made an art out of making love. One such courtesan was dancer Lola Montez, who lived from 1818 to

1861. Her conquests included Alexander Dumas, Franz Liszt, the Czar of Russia, and King Ludwig I of Bavaria, who made her a baroness. Ludwig's antics with Lola cost the sixtysomething-year-old his throne, which only fueled Lola's wild reputation. Her "Spider Dance," in which she writhed in an imitation of a maiden caught in a web, probably didn't hurt either.

Before Helen Keller began to write about blindness, the topic was taboo in women's magazines because it was often caused by venereal disease.

What do you like to do in bed besides sleep? Fifty percent of men said have sex; only 20 percent of women gave that same response. A large proportion of women (23 percent) would rather read.

When asked what color they prefer for their bedrooms, women tend to choose blue, men white.

A woman's magazine asked whether you would rather have sex or chocolate. Seventy percent of those responding preferred chocolate.

Shades of the Independent Prosecutor

Catherine Monvoisin, known as "La Voisin," was a seventeenth-century provider to the French court of Spanish fly and other aphrodisiacs as well as poisons to get rid of unwanted husbands and rivals. Someone ratted on her, and King Louis XIV investigated more

than 442 ladies and gentleman of the court. Caught in the sting was his favorite mistress, the Marquiese de Montespan, whom he banished from his affections for her shenanigans. La Voisin herself was burned at the stake for her troubles.

HERE'S A GUY WHO REALLY KNEW ABOUT VENGEANCE

Catherine, the wife of Russian Czar Peter I, had a wandering eye, and Peter caught on. To teach Catherine a lesson, he forced her to watch her lover be killed, then pickled his head and kept it in their bedroom.

PREGNANCY PRECAUTIONS

- In twelfth-century Europe, bee-eating by women was said to be effective against pregnancy. So was holding a stone while making love. (But only if the woman held it.)

- In the Gold Rush days, women of the Wild West would use a half an orange as a diaphragm.

- In ancient Persia, to prevent pregnancy, it was recommended that right after sex, women should jump backward 9 times, then pat their belly buttons while sitting on their toes.

Exhibiting a penchant for procreation, women are more prone to adultery when they are ovulating.

Among the women of the world, Australian women are the most likely to have sex on a first date.

Up until the '60s, Catholic girls were told to avoid patent leather shoes because boys could see up their skirts in the shoes' reflection.

A woman successfully sued the city of San Francisco after a cable car accident, which she said turned her into a nymphomaniac who had sex as many as 50 times in a work week.

Research shows that when we are sexually interested in someone, our pupils dilate. This is something that courtesans in Italy knew in the sixteenth century without the benefit of science. That's why they used to put belladonna in their eyes—to make them dilate and therefore mimic lust.

What, according to surveys, is women's favorite part of the male anatomy? **Buttocks**.

Football is the most sexually exciting sport to females, reports *Playboy*.

Fifty-eight percent of female *Penthouse* magazine readers would be willing to have sex with a complete stranger for $1 million.

Female romance novel readers apparently like to play out their readerly fantasies: they have twice as many lovers as those of us who don't read such books.

Single women beware! If you have sex with a married man, there is a 70 percent chance the man will end the relationship with you.

WE DO LOVE TO TALK
When women have their first sexual encounters, within one week, 25 percent of us have told 5 or more of our closest friends.

About half the women in the world have one breast that's noticeably larger than the other.

When couples are asked how long they engage in sexual activity, they estimate 40 minutes counting foreplay. For longstanding partners, the time goes down to about 15 minutes.

If you spend the average amount of time (15 minutes) and the average number of times (3,000), you will spend around 620 hours in your lifetime having sex.

A *Playgirl* poll revealed that 96 percent of women have had sex when they didn't feel like it. And survey after survey confirms that 66 percent of women have faked an orgasm at least once.

Only 1 woman in 4 can't remember the names of all the men she's had sex with in her life.

Females Dish the
Birds and Bees

"My big fantasy has been to seduce a priest." —*Linda Ronstadt* (Maybe that explains her interest in California ex-Govenor Jerry Brown; he studied for the priesthood as a young man.)

"Only good girls keep diaries. Bad girls don't have time." —*Roseanne*

"The whole thing lasted about a minute and a half, and that included buying the dress."
—*Joan Rivers* on her first time

"I have always had a talent for irritating women since I was 14." —*Marilyn Monroe*

"Men aren't attracted to me by my mind. They're attracted to me by what I don't mind."
—*Gypsy Rose Lee*

Actress Sarah Bernhardt was famous for her propositions to European leaders, including the pope.

In Siberia in ancient times, a woman signaled her interest in a man by throwing dead lice at him.

It wasn't fun being a woman of ancient times, even if you weren't a slave. In ancient Greece, women were considered to be irrational, oversexed, and morally loose. They had no political or civil rights and were beholden their entire lives to either their husbands or their nearest male relatives. Women spent their lives in women's quarters, not seeing their husbands even for meals. When the man wanted an heir, his wife had to have sex with him at least 3 times a month until she got pregnant. The rest of the time, he took his sexual activity elsewhere. The exception to this female confinement was the *hetairai,* or courtesans. Not only were they free from constant male supervision, but they were educated—in culture and politics, as well as sex.

Things were a bit different later in Rome. Upper-class women were free to do anything they wanted—as long as it was insignificant socially or politically. Generally speaking, they spent their days shopping, beautifying, marrying, taking lovers, and divorcing. Unlike everywhere else, Roman women were free to divorce—and they did often, partially due to a law that allowed their fathers to reclaim at least a portion of their dowries if

the marriage ended. They'd have a fling with some guy and come back home to try again. One woman had 8 husbands in 5 years. Why such sexual freedom in an age that was generally repressive for women? Women far outnumbered men, so if a man wanted heirs, he had to dance to the woman's tune.

The more education you have, the less sexual activity you tend to engage in. (Busy doing other things, I guess.) Conversely, the more TV you watch, the more sex you tend to have. And studies have shown that watching PBS is more positively related to increased sexual activity than watching other programs.

Houses of the Rising Sun

❀ The first known brothels date back to 3000 B.C. in Sumer. In Europe, they didn't catch on until 600 B.C., when Greek ruler Solon sanctioned their use. In Greece, they were nonprofit businesses that cost a mere penny per visit. (Is that where the expression "a pretty penny" came from?)

❀ There is a museum in Washington, D.C., that traces the history of prostitution around the world. It's called the Red Light Museum.

❀ Where did the red light district get its name anyway? From the light that hung on the back of railroad trains. These were carried from train to

train by workers, and when the railmen stopped and frequented a house of ill repute, they would hang their lanterns outside the brothel's door.

❀ Historians tell us that Louis XV spent more money on sex than any other human being who has ever lived by creating a harem on the grounds of Versailles. Costs included maintaining illegitimate children, dowries for ladies of the night who were retiring into marriage, and an enormous salary to the madam who found him the women of his dreams. Cost to Louis? $600,000 per year—in the 1700s!

❀ Prostitution isn't what it used to be. There are an estimated 1 million prostitutes working in the United States right now. However, in the mid-1800s, there were 100,000 ladies of the night in London *alone,* and in early nineteenth-century Vienna, there was 1 prostitute for every 8 men.

❀ Many of us Westerners assume that geishas are prostitutes. Most are not. Geishas are a class of professional women in Japan whose job is entertaining men. Some sing, others dance or play instruments. They are all able conversationalists.

❀ It was prostitutes who first started the craze for breast implants—Japanese prostitutes after WWII, to be exact. Naturally flatter-chested than their American counterparts, they were looking for a way to be more alluring to American servicemen stationed in their country. They tried many things, ultimately allowing doctors to inject them with Dow Chemical's newly created substance, silicone. By 1950, silicone was the hottest item on the Japanese black market, and the practice quickly spread to Hollywood and from there to the rest of the United States.

❀ Historically in India and in other parts of the world, there were temples where sacred prostitutes lived and worked. These women were considered priestesses and offered sexual services as blessings in exchange for money for the upkeep of the temples.

❀ Where did the name *hooker* come from? From Brigadier General Joseph Hooker, who served in the Union Army during the Civil War. He became renowned for allowing prostitutes to follow his soldiers. These women were originally called "Hooker's division" and then "hookers."

❀ Perhaps the most famous house of ill repute is the Chicken Ranch in Texas, where during the Depression, you could pay for your evening's

pleasure in chickens. This caused a great number of chickens to be roosting about, and the proprietors spent a lot of time making sure their customers weren't stealing their chickens to get another turn for free.

The rumors about Catherine the Great's unnatural love for her horse is, apparently, just that.

Of those who are having affairs, women tend to think their lovers are better sex partners, while men say their wives are.

Making love is not a great workout. It only burns about the same number of calories as climbing 2 flights of stairs. You'd do better walking fast or even having an argument—both raise your heart rate more.

The first popular sexologist was Dr. Marie Stopes, who lived in England from 1880 to1958. She was very interested in sexual rights for women; she had been in a marriage that was never consummated and was concerned that women know as much as possible about sexuality. Her 1918 book *Wise Parenthood and Married Love* was considered shocking because it encouraged women to actually enjoy sex. Soon women throughout Great Britain were writing to her for advice, and a book of those letters were eventually published too.

Too Sexy for Show

✱ In traditional Chinese culture, it was acceptable for artists to depict both nakedness and sexual relations. But under no circumstances could they show a woman's naked foot. Somehow Europeans got hold of a similar notion. During the Renaissance, you could paint a woman totally nude, but you could not show her bare feet. And during the nineteenth century in Europe, it was acceptable for actresses to show any part of their anatomy except their toes. *That* got them charged with indecent exposure.

✱ The foot taboo in China extended beyond art. It was illegal for a man to look at the naked foot of a married woman. If he did, her husband had to kill him.

✱ In Laos, it is still illegal for a woman to show her toes in public.

They Were Taking No Chances

To ensure the purity of women in medieval Japan, it was illegal for a woman to be alone in a room with a man. If she were caught doing so, even innocently, she would be killed.

Extreme liberals or extreme conservatives tend to be more sexually active than those in the middle.

Researchers explain it by saying that if you are passionate in one area of your life, you will be passionate in others. That seems to be corroborated by the fact that thrill seekers have the most sex of anyone.

The Lowdown on Lip Locks

♥ No, the French do not call it a "French" kiss. They call it an "English" kiss.

♥ Sweet 16 and never been kissed? Not likely. The average American is 13 when that happens.

♥ Kissing in public was considered quite offensive in the early days of the United States. In 1656, a Bostonian was placed in the stocks for kissing his wife on the street. And there are still laws on the books around the country that prohibit kissing. For instance, don't kiss a stranger in Cedar Rapids, Iowa; you could land in the clinker. And men with mustaches are not allowed to "habitually kiss human beings" (I guess other creatures are okay) in Indiana.

♥ When is a kiss not a kiss? Instead of touching lips, the Pacific Island people, the Tinquian, place their lips near their loved one's lips and breath in quickly.

♥ Other indigenous people spurn kissing as well. When they first saw Europeans kissing, members of the Siriono of South America were horrified. Too dirty, they thought.

♥ Women tend to like to kiss more and longer than men, and tend to recall their first kiss much more than men.

♥ Throughout parts of the East, hand kissing is the custom. This is a practice in which you kiss your own hand, then press it against the forehead of the other person. (Much less germ-laden.)

♥ The ancient Romans differentiated between three types of kisses: *basium*, which was the kiss between acquaintances (akin to the socialites' air kisses of today, I would guess); *osculum*, the kiss between true friends; and *suavium*, the lovers' kiss.

The Book of Sexual Records says that the oldest wife ever cheated on was a 97-year-old Frenchwoman. When she found out her 100-year-old husband had a mistress, she kicked him out of the house.

Diminutive Dr. Ruth Westheimer has a mission in life: in her own words, to make sex "fun, safe, adventurous, and fulfilling." By the mid-1990s this little Jewish grandmother had published 11 books, had a syndicated column in more than 100 newspapers, and was a frequent TV guest. She credits her success to the way she looks: "If I'd been a tall blonde in a miniskirt, it wouldn't have worked."

A study was done on 200 single bar goers between 9 P.M. and midnight. They were asked how attractive they found members of the opposite sex in the room. As time passed, the women's reports of the men's sexiness remained consistent. If a woman found a man appealing at 9 P.M., say, she felt the same way at midnight. But for the men, it was a very different experience. The later it got, the more attractive men found the women. Women rated as "acceptable" at 9 became a "*Fox*" by 12. No, it was not the alcohol talking. It happened whether a man had one drink or many. It was, scientists concluded, that men were so unconsciously interested in "scoring" for the night that their opinions changed to keep the possibility open.

Does Music Get You in the Mood?
Apparently, only jazz. Jazz lovers, after controlling for age and race, are 30 percent more sexually active than fans of other types of music. Rap, rock, classical, or hip hop have no such amorous effect.

Be Careful *Where* You Get in the Mood

Some people get into trouble with the locations they choose to frolic in:

❣ There used to be a strip bar in San Francisco that had a piano that would rise to the ceiling when a button was pushed. One night, after hours, the police got a call that there had been an accident at the club. Apparently, one of the women who worked there was entertaining after hours. She and her partner got a bit carried away, and the piano rose, crushing him to death. She escaped out a ceiling hatch.

❣ A British couple were having a good time on top of a cliff by the ocean when the man rolled over and plunged into the Atlantic to his death.

❣ A woman from Ohio and her lover were taking the opportunity for a bit of fun in a car parked in the garage of an abandoned house. A very large man, he had a heart attack and died, pinning her under him for four days until someone finally heard her screams and called the fire department.

The Personals Can Be Hazardous to Your Health

A 70-year-old actress, identified only as Eleanor B., died when a large pile of personal ads she had been clipping fell on her and smothered her.

What's one of the most popular shows on Japanese TV these days? A program that consists of young women in bikinis crushing aluminum cans between their breasts.

WILD AS SHE COULD BE

As a young girl, Martha Jane Canary was pretty much left to her own devices. At 14, in 1866, she put on men's clothes, bought a gun, and headed west, as so many young men were doing. There she found success of a sort as Calamity Jane, making her living at various times as an army scout, Indian fighter, and wagonner. But her biggest claim to fame was in the bedroom. Married 12 times, she "boasted that she had been banned from a brothel in Bozeman, Montana, as a bad influence on the B-girls," writes Autumn Stephens in *Wild Women*. "And, she bragged, she was the only woman in the West who had both worked the whore-houses and patronized them."

In the 1990s, romance novels went from 30 percent of paperback sales to 47 percent. Experts believe it's because of sexual fears. "The **BOOKS ARE SAFE SEX**," said one industry analyst.

One-quarter of people who lose their sense of smell (how common is that?) also lose all sexual desire.

In her day, Marlene Dietrich was as well known for her sexual conquests as her acting. She claimed

to have slept with Frank Sinatra, Edith Piaf, Kirk Douglas, and even JFK—the latter when she was 62 years old!

It wasn't until 1967 that singles bars came into vogue.

Just Say No

In ancient Rome, six young girls, ages 6–12, were chosen to maintain the fire in the tabernacle of the temple of Vesta. (Hence the term "vestal virgins.") Taken from nobility, they swore to remain virgins as long as they attended the temple fire, which generally was for a term of 30 years. They could leave at any time to wed, at which time another girl would be chosen. But if any woman broke the vow of chastity before officially retiring, she was sealed up in an underground room and left to die.

In the 1970s, the Rhode Island legislature, casting about for new ways to increase their coffers, I presume, debated charging people a $2 tax every time they had sex. Enforcement, naturally, was the stumbling block.

What's in a Word?

❀ The word *hussy* comes from Old English and originally meant "housewife." By the seventeenth century, it had transformed itself into the word for a loose woman.

✽ A legal term for adultery is "**criminal conversation.**"

FUNNY SEX TITLES

In researching this book, I checked out *amazon.com,* which listed 17,092 books when I typed in the word *sex.* There really aren't that many; the search engine included in that count every book on relationships or feminism (confusing sexism with sex). Still, there are a lot. Looking at the first 1,000 or so, I got a chuckle out of:

- *52 Invitations to Grrreat Sex (Envelopes Included)*

- *Advice for a Young Wife from an Old Mistress*

- *Affair: How to Handle Every Aspect of Your Extramarital Relationship with Passion, Discretion, and Dignity*

- *The Art of War for Lovers*

- *Babies and Other Hazards of Sex: How to Make a Tiny Person in Only 9 Months with Tools You Probably Have around the Home*

- *Bad Sex Is Good*

- *The Bluffer's Guide to Sex*

- *The Book of the Penis (by a woman)*

- *Advice for a Young Wife from an Old Mistress*

- *Bulletproof Diva: Tales of Race, Sex, and Hair*

- *Catch & Release: The Insider's Guide to Alaskan Men*

- *Chinese Ghost Stories for Adults: Sex, Love, and Murder between Spirits and Mortals*

- *Country Ways: Secrets for Finding and Keeping a Country Man*

- *The Cult of the Born-Again Virgin: How Single Women Can Reclaim Their Sexuality*

- *Don't Bite the Apple 'Til You Check for Worms: A Survival Guide to Love, Sex, and Singleness*

- *Dream Lovers: Women Who Marry Men Behind Bars*

- *The Ethical Slut: A Guide to Infinite Sexual Possibilities*

Good News

While women tend to wash their hands more than men, men are more likely to wash their hands before having sex.

In 1996, Americans spent almost $1 billion on phone sex.

In a study done for *Playboy*, 61 percent of the men responding said they were almost always the one who initiated sex, with only 14 percent saying women tended to take the lead. And 52 percent claimed they were more sexually adventuresome than their female partners.

XOXO Statistics can be deceiving. The average adult American claims to have sex once a week. But because that's an average, it includes all those (1 in 5) who haven't had sex in a year, and the 1 in 20 who have sex every single day. Looked at another way, about 15 percent of us are having over half the sex and 20 percent are having none.

Men report more sexual activity than women, but that's not just male boasting. Because men tend to die sooner than women, it is the vast majority of women without partners who are reporting the least sex. When you look at married couples, the numbers match up—almost. Husbands and wives guess within one incident of one another how frequently they have sex, with the man, for whatever reason, reporting the extra session.

Attraction 101

Many surveys have been done in the United States and Europe regarding what attributes men and women find most sexually attractive in the opposite sex. Here's a summary, taken from *The Lovers' Guide Encyclopedia,* ranked in order. The differences speak for themselves.

Male Attributes Chosen by Women

1. Intelligent

2. Sense of humor

3. Successful

4. Good in bed

5. Reliable

6. Physically attractive

7. Sensitive

8. Kind

9. Handsome

10. Similar interests

Female Attributes Chosen by Men

1. Physically attractive

2. Beautiful

3. Kind

4. Sensitive

5. Sense of humor

6. Intelligent

7. Similar interests

8. Reliable

9. Sporty

10. Successful

Courtship Gestures

Studies in body language reveal that we make certain characteristic moves when we want to indicate to someone we are sexually interested in them.

WOMEN

* Cross legs in direction of the person

* Straighten body, drawing attention to breasts

* Stroke hair or tilt head

* Lean forward

* Soften and lower voice

* Open eyes wider

* Touch person, perhaps by brushing a piece of lint off his clothes

MEN

* Smooth hair

* Pat clothes

* Stand taller and thrust chest out

* Soften and lower voice

* Sit with legs apart

* Touch person, perhaps with hand on shoulder

* Open eyes wider

Beyond the West

Other cultures have very different standards of sexual attractiveness. Here are a few historical preferences:

* **Mayan:** Crossed eyes

* **Yapese:** Black teeth

* **Maasai:** Black gums and tongue

* **Ganda:** Pendulous breasts

* **Tiv:** Fat calves

* **Chinese:** Bound feet

* **Syrian:** Joined eyebrows

* **Kwakiutl:** Flattened heads

* **Mongols:** No eyelashes or eyebrows

* **Ila:** Protruding navels

* **Hottentots:** Huge buttocks

It's Too Darn Hot

Scientists confirm that there are fewer births 9 months after a heat wave. An increase of 21 degrees on the thermometer reduces birth rates 6 percent. Most folks believe that's because it's too uncomfortable to fool

around, but studies have also shown lower sperm rates and more miscarriages in hot weather.

In ancient Phoenicia, it was common practice for men to offer their young daughters to male houseguests. And in Babylonia, all women had to work as sacred prostitutes at the temple before being considered for marriage. Also in Babylonia, men could use their wives as collateral for loans. If he forfeited, the money lender could take the woman.

Where did the habit of long tablecloths come from? From Victorian times, when it was believed that the sight of naked table legs was too suggestive.

In the 1950s, panty raids swept through college campuses, with men running to women's dorms demanding female underwear. The great sexologist of the time, Dr. Alfred Kinsey, declared of the practice, "All animals play around."

One in five women would like to have a penis.

Marvelous Madams

U.S. history is full of colorful stories of women who took the career limitations of their gender and turned a profit. Here are some of my favorites from *The Bordello Cookbook:*

❀ Minna and Aida Everleigh (not their real last name) were two sisters who ran what clients

described as "the most magnificent bordello in North America"—the Everleigh Club in Chicago, which flourished from 1900 to 1911, the era of Al Capone and his fellow gangsters. Aside from the luscious ladies, the club boasted gourmet food. Both cost a pretty penny; the price for the food or the females was $50 and up—in 1900! Once the restaurant put on a dinner for 6 hosted by a railroad magnate that cost him $1,200 per person just for the food and drink. The club was so famous that when Prussian Prince Henry came to the United States, he made it his premier stop, and had such a good time that he toasted the sisters with champagne from a prostitute's shoe. The place itself boasted 14 reception rooms, a huge ballroom with a fountain, an art gallery, a $15,000 gold-plated piano, and rooms with various themes including Chinese, Moorish, Japanese, Silver, and Egyptian. The Gold Room had 18-carat gold spittoons and sconces. The sisters really knew how to create atmosphere. Whenever Minna was in the mood, she would declare it Butterfly Night and release

hundreds of butterflies into the public rooms. Canopied beds sprayed perfume on guests as they frolicked, and Persian rugs boasted mattresses under them for maximum comfort. The sisters also knew how to keep business rolling—paying all the right officials and giving all the journalists in town the pleasures of the house for free. Such actions really paid off—the duo made about $10,000 a month in profits for 10 years or so, until a reform-minded mayor put them out of business. Minna and Aida eventually changed their last names and moved to New York, where they lived the rest of their lives as respectable, upper-class women.

❀ During the same time the Everleighs were flourishing, *the* place to go in New Orleans was Mahogany Hall, to see Miss Lulu White. Now Lulu was not much to look at in her "civvies," but when she dolled up, she could really turn the heads. Every evening, this madam would descend the staircase of her bordello, singing "Where the Moon Shines" and wearing more diamonds than

has been seen on a human before or since. She had diamonds on every finger, diamond bracelets all the way up both arms, a diamond necklace, and a diamond crown perched atop her red wig. But her *pièce de résistance* was her smile—which revealed diamond-studded teeth. Poor Lulu had a sad end, though— in a deal to buy a Hollywood studio, she trusted her paramour with her fortune, and the cad ran off with the cash.

❀ Down the road a piece from Miss Lulu's was Countess Willie V. Piazza, another madam of note. Willie, who was no more a countess than I, always sported a monocle and a 2-foot cigarette holder. By her side was her doorman, a midget named General Jack Jackson. One of her claims to fame was that jazz great Jelly Roll Morton played often at her place because, he said, Willie was "the only madam in town with sense enough to keep her piano tuned."

❀ Kentucky madams were of a different stripe. One of the best known was Pauline Tabor, who had been a Sunday School teacher before divorce left

her penniless. A lady had to support her two young sons somehow, and "the oldest profession in the world" was this gal's solution. She made a fortune in her 25 years in the game, but she never lost her do-good mentality. When the local newspaper began an "Adopt-a-Family" Christmas drive, Pauline and her women decided to participate. The newspaper had serious misgivings, until Pauline threatened to hold one of her own that would outshine theirs. The family they were given—parents and 12 children ranging from 17 to 7 months on the brink of starvation—was supplied with food, clothes, toys, coal, and furniture, and Pauline's house was invited to join in the drive every year after. Once, when one of her girls fell in love with and married a customer, Pauline was asked to give away the bride in the ceremony. "And who ever heard of a madam giving the bride away?" she queried. "A madam **NEVER GIVES AWAY ANYTHING.**"

5

The Feminine Physique
Fascinating Facts about the Female Form

*W*omen cry approximately 5 times as much as men. Women's hearts beat faster too. Three out of five women have cried at work.

Nobody knows if it is nature or nurture, but women are less able to whistle than men. But women can do splits more easily—and don't you forget it!

Again and again, researchers have shown that women are more "other-centered" than men, who tend to be more self-centered. A particularly amazing study in the '70s showed that this difference goes so far as literally to affect what we see. A group of boys and girls were given binoculars that showed their left and right eyes two different images simultaneously. They were all shown the same images, but girls reported seeing significantly more people and boys more things.

Women are more likely to stop for a yellow light than men—30 percent to 9 percent. We are more likely to buckle up as well.

Let's just face it, we're better drivers. According to *Mind-Bogglers*, 92 percent of all drivers who drive under the influence of drugs or alcohol, drive over the speed limit, or cause death or bodily harm while driving are men.

Ninety-five percent of aerobics class attendees are women.

The Nose Knows

❀ Because of their estrogen levels, women have a much better sense of smell than men.

❀ Blind and deaf from birth, Helen Keller had such an acute sense of smell that she could, she claimed, tell the differences among her friends when they entered the room.

Every minute, you take in 7 quarts of air; your right lung takes in more than the left.

Girls learn to speak, on average, sooner than boys and learn to read more quickly. Boys generally catch up, but in adulthood, women tend to have larger vocabularies.

Women get more colds than men, although not as children—boys have more colds than girls.

The Bulge Battle

✳ Fat makes up approximately 25 percent of a woman's body (and 15–18 percent of a man's), which makes it harder for a woman to lose weight than a man.

✳ Women between 20 and 44 years old are more likely to be overweight than men of the same age.

* Thirty-five percent of women have fasted to lose weight, and 45 percent have popped diet pills.

* A study of 3,000 children in grades five through eight discovered that 55 percent of girls think they are **FAT** (compared to only 28 percent of boys).

* Being fat makes you feel bad, right? Only if you are a woman. A study of 42,000 women and men reported in the *American Journal of Public Health* found that women who were obese were 37 percent more likely to suffer from depression than women of average weight. However, for men it worked the other way—fat men were 37 percent **LESS** likely to be depressed; it was the scrawny guys who suffered the most (they were 25 percent more likely to be depressed). The reason, says researchers, lies in our stereotypes of body image for women and men. It's "better" in the eyes of society for a man to be hefty and a woman to be skinny.

* American women's obsession with thinness was ushered in in 1924 by the book *Diet and Health*. The book was written by Lulu Hunt Peters, M.D., also know as "The Siren of Slenderizing." The tome, which had women striving for the flapper's boyish slimness, remained on the best-seller list for 5 years.

* Women, particularly unhappily married women, are vulnerable to gaining weight after tying the knot. One study found that women in marital misery gained an average of 42 pounds over twelve years.

* The creator of Weight Watchers, Jean Nidetch, weighed 214 pounds before she came up with the idea for the diet plan. A year later, after following the program, she weighed 142.

* In 1996, for the very first time in history, the number of overweight Americans exceeded the number of normal-sized ones.

THE NEWEST IN WEIGHT LOSS GIMMICKS

A recent "Dear Abby" details a new kind of weight-loss practice: the weight-loss shower. A woman who lost 30 pounds is hosting a party to celebrate her achievement. Sounds fine, right? But she is asking invitees to bring money to help her buy a new wardrobe. The letter writer was shocked and so was Abby.

Only 22 percent of women like what they look like naked; 68 percent of men do. That might explain why almost twice as many men as women have been skinny-dipping with a member of the opposite sex.

The average female thigh is 1 1/2 times larger than a man's. How unfair!

Trying to Age Gracefully

According to *Longevity* magazine, men hate the following about aging women's bodies (the last two don't seem to have anything to do with aging to me!):

1. Large hips (59%)

2. Wrinkles (51%)

3. Gray hair (41%)

4. Short legs (33%)

5. Small breasts (25%)

What women hate most about aging men's bodies:

1. Portly body (70%)

2. Baldness (49%)

3. Shortness (48%)

4. Love handles (47%)

5. Wrinkles (12%)

Are we all fooling ourselves? Eighty-four percent of women aged 30 to 50 think they look younger than their actual age.

Only 25 percent of women aged 30 to 50 think that as people age they should let nature take its

course. However, 89 percent of women say that they feel more confident as they get older.

It's All Relative

According to a survey by Clinique:

❋ Women aged 16 to 29 consider 43 "the end of youth."

❋ Women aged 30 to 49 consider 56 "the end of youth."

❋ Women aged 50 consider 65 "the end of youth."

Women today live, on average, twice as long as they did only 100 years ago!

Women blink twice as often as men.

Women are said to sleep and dream more than men.

If you wonder why you lie there awake while the guy next to you sleeps peacefully each night, one reason is that women are 3 times more sensitive to noise while sleeping than men.

Only 1 in 1,000 women is colorblind, compared to 7 men in 100.

Women laugh less than men. Supposedly the average man in the United States laughs 69 times every day, while women guffaw only 55. And when women laugh they do so more quietly and for a shorter amount of time than men.

The ladies of the court of Louis XI were so beauty-conscious that they dined primarily on soup so they wouldn't have to chew. Chewing was feared to cause wrinkles.

Pregnancy and Childbirth around the World

❀ Suffering from arthritis? Here's a temporary cure: Get pregnant. The pains will almost certainly go away, at least until the baby is born.

❀ Hawaiian midwives are called *kahunas*. Some are known for being able to take the pain of childbirth onto themselves or have someone other than the pregnant woman experience it.

❀ When a woman is pregnant, her uterus expands to **500** times its normal size!

❀ To keep the baby from "sticking" in the womb, Hawaiian women are encouraged to gently shake their bellies when they take baths.

❀ Women from a tribe in Malaya give birth lying face down on the boats they live on, whereas

women in Kenya, the Philippines, and India, among other places, tend to stand up.

❀ A boy or a girl? A recent Swedish study indicates that if you suffer from terrible morning sickness, chances are you are having a girl. The nausea is from a hormone that is found in higher concentrations in women carrying girls than in those carrying boys.

❀ Women in Latin America who want to get pregnant buy a pomegranate in honor of Yemaya, the goddess of motherhood. The woman cuts the pomegranate in half, coats it with honey, writes her name on a slip of paper, and then encloses the slip of paper as she puts the two halves back together. She then offers it to Yemaya with a prayer that she be as fruitful as the pomegranate.

❀ The Kalapalo women of Brazil give birth in hammocks.

❀ In medieval Europe, laboring women sat in birthing chairs that had holes in the middle.

❀ Among certain tribes in Sumatra, when a young woman is pregnant for the first time, her parents make her a special piece of cloth called a "soul cloth." This cloth is covered with designs that are used to tell the woman's future and as protection during labor.

❀ Scientists have concluded that when they are first born, babies look more like their fathers than their mothers. This is an adaptive mechanism to help the father bond with the baby, researchers speculate, for fathers can never be sure the baby is theirs.

❀ In many cultures around the world, when a woman goes into labor, the rest of the family loosen their hair, set their animals free, and uncover their pots as symbols of an unobstructed birth.

❀ According to Korean folklore, if you dream about the sun, dragons, snakes, tigers, horses, or pigs while pregnant, your child will be a boy. If it's a girl, you will dream of flowers, apples, butterflies, cherries, owls, rabbits, or jewels.

❀ The umbilical cord is about 26 inches long, just long enough to be able to bring the baby to the breast before cutting it.

❀ The Celts believed that human souls inhabited butterflies and houseflies, and they flew around looking for a mother. When a woman swallowed one of these, she would become pregnant.

❀ Eighty-two percent of women now discover whether they are pregnant by using a home testing kit.

Russian scientists have discovered that if you are a girl and your father is older than 50 when you are born, you live on average 6 years less than a boy born under the same circumstances.

An amazing study done at Iowa State University in 1969 found that the gender of a child may be determined by the stress levels of the parents at the time of conception. They discovered that children tended to be the same gender as the parent under the least stress!

Where the Stork Comes From

Women around the world tell children that the stork brings newborn babies. (A variant of the story is that the stork bites the mother when it brings the baby, which is why Mom has to stay in bed.) This myth got established from the belief that storks are particularly caring toward their young, which biologists now tell us isn't true. The association between storks and babies is so strong that it was believed that the souls of unborn children lived in the swamps, marshes, and ponds that are storks' natural habitats.

The very first beauty contest was held in the seventh century B.C. People from Corinth established another town, called Basilis, nearby. To celebrate the event, the ruler of Corinth called for a beauty contest, which was held annually for centuries. Whether the judging was impartial is open to question. The first year's winner was the ruler's wife.

A woman from Scotland went to bed one night and woke up speaking with a South African accent. Eventually she was diagnosed as having Foreign Accent Syndrome, which is actually the result of a minor stroke. Only 11 other people have ever been diagnosed with this malady.

Baring It All

- The Victorian cure for flabby breasts was a bath in fresh strawberries.

- In the eighteenth century, baring one's bosom was considered racy. But what to do about all those oil paintings in the family gallery of buxom seventeenth-century relatives? Why, have a painter come in and paint a big handkerchief over the bosoms.

- "If I hadn't had them, I would have had some made." —*Dolly Parton* on her sizable assets

- Humans are the only mammals whose breasts are prominent throughout their lives. In all

other mammals, breasts are flat except during pregnancy and lactation.

𝕚 We've all heard of the dangers of breast implants. But what about their hidden benefits? I am referring to the story of topless dancer Dora Oberling, whose breast implants actually saved her life when she was shot in the chest by a disgruntled lover. Bystanders thought she was dead, but she was able to get up and walk away under her own steam; the silicone stopped the bullet.

𝕚 The IRS has allowed female exotic dancers to list their breasts as business assets. The most famous case was of a woman who called herself "Chesty Love." She was allowed to deduct $2,080 each year for depreciation of her artificially enhanced bosom because, she said, she had done the enhancement purely for business purposes.

𝕚 Betsey Johnson had one of her breast implants deflate on her one day. "The longer I looked at my flat-chested side," she told a writer for the *San Francisco Chronicle*, "the better it looked. I felt fate had sent me a message, so I had both implants removed."

Almost twice as many women as men are double-jointed—21 as compared to 14 percent. And being right-handed ups your odds.

Twice as many women as men can touch their tongues to their noses (my grandma could!).

The truth is out! It is women, far more than men, who are guilty of not squeezing the toothpaste out from the bottom of the tube. But we're better about flossing than men.

Slightly more women than men prefer baths over showers (28 versus 22 percent). I've certainly never seen a man in a bathtub.

On the subject of bathing, it is said that Queen Isabella of Spain, who lived for 53 years, bathed only twice in her life.

Athlete's foot plagues men (46 percent) much more than women (14 percent).

Almost half of all women carry something in order to defend themselves against an attacker—mace, pepper spray, a nail file, or hat pin.

About one-third of us never sit on a public toilet seat, and another third do so only after covering it.

What do women like to do to relieve stress, in order of popularity?

1. Watch TV.

2. Listen to music.

3. Take a bath.

4. Scream at someone.

5. Clean house.

6. Go for a walk.

7. Exercise.

8. Have sex.

9. Have a drink.

As we grow older, both men and women tend to snore more, with women catching up to men after menopause.

Twenty percent of women, married or not, sleep with stuffed animals.

Women are, on average, 5 inches shorter than men.

While women are getting taller with each generation because of better nutrition, there have always been fantastically tall females. Two such ladies were Ella Ewing, who lived from 1875 to 1913, who was 7 feet, 6 inches tall, and Anna Hanen Swan, 7 feet, 5 1/2 inches tall, who lived from 1846 to 1888. Anna married one of the tallest men of the time, Martin Van Buren Bates, who, at 7 feet 2 1/2inches, was still dwarfed by his wife.

The tallest known woman in the world was Zeng Jinlain of China, who was 8 feet, 1 3/4 inches tall.

The Monthlies

* Here's a fact I am dying to know how they discovered and why they were investigating it in the first place: While a woman is menstruating, her middle finger's sensitivity is lessened.

* In Victorian times, women took to their "sick beds" each month when they were menstruating.

* The modern tampon was invented in 1933 by a male gynecologist. Currently over 70 percent of women use tampons.

* If you were never pregnant and began menstruating at age 12, the average in the United States, you will have approximately 500 periods in your lifetime. Recently researchers have been looking into the theory that breast cancer and ovarian cancer are somehow related to the number of periods a modern woman has. Anthropologists have discovered that in indigenous cultures, due to late onset of menstruation, frequent pregnancies, and breastfeeding, the average woman only menstruated 100 times in her life.

* A new study indicates that just like women living together synchronize their menstrual cycles, women who are breastfeeding affect the other women in the house, giving them shorter menstrual cycles.

Oh, What Social Creatures We Are

A study done at a university discovered that women tend to wash their hands in public bathrooms much more frequently if someone was there to observe them. If they thought they were alone, only 3 out of 19 women washed their hands. Unfortunately, the study was not repeated with men.

Morticians report that dead bodies don't decompose as fast as they used to. They speculate it's due to us eating so many preservatives!

Stay-at-home moms, who used to be called housewives, walk 10 miles a day around the house if they do their own household chores. And if they make all the beds for a family of four, they will spend 25 hours a year making beds. (I knew there was a reason I never make the bed!)

Of Hot Flashes and Other Ignominies

✳ The average age of menopause, defined by the cessation of menstruation, is between 50 and 52. And depending on what study you look at, between 47 and 85 percent of women report experiencing hot flashes during menopause. (Women in cultures that have a lot of rice and soy in their diets, like Japan, report far fewer hot flashes.)

✳ The most common menopausal complaints? Number 1 is weight gain, followed by sleep problems, hot flashes, fatigue, lost sexual desire, and forgetfulness.

✳ So many of us menopausal women are taking estrogen replacement that it is now the most prescribed drug in the United States.

In traditional Chinese culture, doctors were forbidden to touch or look at women's bodies. So each doctor carried small ivory carvings of a woman's body with him to the curtained sickbed. He would ask the woman to mark the troubled areas on the doll, then push it through the curtains. She would indicate the problem and he would then treat her.

Most of us think we are the most attractive member of our family, according to the Peoplepedia Opinion Poll, with women choosing themselves twice as much as men.

Our bodies have about 60 trillion cells, each of which has approximately 10,000 times as many molecules as the Milky Way has stars, reports Isaac Asimov.

Under the Knife

✳ Three out of every 4 nose jobs are done on a woman.

* The most popular cosmetic surgery for women is liposuction, followed by eyelid surgery.

* There's a lot of fat being removed lately. According to the National Clearinghouse of Plastic Surgery Statistics, there were 47,212 liposuctions done in 1992 and 172,079 in 1998.

* The Never Satisfied Department: 40,000 women per year have their breasts enlarged and 30,000 have them reduced.

* Cindy Jackson, a.k.a. "the human Barbie Doll," has had 27 plastic surgeries in 9 years to try to achieve Leonardo da Vinci's ideal of a classically proportioned body and face.

* Canadian Krystyne Kolorful has tattoos over 95 percent of her body, which makes her the most tattooed woman in the world. She's a strip tease artist, so I wonder if their cost was tax deductible?

* Then there's Scotland's Grace Martin, who has 290 body piercings, to hold the world's record for Most Pierced Woman.

* Britain's Donna Campbell had the longest sneezing fit on record. The 12-year-old sneezed continually for 978 days.

Female Health Risks

★ One out of every 8 women who lives to age 95 gets breast cancer, but the risk of developing it before the age of 70 is 1 in 14.

★ While breast cancer among young women is on the rise, 80 percent of breast cancers occur in post-menopausal women, and 60 percent of women with breast cancer live as long as women without the disease.

★ We may be afraid of breast cancer, but the American Medical Association informs us that more women die from lung cancer (from smoking, mostly) than breast cancer.

★ Women who start having intercourse before the age of 16 are twice as likely to develop cervical cancer than women who wait until their twenties.

It's just not fair. A 9-year study on diabetes shows a link between the disease in black women and lifestyle issues such as poor diet, being overweight, and lack of exercise. But it found no such correlation for black men. Such factors accounted for half of all the cases of diabetes in African American women, but virtually none for black men. Black women develop diabetes twice as often as whites; weight, diet, and exercise account for only about half the difference. It is speculated that either there is another environmental factor at work in the other 50 percent, or some genetic predisposition.

6

Truly, Madly, Deeply

Ladies Look at Love, Marriage, and the Baby Carriage

According to a study from Arizona State University, women who never have children are happier in their marriages than their husbands are. Other studies have shown that couples are happiest before kids are born and after they leave permanently.

Two women under one roof? That's the Chinese written character that means "trouble."

If you are a man in Australia, be sure not to wink at a woman. It is considered rude, even in friendship.

Beginning in 1838, it was against the law in Los Angeles to serenade a woman without a license.

In Little Rock, men and women are prohibited from flirting on the street. The fine, if caught, is 30 days in the clink.

Of Hearts and Flowers

♥ Where did the idea for Valentine's Day come from? One version claims that it comes from the belief during the Middle Ages that February 14 was the date that birds chose their mates, which led to the notion that women and men do the same.

♥ And then there's the story of Saint Valentine, who performed marriages against the wishes of the Roman emperor Claudius (he had banned marriages because he didn't want soldiers to have family ties to distract them from their job of killing). Claudius found out and jailed Valentine, sentencing him to death. While in jail, the legend has it he became a teacher to the young blind daughter of his jailer. Julia's sight miraculously returned. The night before he was to be killed, he penned Julia a letter, signing it "*From Your Valentine*." This is supposedly the origin of sending love notes for Valentine's Day. Unfortunately for the romantics among us, in 1969, Valentine lost his status as a saint, because there was no record of his actually having lived.

♥ Here's another story of where the holiday comes from: Before Christianity, the Romans held a fertility festival in mid-February in honor of the god Lupercus. At the festivities, the names of all the unmarried women were placed in a box and drawn one after another by available men. The couples would then frolic together throughout the year. When Christianity came to Rome, Pope Gelasius turned it into a festival to honor Saint Valentine; the names drawn out were those of saints to be emulated. But the love connotation stuck.

♥ The first known Valentine's Day card was sent in 1415, when the duke of Orleans, who was imprisoned in the Tower of London, sent a love note to his wife. The note is on display today at the British Museum.

♥ The first maker of American Valentines was Esther Holland. Her frilly creations went for as much as $35 in the 1870s.

♥ How did lace get associated with this day for lovers? It dates back to the days when women could not express their intentions to men directly. If a woman was interested in a man, she would drop her lace handkerchief in his vicinity in the hope that he would retrieve it and strike up a conversation.

♥ Americans send more cards on Valentine's Day than on any other holiday except Christmas.

It's difficult to be a woman interested in finding a man in Russia and the former Eastern European block countries. More than anywhere else in the world, women outnumber men. Latvia leads with 116 women for every 100 men, the Ukraine 115, and Russia 113. The reverse is true in the Arab countries: there men outnumber women as much as 197 (in Qatar) to 100.

What Matters to Us in a Mate?

A survey of "Sex and Singles" asked women and men what they're looking for in a long-term relationship. Sixty-one percent said friendship; love, 58 percent; honesty, 57 percent; and trust 56 percent. Only 29 percent of us said good sex, and financial security ranked lowest, at 12 percent.

There's an old wives' tale that if you want to attract a lover, or to strengthen the love you already have, you should make something by hand and give it to the beloved as a gift. The energy you imbued in the item as you made it will bind the person to you.

Two out of 3 women read advice columns and take the suggestions to heart.

The Bathroom Saga

Why do women tend to go to the restroom en masse, whereas men go alone? No one knows for sure, but numerous theories abound. One is that women are more relationship-oriented than men and so take every possible chance to bond with one another. Another is to kill time in the inevitable long lines that occur in every public ladies' room. Still another is that it's for safety; we're worried about what might happen in the stall with our clothes down around our ankles, so we feel more comfortable with a companion. And yet another idea is that it gives us a chance to trade hair and makeup advice and tips—and, of course, the chance to dish the men we're with.

A Bit Bitter, Ladies?

"Women speak because they wish to speak, whereas a man speaks only when driven to speech by something outside himself—like, for instance, he can't find any clean socks." —*Jean Kerr*

"Women want mediocre men, and men are working hard to be as mediocre as possible."
—*Margaret Mead*

"My cliches about men: as vain as a man, as selfish as a man, as tricky as a man, as two-faced as a man."
"What has a man ever done to you?"
"Nothing. But they have caused all the trouble in the world and brag about it." —*Elsa Triolet*

"I require only three things of a man: that he be handsome, ruthless, and stupid." —*Dorothy Parker*

"In the long run wives are to be paid in a particular coin—consideration for their feelings. As it usually turns out this is an enormous, unthinkable inflation few men will remit, or if they will, only with a sense of being overcharged." —*Elizabeth Hardwick*

"The people I am furious with are the women's liberationists. They keep getting up on soapboxes and proclaiming women are brighter than men. That's true, but it should be kept quiet or it ruins the whole racket." —*Anita Loos*

"During the feminist revolution, the battle lines were again simple. It was easy to tell the enemy, he was the one with the penis. This is no longer strictly true. Some men are okay now. We're allowed to like them again. We still have to keep them in line, of course, but we no longer have to shoot them on sight." —*Cynthia Heimel*

Eighty-two percent of single women say the men in their lives want to avoid commitment, says the Hite Report.

Women tend to choose a mate based on his earning potential rather than his attractiveness.

The Lowdown on Jealousy

✳ Women get jealous over emotional infidelity, whereas men are worried about sexual infidelity.

✳ Women tend to blame themselves for their men's straying, whereas men blame others.

✳ When a relationship is threatened, women tend to want to save the relationship; men want to save face.

✳ Eighty percent of women hiring private detectives are single professional women in their late twenties to forties who want to check up on a man in their lives.

✳ The less educated a person is, the more he or she is prone to jealousy.

Love's Chemistry

According to biochemists, while we are falling in love with a particular person, the biochemical experience is the same for all of us—we're literally drugged by our mate. When we are attracted to someone, our brains release a number of natural amphetamines that produce a sense of elation and large quantities of endorphins that flood our bodies with a sense of well-being. Scientist believe such chemicals exist to help with the stages of attraction and attachment. This chemical high can last for as long as 2 or 3 years before it starts to slow down, which is why the divorce rate peaks at 4 years. Those of us who are on a perpetual search for this "love high" are disappointed when it goes away and discard our partners in hopes of having more long-lasting feelings the next time. How-ever, such euphoria just doesn't last forever, researchers warn. To make a relationship work long-term, we need to stop focusing on that "feel good" sense and develop a more well-rounded connection to the other person.

The Census Bureau estimates that one-third of those living in unmarried-partner households are gay or lesbian.

What Men Do for Love

We often think of men as being relationship-phobic, but here are 4 guys who really went to extremes to attract the women of their dreams:

♥ A 28-year-old man talked a friend into stabbing him to find out if his ex-girlfriend would visit him in the hospital. The friend obliged, and the guy was hospitalized. No word, however, on whether his plan worked.

♥ A 35-year-old Canadian was caught puncturing the car tires of women he was interested in. He did it so he could then rescue them and they would fall in love with him.

♥ An Arizona State football player asked to use a woman's cell phone, then told her he would get kicked off the team for violating NCAA rules regarding cell phones unless she married him. The woman took pity on him and they wed. The marriage has since been annulled.

♥ A 42-year-old Italian became convinced his wife didn't love him anymore and got out his gun to shoot himself in despondency. Just then his wife came in and was able to convince him that she did indeed love him, so he should put the gun

down. He dropped it to the floor, whereupon it went off, killing his wife in the process.

The Babylonians were into fairness, at least in marriage. Each year, they would auction off eligible girls. Men would bid high for the beautiful girls, and the money would then go to provide dowries for the less-endowed ones so that they too could have husbands.

Online Love

There's a host of folks looking for a mate online. Here's a few to visit. (Note: They do not screen their clients, so beware.)

- *www.matchmaker.com*

- *www.udate.com*

- *www.americansingles.com*

- *www.match.com*

- *www.XseeksY.com*

IF YOUR SEARCH PROVES FRUITFUL

Check out *www.theknot.com*, the new hot source for wedding information and paraphernalia.

Researchers in Switzerland have discovered that women tend to choose men whose natural body odor is different from theirs. This is a biological adaptation, they say, because it tends to result in children

with better immune systems than those whose parents have similar smells.

In 1991, the percentage of men who never married was 26.1; of women, 19.3.

The Trip Down the Aisle

- ❦ "The trouble with some women is that they get all excited about nothing—and then marry him."
 —*Cher*

- ❦ In Greece, when a woman gets married, she writes the names of all her single women friends and family on the bottom of her shoe. After the wedding, the sole is inspected; if your name has been worn off, you'll be next to be married.

- ❦ In ancient Greece, women marked their age not from when they were born, but from when they wed; life before wedded bliss was considered irrelevant.

- ❦ In 1477, Anne of Burgundy became the very first woman to be given a diamond engagement ring. Before that time, only men wore diamonds. Anne's generous fiancé was Maximillian I.

- ❦ During the Revolutionary War, patriotic American brides wore red, not white, to show their allegiance to independence.

- These days, 3 out of every 4 first-time brides wear diamond engagement rings, which usually are round and cost about $1,500 each.

- A one-carat diamond weighs 200 milligrams. The measurement, a carat, comes from the weight of a carob seed.

- The most expensive diamond ever sold at auction went for over $16 million. It was pear-shaped.

- The most expensive wedding dress in the world is supposedly worth more than $7 million. Created for show, not wear, it's embroidered in diamonds and mounted on platinum.

- While the average wait between engagement and wedding remains 1 year, the longest engagement on record was between Ann McCloy and Edward Ballard, who were formally engaged for 30 years. They never did marry.

- The youngest married couple in the world is a pair from Bangladesh, who were wed by their parents at ages 11 and 3 months to end a feud between the two families.

- In Los Angeles in 1976, a woman legally married a 20-pound rock with 20 guests present.

- Actually, marriages between people and objects have a long history. In India, there is a tradition

of tree marriages among the Brahmins of Southern India. They did not consider it proper for a younger brother to marry before an older. So if a younger wanted to wed and the older had no prospects, the older would marry the spirit inside a tree, freeing the younger brother to wed. (No word on whether older brother could later marry a woman.)

❦ Nine out of 10 brides are traditionalists—they wear something old, something new, something borrowed, and something blue. Many get 3 in 1 with a borrowed heirloom blue garter.

❦ Wedding rings are exempt from consideration as an asset in a bankruptcy hearing. What this means is that no one can take it from you against your will under any circumstances.

Paul and Mary Onesi have been married for 82 years, making them the longest-married couple in the United States. They have lived in the "honeymoon capital" of the world, Niagara Falls, for the past 52 years.

In 1892, the Italian government raised the minimum age for marriage for girls—to 12.

Of White Weddings and Garters

Wedding customs come from all sorts of places. Here are my favorites:

- Why do most weddings take place in June? That was the time the Romans favored, in honor of Juno, goddess of women.

- In Roman weddings, the bride's head was covered by a veil to protect her from evil spirits; the preferred color was red. The joyous couple were showered with grain for fertility.

- We got the idea for walking down a carpet from the Chinese, who believed it was bad luck if a bride's shoes touched the ground.

- Nordic brides put a penny in their shoe for good luck; the custom these days is to use a dime.

- The idea for groomsmen and the best man comes from the Scottish. Back in the days when a clansman would just make off with the woman he desired, he enlisted his friends to help fend off her pesky relations. The strongest of these groomsmen was the best man.

- Where did the wedding toast come from? In medieval France, wine was served with pieces of spiced toast at the bottom. The first person to

drink his wine and eat his toast could give a speech—the "toast" to the bride and groom.

❦ Wedding rings, they say, are leftover from the days when men would capture a bride and tie her to the house in irons.

❦ On a happier note, we wear wedding rings on our left hands thanks to Greek physicians of 3 B.C. They taught that the ring finger of the left hand had a "vein of love" that flowed to the heart.

❦ The notion of the honeymoon comes from Northern Europe, where it was popular to drink honey mead as an aphrodisiac. According to custom, the newlyweds were supposed to drink a glass of honey mead every day for 1 complete cycle of the moon and stay away from either of their parents.

❦ The use of Mendelssohn's "Wedding March" dates back to the days of Victoria, Empress of Germany and Princess of England. In 1858, she wed Prince Frederick William of Prussia. Mad for Mendelssohn, she insisted on the piece, setting off a practice that continues to this day.

HERE'S A WEDDING BEST FORGOTTEN

A couple were getting married one day in Missouri when a woman they both knew slightly from high school burst in and shot at them, then turned the

gun on herself. They were unharmed; she died. A photo of the groom from their yearbook was found in the woman's possession. The couple, after recovering from the shock, went on with the wedding, only to have the bride's grandmother die during the reception of a heart attack.

Beyond Garters and Toasts

❀ In the traditional Chinese wedding ceremony, 2 goblets of wine and honey tied together with a red ribbon are presented to the couple. In Chinese symbology, red is the color of both joy and courage, so the custom represents not only the joy and sweetness of the love that the two will share, but also the courage their relationship will necessitate.

❀ In Burma, both the man and the woman have a bouquet that they hold during the exchange of vows. This is to symbolize the importance of the vows to both of them. Afterward, they dip their hands in a bowl of water to symbolize their sharing of the water of life.

❀ In Germany and Greece, the bride and groom carry candles decorated with flowers

and ribbons, representing the illumination they wish to bring to one another.

❀ In Holland, rather than a receiving line, the couple sits on thrones under a canopy of tree branches, and guests come to them to offer their wishes. Symbolizing the evergreen freshness of love, this practice is done as a ceremony *before* the wedding, which sends the couple off to the wedding in a wash of good thoughts.

❀ In Hindu weddings in India, the bride and groom exchange flower garlands at the start of the ceremony. They then receive protective wrist amulets and listen to the recitation of their family lineages. Tied together with a sash, they walk 7 times around a ceremonial fire to symbolize their willingness to face life's challenges together. Finally, the groom's brother sprinkles flower petals on the pair at the end of the cere-mony to symbolize a life of beauty and fragrance.

Dangers of the Veil

An Egyptian man fainted dead away when he discovered that he had not married his 18-year-old fiancée, as he thought, but her fortysomething aunt. His intended's in-laws had pulled a switcheroo, and because of the heavy veil Egyptian brides wear, he was fooled until after the ceremony.

Tying the Knot,
Celebrity Style

♥ Tom Thumb was a famous circus dwarf in the nineteenth century. When he married fellow circus dwarf Lavinia Bump, the event was dubbed by the press as "The Fairy Wedding." The ceremony was the talk of the country, with more 2,000 guests, including President and Mrs. Abraham Lincoln.

♥ The most watched wedding in history was, of course, the marriage of Diana Spencer to Prince Charles in 1981. Almost 800 million people around the world were glued to their TVs to view the event. Mementos from the wedding brought in an estimated $1 billion.

♥ Liz Taylor's 1991 wedding to Larry Fortensky was the most security-conscious Hollywood nuptials ever held. The wedding took place at Michael Jackson's estate; to keep out journalists, there were 80 security guards as well as mounted police and secret service. To discourage helicopters, balloons were floated 540 feet above the estate. One determined photographer parachuted in, but was arrested before taking any film.

♥ The largest wedding of all time took place at Olympic Stadium in Seoul, when Rev. Sun Myung Moon married 35,000 couples. An additional 325,000 were married via satellite at the same time.

A recent poll found that while 85 percent of the women surveyed were satisfied with their marriages, only 57 percent were satisfied with their sex lives.

We Really Do Talk More

Research confirms it: Women say approximately 7,000 words a day; men, 2,000. No wonder men and women can get into such communication tangles.

Scientists have recently discovered that women gossip only slightly more than men but are much more inclined to discuss family and friends, whereas men spread rumors about sports figures and politicians. And women tend to gossip as a way of expressing indirect anger. Men tend to take gossip less seriously than women, but women are the ones who tend to stop if they think it's harmful.

Forty percent of us women have thrown a shoe (average size: 8B) at a man who has offended us.

Trouble Spots

✳ Nine out of 10 women who are married would love it if their mothers-in-law dropped off the

face of the Earth. Mothers-in-law rank with sex and money as problem issues in relationships for 90 percent of women.

✳ What do couples argue about? Aside from money, 28 percent of couples bicker over what TV shows to watch, followed closely by not spending time together (21 percent) and how to discipline the children (20 percent).

✳ Twice as many men—22 percent—as women—11 percent—have forgotten their wedding anniversaries. The longer you've been married, the more likely it is that you will forget.

The 7-year itch is real—the typical American woman who gets divorced has been married 7 years, according to the National Center for Health Statistics.

After a divorce, the average woman's income declines about 73 percent, while a man's increases 42 percent.

The average person falls in love 6 times in his or her lifetime. Women fall in love more often than men, and they are the relationship enders as well— 70 percent of the time.

The largest recorded divorce settlement was the one between Soraya and Adnan Khashoggi. Adnan ended up giving his ex-wife $874 million— plus property.

Just Saving Her From Herself
In Kentucky, it is against the law for a woman to marry the same man 4 times.

Now *There's* Grounds for Divorce
A woman in Saudi Arabia may divorce her husband for failing to keep a steady coffee supply in the house.

For Some Women Divorce Is Just Not an Option

❖ A Frenchwoman was convicted of killing her husband by feeding him fruit tarts laced with tranquilizers. She only got 5 years, however, because she convinced the court that she wasn't trying to kill him, only make him shut up.

❖ A Canadian woman was convicted of attempting to kill her husband by smearing peanut butter over his face while he slept. Apparently, he was highly allergic to the nuts and she was hoping to send him into fatal shock. He started choking, however, which woke him up in time to give himself a shot that saved his life—and put her behind bars.

Some states are scrupulous in enforcing the no-fault divorce law, which holds that the person making the most money of the pair must pay alimony to the other, regardless of mitigating circumstances. Thus it was that a woman from Colorado had to pay

$4,000 to her husband, despite the fact that he was about to go to jail for 12 years for trying to kill her.

Chore Wars

* Seventy-six percent of the fair sex say they make their beds every day; only 46 percent of men say they do. I wonder if the 72 percent includes the beds women are making for their men?

* The Rude Awakening Department: A study done among students at the University of California at Berkeley found over 60 percent of female seniors expecting parity in the kitchen with their husbands to be, but only 31 percent of men thought they were going to share the cooking duties.

* Married women are the laundry-doers in 93 percent of heterosexual households. On their own, though, men do at least 1 load a week.

* In male/female households, married or not, 3 out of 5 women are in charge of balancing the checkbook, and most of them are solely responsible for the bill paying.

* A woman who was feeling taken for granted by her family climbed a tree and vowed not to come down until her husband and 2 kids promised to appreciate her more and help out around the house. No word on how long she languished.

* In homes where both partners have full-time jobs outside the home, women do 70 percent of the housework too!

* Single mothers spend less time on housework than married moms, leading to the conclusion that men are making a great deal of the mess.

* One researcher commenting on the overworked nature of the American woman said, "**These women talk about sleep the way a hungry person talks about food.**"

* The American male isn't the worst housework slouch. He spends an average of 108 minutes a day on child care and domestic duties, compared to only 11 minutes by Japanese men.

* We can't lay the blame completely on men. In a survey of working women, 53 percent said they were not willing to give up any of their housework responsibilities. Why? They don't like the way the men in their lives do them.

Nine out of every 10 American women use their husbands' last names after marriage. Those of us who don't tend to be affluent professionals who have established our own names in a field of expertise, or individualists who consider it an outdated custom. Not surprisingly, the older you are when you wed, the more likely you are to keep your own name.

A study on infidelity done by the University of Texas has revealed a set of behaviors that goes along with unfaithfulness. Most go along with all sorts of other things, but here goes. The list includes taking too long in the bathroom, forgetting to turn off lights, going into debt, and laughing at animals when they are hurt.

Three out of 10 wives have no idea what their husbands' salaries are.

Anne Hayes is the wife of college football coach Woody Hayes. Once, when a heckler shouted to her, "Your husband is a **FATHEAD!**" the quick-witted Anne replied, "**WHAT HUSBAND ISN'T?**"

Who were the six wives of Henry VIII? He actually only beheaded two of them:

1. Catherine of Aragon, escaped via divorce

2. Anne Boleyn, beheaded

3. Jane Seymour, died in childbirth

4. Anne of Cleves, divorced

5. Catherine Howard, beheaded

6. Catherine Parr, survived him as his wife

A champagne company did a survey to discover what terms of endearment we tend to use for our mates. *Honey* won out, favored by 26 percent of folks, followed by, in order, *Baby, Sweetheart, Dear,*

Lover, Darling, and *Sugar. Angel* and *Pumpkin* were tied for the eighth spot, as were *Beautiful* and *Precious* for tenth.

The Couple That Plays Together . . .

♣ Here's a romantic sport: wife carrying. It's an annual contest in Finland, in which men carry their wives around an obstacle course that includes wading in chest-deep water. The winner gets the weight of his wife in beer. His partner, who does not have to be his wife, must be at least 18 and sport a crash helmet for the event.

♣ Then there are the winners of the Longest Kiss contest, who stood and locked lips continuously for 29 hours. Mark and Roberta Griswold did it without even one rest or bathroom break!

All in the Family

Here's a convoluted relationship dynamic: You know Sally Hemings, the black slave believed to be Thomas Jefferson's mistress? Well, she was Tom's wife Martha's half-sister. That's because after the death of his wife, Martha's father, John Wayles, took slave Betty Hemings as his concubine. Betty had 6 children with Wayles, including Sally.

A recent study by *Consumer Reports* revealed that men do, indeed, hog the TV remote control—twice as much as women do. They also channel surf more (85 percent to 60 percent).

A survey of very affluent people reported that if they had more time, 40 percent of those surveyed would spend it with their families, while only 9 percent said they would have more sex. And just 1 in 20 claimed that money was the thing that brought them the most satisfaction in their lives; the majority—72 percent—said it was the love of family and friends that made them happy.

Mother Love

♥ The model for the Statue of Liberty was the mother of the statue's sculptor, Frederic Auguste Bartholdi. He used his mother, Charlotte, he claimed, because she was honest and strong. She looks sad because that is how his mother looked when he left Europe for the United States to escape the Franco-Prussian war. The statue is so heavy that each of Lady Liberty's fingernails weighs 100 pounds.

♥ The 3 leaves of the shamrock stand for the Three Brigits, the "mother-hearts" of Celtic tribes.

♥ "God could not be everywhere, so he created **MOTHERS**." —*Jewish proverb*

♥ Around the world, in most every language, the word for mother almost always starts with an "m."

♥ According to the Peoplepedia Opinion Poll, mothers score higher than fathers these days as the person who is most likely to give you good advice.

♥ Is This Weird or What? Teddy Roosevelt's mother and his wife died on the same day—Valentine's Day 1884. His wife died in childbirth, his mother of typhoid fever. Teddy was plunged into grief and retired from public life for 2 years.

♥ "The real menace in dealing with a 5-year-old is that in no time at all you begin to sound like a 5-year-old." —*Jean Kerr*

The higher your education level, the more likely it is that you are childless. Only 10 percent of women who never finished college don't have children, but that number jumps to 28 percent for women with 4-year college degrees. And the trend holds for women of all races, although the numbers vary, with Hispanic women having the most children overall—an average of 3.2.

Men continue to express an overwhelming preference for sons—in a recent survey, 48 percent of would-be dads want a boy; only 9 percent would prefer a girl. The rest have no preference.

ONCE A MOM...

When Franklin Roosevelt was president and his mother was in her eighties, he remarked that he had

never gone outside once in his whole life without his mother yelling, "Franklin! Are you sure you're dressed warmly enough?"

In 1999 in Great Britain, 300 women bought insurance against the chance of having a virgin birth, which they were fearful would happen at the turn of the millennium. What good, one wonders, would the insurance do?

This sounds like an urban legend to me, but the author of *The Best Book of Bizarre but True Stories ... Ever* maintains it's for real: When a couple was unable to pay the hospital bill for the birth of their daughter, the hospital refused to release the girl. They kept her for 6 months until the couple came up with the loot, which they were only able to raise after a newspaper publicized their plight.

The Times They Are A'Changing

❊ A poll done in 2000 showed that young men think of themselves as fathers first and then workers. Approximately 70 percent of men in their twenties and thirties answered that they would be willing to trade pay for more family time; only 26 percent of older men said that. And only one-quarter of the young men surveyed said having a job with a lot of prestige was important. The exception to these findings came from male high-tech workers, who believe they can work their tails off for a few years and then cash out with big stock options.

* Men say they want more time with their kids, and younger men are taking it. Seventy percent of fathers 35 or under spend at least 3 hours a day with their children, and 82 percent spend 7 hours or more on the weekend.

* We All Want a Break: In a 2000 *Parents* magazine survey, 77 percent of working mothers and 66 percent of working fathers said they would stay home fulltime to be with their kids if they didn't need the salary. That's a huge change from 1996, the last time the magazine asked the same question. Then only 29 percent of women would opt to stay home if they could.

But Not THAT Much

Moms are still putting in the most time though—1 in every 3 dads report they spend less that 3 hours a day with kids; only 1 in 20 women spend so little time. And while 1 in 4 working moms take at least a year when their babies are born, only 1 percent of fathers do.

How much time do parents think they should spend with their kids each day? At least 5 hours. Those who spend more time tend to worry less about their children's mental, emotional, and physical well-being.

Go Away, Dr. Spock

Today's parents feel pretty confident going against childrearing experts. We do what *we* think is right, regardless of what *they* say. To witness:

❀ Experts almost unilaterally agree that spanking is never justified; only 13 percent of parents agree.

❀ The American Academy of Pediatrics recently announced that children under two should not watch any television at all because it slows brain development. Fully 87 percent of parents ignore that warning, and 68 percent don't even think it's true.

❀ The American Medical Association says it can be dangerous to let an infant sleep in the same bed as parents. Over one-third of American parents do it anyway.

❀ Doctors recommend that babies be breastfed for a full year. Generally speaking, we manage to do it for a first child, but two-thirds of mothers only breastfeed a younger child until 6 months old.

❀ So if we ignore experts, whom do we ask for advice? Eighty-seven percent of those polled rely on their pediatricians, and 57 percent say they rely on grandparents and parents as their primary source of advice for Matthew's or Molly's first 3 years.

7

*B*arks, Coos, and Purrs

Promise Me Anything but
Don't Diss My Dog

We really love our pets these days. Pet owners outnumber households with children by 2 to 1.

We have pets primarily for companionship. Only 11 percent of dog owners and 6 percent of cat owners have them as companions for their children, and only 7 percent of dogs are kept for protection.

Increasingly we consider our pets as our children—two-thirds of us admit that having a pet fills a need for parenting. According to the American Animal Hospitals Association, 55 percent of us consider ourselves our cat's or dog's mom or dad rather than master (24 percent) or friend (25 percent).

Eighty percent of us buy our pets holiday presents. We also buy our furred loved ones birthday presents, bake them special cakes and sing "**Happy Birthday to You**" (one-quarter of us admit to this), sign their names on birthday cards to others, and even leave them messages on our answering machines when we're away. And 60 percent of owners include their animals in holiday festivities.

Women in particular look to their pets for affection. Forty-eight percent of us say we rely more on

I Love Fido

our dogs for affection than our spouses or children. Only 38 percent of men do the same.

Overwhelmingly women are responsible for pet care—in 72 percent of pet-owning households the task falls to females.

By the Numbers

* There are about 120 million dogs and cats in the United States.

* As of 1987, cats became the number 1 pet in America, pushing dogs into second place (less work for us career women).

* Nearly 38 percent of American households have dogs and 30 percent have cats (cat lovers tend to have more than 1 cat, which accounts for their higher total overall).

* At any given time there are over 1 million stray dogs and half a million stray cats in New York City alone.

* Americans spend more than $23 billion annually on their pets—up an amazing 9 percent a year from 1993 to 1997. By 2000, 800 million of those dollars were spent online.

* The cost of a dog from puppyhood to the grave: $14,000.

* Every single hour, 125,000 puppies are born in the United States.

* Only 13 percent of pet owners keep birds; 5 percent have reptiles.

* Pet food sales exceed those of pasta, baby food, and juice—*combined.*

* When dog owners divorce, neither is willing to give up the pet in 38 percent of cases. So where does Fido go? Eighty-one percent of the time, judges award custody to that traditional caretaker, the wife.

A Stickler for Superstition

Hope Montgomery Scott was a Philadelphia high-society grande dame known for her lavish dinner parties. One evening, however, a guest got sick at the last minute and had to cancel. Hope was distraught—now her party numbered 13. She tried to convince the cancelee that he *had* to attend, despite his fever of 104. When at last he convinced her he could not be there, she replaced him at the table with her dog.

Based on cave paintings, it is clear that dogs were the first domesticated animals. Nearly 50,000 ago, they were being used to help cavemen with hunting.

Cats were domesticated only about 7,000 years ago, in Egypt, to keep the mice out of granaries. Clay figures of women playing with cats (the special bond between women and cats has been forever, I guess) have also been found in Turkey; that indicates that cats were domesticated there around the same time.

In the last 4,000 years, no new animals have been domesticated.

Ancient Egyptians believed that cats were descended from Pasht, daughter of the moon and a goddess in her own right, whereas dogs were thought to be descended from Anubis, god of the underworld. Both species were bejeweled—cats with gold earrings, dogs with silver necklaces. Whenever family portraits were painted, Fifi and Fido were included. Around 2500 B.C., it was trendy to have cats sing at parties (maybe howl is more like it), accompanied by women playing musical instruments. And if you killed a dog or cat, even a stray, you yourself would be executed.

As you can tell from any visit to the statues in the antiquities section of a museum, Egyptian cats were quite striking. In Rome, in the early twentieth century, Princess Natalie Troubetskoy saw two Egyptian cats who were descended from that ancient line. The cats were owned by the Egyptian ambassador. Awed by their beauty, the princess made it her life's work to create a breed that would look like the original

Egyptian sacred cats. She found a female in Cairo and borrowed the Ambassador's male cat, and was off on the adventure of creating the line that is known today as the Egyptian Mau.

No, They Weren't Worried about Fleas
The Cold War began thawing when Khrushchev gave Caroline Kennedy a Samoyed puppy, Pushinka, who was the daughter of Strelka, the first dog to survive space flight. Not taking any chances, however, the CIA checked out Pushinka for bugs of the mechanical variety before letting her live in the White House.

A dog was featured once on *Oprah* for saving her mistress by calling 911. The woman had stopped breathing, and the Irish setter, failing to wake her, did as she had been trained to do—pushed the 911 button that had been programmed into the woman's phone.

Elizabeth I put down a rebellion by the Irish in 1560 with a force that included fighting mastiffs—8,000, to be precise—wearing chain mail suits with spiked collars.

While she deplored cockfighting as "masculine," lovely Queen Liz I had a weakness for a particularly nasty sport: bearbaiting. In it, chained bears were attacked by dogs while she watched. She even had a special pit just for this "amusement."

Pet-Styles of the Rich and Famous

♥ Queen Victoria loved her dogs second only to her beloved Alfred, and they accompanied her to all her audiences. A poodle of hers once attacked Tom Thumb and P. T. Barnum while they were being presented at court. Her favorite dog was a miniature spaniel named Dash. She would dress him for dinner in blue pants and scarlet jacket and serve him coffee in a cup. She even claimed that he could eat partridge with a fork and that she taught him his letters and numbers by having him kiss each letter or number as she named it.

♥ Ava Gardner loved her corgi Morgan, and in her will left him a salary and his own maid and limo. Morgan lived the high life for 7 years after Ava died. Then he, too, passed on. (He had been a gift from husband Frank Sinatra.)

♥ Morgan wasn't the richest dog in the world. That status belongs to Toby, a poodle that inherited $15 million when her owner Ella Wendel died. Ella loved animals—throughout her life, her dogs each had their own bedroom, slept on silk

sheets in tiny four-poster beds, and were served meals by the butler. Toby, sadly, got caught in a fight over the money. Wendel's relatives contested the will, keeping her in a box and feeding her from a regular dog bowl. Before the suit was settled, the estate's executors had Toby put to sleep (presumably for just causes).

♥ In the twentieth century, over 1 million dogs and cats were named as beneficiaries in wills.

♥ One hundred and sixty-one strays were left $4.3 million by oil baroness Eleanor Ritchey.

♥ The most lavish pet wedding ever held was between 2 cats in Thailand. They were married in a disco and they wore matching outfits. The groom arrived by limo; the bride by helicopter. The wedding cost over $40,000, including the bride's dowry.

♥ When her husband died, the duchess of Windsor started sleeping with her 2 pugs. "It is flattering to know," opined the 76-year-old, "that there are creatures who still want to share my bed."

♥ Madonna sent her dog to a **THERAPIST** after he became depressed over the birth of her daughter.

♥ For more than 2,000 years, until the fall in 1911 of Li Hsui, the last Manchu queen, it was the habit of the imperial families of China to keep

Pekinese. The dogs, which the royal Chinese considered sacred, had their own wet nurses and eunuchs to protect them, and a great number of the pups had their own palaces with a full complement of servants.

♥ Wealthy Westchester County matrons spend as much as $45 a week on grooming their long-haired dogs such as Bichon Frises.

♥ Want your pooch to have the best? Check out Karen's for People and Pets in New York City. Reputed to be the Bergdorfs for dogs, it carries such items as fur coats for poodles, gem-studded collars, and other such goodies.

♥ Or how about Animal Manors, also in New York City? Choose a castle or a French chateau; prices from $400 to $5,000 for the Egyptian temple.

Half of all Americans have pets, and about half of those allow their pets to be present when the humans are having sex.

One-third of those folks who own dogs talk to them on the phone when they are away. Honest—just ask the American Animal Hospitals Association.

Every swan in England is considered the property of the queen.

The smartest breed of dog, according to *The Intelligence of Dogs* is the Border Collie; the most intellectually challenged is the Afghan Hound.

She's Just Slow, Dear

Despite the old adage, dogs can learn new tricks at any age, although it's easiest to train them when they are puppies. The difference in learning tricks actually has less to do with age and more to do with the breed of dog. The smarter breeds—the aforementioned Border Collie, as well as poodles, German Shepherds, and Golden Retrievers—can usually understand a request in 5 repetitions or less, and once they've learned, they will obey on your first command 95 percent of the time. Slower learners, on the other hand, such as Afghans, Chow Chows, and basset hounds, may have to see something 100 times before they get it, and even then they'll only do it less than one-quarter of the time when asked.

Dogs that bite most frequently are German Shepherds, Chows, Italian Bulldogs, and Fox Terriers. The least prone to biting are Golden Retrievers, Labrador Retrievers, sheepdogs, and Welsh Terriers.

While women sleep an average of 8 hours per night, cats sleep 15 and dogs 18 hours a day. About half of us let our dogs sleep with them.

You Knew They Were Good Breeders
All pet hamsters in the United States are descended
from a single female wild golden hamster found with
a litter of a dozen babies in 1930 in Syria.

When you come in the door, whom do you greet
first? Seventy-eight percent of pet owners say their
dog or cat, with spouses a distant 13 percent.

An elderly woman let in a supposed meter reader,
who turned out to be a burglar who knocked her to
the ground. Defenseless, she just lay there, waiting for
it to be over. Suddenly her cat, claws extended, leaped
onto the man and drove him out of the house.

Want the love of a dog but not the daily hassle? If
you live in Japan, you can rent a pooch. There, pet
stores rent dogs by the hour, around $10–$20,
depending on the size. You can also sign your pet up
to a dating service that includes résumé, photos, and
a video preview of her intended.

Cat Peculiarities

✤ Cats have 4 rows of whiskers, which they use to
calculate whether they can fit into a particular
spot or not.

✤ They have 32 muscles in each ear.

❋ Cats can't taste sweet things—they don't have the taste buds for it.

❋ They rub up against you not to be friendly but as a way of depositing their scent on you through glands in their faces, marking you to warn other cats that you belong to them.

❋ Cats are the only animals that walk on their claws, not the pads of their feet.

❋ When they walk or run, cats step with both left legs, then both right legs. The only other creatures that do this are camels and giraffes.

❋ Ever wonder why a cat's tongue is rough? It's got a large number of small "hooks," which come in handy tearing up food.

❋ Cats love to be clean so much that they spend about 40 percent of their waking time cleaning themselves.

❋ If you have a calico or tortoiseshell cat, it most certainly is female. These two kinds of coats are sex-linked traits. All cats displaying these coats are female, or occasionally, sterile males.

❋ A group of kittens is called a *kindle;* adult cats group together into a *clowder.*

❋ Most cats are "alley cats"—some mix of breeds. When it comes to purebreds, the most popular cat by far is the Persian. There are 5 times as

many as any other breed. Maine coons come in a distant second, followed by Siamese, Exotic, Abyssinian, Oriental, Scottish Fold, American shorthair, Birman, and Tonkinese.

❉ No, it's not your imagination—cat hairs actually do cling to your clothes more than dogs'. The reason is that cats' coats have three types of hair: guard hairs on the outside; awn hair in the middle; and downy hair in the undercoat. The guard hairs actually have tiny barbs on them, which makes them stick to everything you own.

❉ Tiddles was a large cat, very large—32 pounds. He was also a working cat—he spent his life in a corner of the ladies' restroom in Paddington Station in London during the 1970s. Tiddles was an incredibly popular restroom fixture; he even had his own fan club. When the head of the club took him to her house once for a bathroom break, Tiddles was very unhappy. The loo was home, and home he went.

❉ If you've lost your precious puss, you might want to call on Saint Gertrude of Nivelles. She's the patron saint of cats (as well as gardeners and travelers).

The number 1 name for a cat is Kitty; for a dog, Brandy. But more than 50 percent of dog and cat owners give their pets a human name, such as Molly, Sam, or Max.

We worry about our precious pets while we're at work—three-quarters of pet owners admit to feeling guilty about leaving them. Half of us leave toys out, and 41 percent leave the lights on so the pets won't have to play in the dark. And one-third leave the TV or radio on as companion for Fido and Fluffy; some go so far as to try to choose something they think their pet will want, like the Nature Channel—no *Washington Week in Review* for these critters.

Our guilt over leaving our pets may account for the fact that 24 percent of pet owners take them to the office.

Pet Cemeteries and Other Afterlife Issues

ᔥ If you have a pet headed for the hereafter, check out the Hoegh Pet Casket Company in Gladstone, Michigan. You can see the casket showroom and factory, as well as a pet cemetery.

ᔥ When pets die, 60 percent of owners bury them in the backyard; 25 percent have them cremated.

ᔥ In ancient Egypt, entire families would shave their eyebrows and rub mud in their hair as signs of mourning when their cats died. When Cleopatra killed herself, she first poisoned her cats so they could accompany her to the underworld.

🍃 Princess Diana is interned in what used to be her family's pet cemetery.

According to the American Animal Hospital Association, half of all pet owners would rather be stranded on a desert island with their cat or dog than with a person (even when given the options of Leonardo diCaprio and Cindy Crawford).

According to the Institute for the Study of Animal Problems in Washington, D.C., dogs and cats have a dominant side just like people—they favor either their right or left paws.

Twenty-five percent of pet owners blow-dry their pet's hair after a bath.

A full 43 percent of pet owners have photos of their pets on display at the office, and 31 percent carry one in their wallets.

Half of pet owners claim they have taken time off from work to care for their sick animals.

Dog Facts

✦ There are 701 types of pure breed dogs.

✦ I bet you thought your dog sweated by panting and slobbering all over you. Not so. Dogs actually sweat through the pads of their feet.

✦ Contrary to popular belief, dogs are not color blind. They see color, but faintly, like human vision at twilight.

✦ What tricks do we teach our dogs? Not many. Only 21 percent can sit; 15 percent can shake; and 11.4 percent can roll over. And a mere 1.7 percent of dogs in this country can fetch a newspaper.

✦ The most talented pooch in the world is a Canadian toy poodle named Chanda-Leah. Owner Sharon Robinson has taught her to do more than 300 tricks, and the pooch has so many requests for appearances that she has her own publicist.

✦ In 1991, Millie the dog made 4 times as much money as a writer than her owner George Bush did being president of the United States. "Dictated" to Barbara Bush, Millie's autobiography sold over 400,000 copies.

The idea that black cats are unlucky is particularly American. In Asia and England, black cats are considered lucky.

A cat lover is an **ailurophile**, whereas a cat hater is an ailurophobe.

Dogs have 42 teeth, cats about 30.

These days, pet pampering goes way past hand-knit sweaters and velvet collars. Today's dogs and cats

have their own Web sites, catalogs, hotels, groceries, furniture, superstores, and, in upscale places like Santa Barbara and San Francisco, even specialty markets that sell baked goods only for dogs. There's a fast-food place in Toledo that caters solely to dogs. Since 1992, 500 discount giants have tapped this burgeoning market of pet pampering, even encouraging pets to browse the aisles with their owners.

And what can you get from those upscale mail order catalogs? A contraption that allows your dog or cat to ring the doorbell, pet sanitary napkins, pet toothpaste, holiday collars that blink, and all manner of flavored chew toys, to name just a few of the more interesting items.

Who spends the most on their animals? Forty-five- to 54-year-olds. They spend 64 percent above average on pet food alone. Nothing but the best for their pets, which explains the huge rise in premium pet food sales in the 1990s.

Spending on animals differs from region to region. Some of these differences make sense. In the cold Northeast, for example, folks buy more kitty litter (for when it's too cold to go outside).

For Fifi

But others are quizzical—why, when flea infestations are the worst in the South, where it doesn't freeze, are they the least likely to buy flea spray?

If you live in the San Francisco Bay Area and have a bored herding dog, you can take her to a sheep co-op, located in an upscale suburb, that exists to teach dogs such as Border Collies, Australian Shepherds, and Belgian Sheepdogs how to herd. Generally speaking, the dogs come once a week for 2 hours at a cost of $20. The women who run the co-op want to make sure the sheep feel "safe, happy, and not at all stressed out," so nice dogs only, please. Barking or biting gets one booted out.

It's not just a California thing. According to *Time* magazine, competitive sheep herding is "among the fastest-growing outdoor sports in the United States. Fifteen years ago, perhaps a dozen sheepdog trials were held each year; now there are more than 250."

Dog Rules of Thumb

[adapted from *Never Trust a Calm Dog and Other Rules of Thumb* by Tom Parker]

❖ Figure on 1 pound of dry dog food for every 30 pounds of dog.

❖ In a suburb of medium density, a dog's bark can be heard in 200 surrounding houses—or by 800 people.

❖ Anything over 45 minutes seems like forever to your dog. You will be greeted as enthusiastically coming back from a 2-hour shopping trip as you will coming back from a 2-day vacation.

❖ The rule that you can multiply a dog's age by 7 to find the equivalent human age is an overgeneralization. To truly calculate a dog's age in human terms, count the first year as 15, the second year as 10, and each year after that as 5.

❖ If a dog tolerates gentle handling between its toes, it probably is suited for children.

❖ A kennel should be twice the length of the dog you are building it for. Measure the dog from its nose to the tip of its tail.

❖ The best time for taking a puppy from its mother—psychologically and physically—is when it is 49 days old.

To save time, a 79-year-old Michigan woman decided to walk her dog and mow her lawn at the same time. So she tied her dog to the mower and began trimming the grass around her pond. All went well until the dog got sick of going in circles and tried to take off. The two got tangled with the mower in the rope, fell into the pond, and drowned.

Seventy-eight percent of cats travel with their owners, and 44 percent of hotels allow pets in guest rooms.

Marilyn Monroe once received a white poodle from Frank Sinatra as a gift. Sinatra had named him **Mafia**.

What Were These Folks Thinking?

❉ For some reason, Belgium once experimented with using cats to deliver the mail. Needless to say, the independent creatures didn't take to it too well.

❉ In the 1960s, the CIA tried a similar thing. They thought it would be a wonderful idea to outfit a cat with a transmitter and have it follow an enemy agent. Because cats are so hard to train, the trainers had to work very hard. Finally they got the cat to do its job, and soon they were hearing their target's conversations. Unfortunately, broadcasting soon ceased when the man crossed a busy street and the cat was run over. They turned to other methods.

❉ Because cats can see so well in the dark, the Army thought they might be useful in the Vietnam War in leading soldiers through the darkened jungles at night. Wrong! Soldiers ended up racing through the bush after birds and mice, got the straps of their backpacks played with by the cats behind them on patrol, couldn't get the cats to go out if it was raining, and had their legs used as scratching posts when they were in danger and unable to utter a sound.

Yes we all love dogs and cats. But what are the other top pets? Thirteen million Americans keep hamsters, mice, gerbils, rabbits, and guinea pigs; 11 million own parakeets; and another 10 million keep freshwater fish. Rounding out the top 10, in much lower quantities, are reptiles, finches, cockatiels, canaries, and parrots.

SHE HAD ON HER TRAVELING SHOES

A Russian cat named Murka lived with a woman who could no longer take care of her. So she gave Murka to her mother, who lived 400 miles away. As soon as Murka got to the mother's house, she disappeared— only to resurface at her original owner's house a year later, filthy, starving, missing the end of her tail, and pregnant. Somehow she had found her way back home over 400 miles.

Elsa was going blind and was encouraged to get a Seeing Eye Dog. But she already had a cat named Rhubarb and decided to try to turn Rhubarb into a Seeing Eye Cat. For a while, Rhubarb protested being on the leash, but he eventually got used to it. He does a pretty good job, too. If the phone is ring-ing while Elsa is outside, he comes and fetches her, leading her into the house.

In the book *Peaceful Kingdom*, there is a story of an elderly woman who was saved by her canary. The woman lived next door to her niece, who would check

up on her in the evenings to make sure the frail woman was all right. One night, the niece looked over and saw the lights were out and assumed her aunt had gone to bed. So she curled up by the fire. Suddenly there was an insistent pecking at the window, over and over. The niece got up and saw that it was her aunt's canary. Hurrying to the house, she found her aunt unconscious in a pool of blood. She had taken a tumble, hitting her head badly. After being rushed to the hospital, she was soon right as rain.

All you dog lovers might want to hightail it to St. Louis and take a peek at the Dog Museum. It's renowned for dog-related art.

An ordinary woman in Southern California had her toy poodle dognapped and held for ransom in 1992. The asking price? Five thousand dollars, until the owner, a retiree on a fixed income, got them to drop the amount to $2,500. She paid, and the dog was delivered to the pound as promised. The pound had been alerted and called 911; police promptly caught the criminal.

$5,000

If you would like your dog to go to summer camp, consider Camp Gone-To-The-Dogs in Vermont, a 500-acre campus with swimming pond, tennis courts, running trails, and dog dorms. The dog-to-human ratio is 2 to 1; no kids allowed. They even offer dog square dancing.

According to the American Animal Hospital Association, 6 in 10 pet owners include news of their pets in holiday cards and letters, and one-third include pet pictures.

Riki was a cat aboard an Italian cargo ship when a small airplane crashed into the ocean nearby. The ship's crew searched for survivors, but as the hours passed and darkness fell, they were about to give up. Suddenly, Riki ran to the ship's prow and began mewing and pacing frantically. As the sailors looked in the direction she was indicating, there was a woman in the water. Riki had saved her life.

Cats purr at about 26 cycles per second, the same frequency as an idling diesel engine, but nobody really knows why they do it. For cats not only purr as a sign of contentment, but to indicate fear and distress as well. (This can be confusing to humans, don't you think?) Scientists believe that endorphins are released when cats purr. This would flood their bodies with a sense of well-being, which might be why they purr when they are sick or afraid, as well as when they are pleased.

Terrible Chain Reaction

It's the stuff cartoons are made of, but this time it was for real. Somehow, a dog on a thirteenth-floor balcony in Buenos Aires fell and landed on a 75-year-old woman, killing her instantly. A crowd gathered; one of those milling around was hit by a bus and died instantly. Then a man who witnessed both events had a heart attack and passed away too.

And We Thought They Couldn't Perform

The 300-seat cat theater in Moscow is so popular that shows are sold out months in advance. If you *could* get a ticket, you would see cats walking tightropes, pushing trains, and playing leapfrog, among many other tricks.

A woman with multiple sclerosis was in a truck that caught on fire. She pushed her dog Eve out to safety but couldn't make it herself. Eve came back, though, and pulled the woman from the truck, dragging her to safety seconds before it exploded. Later Eve was given an award for bravery.

In 1988, pet-grooming parlor owner Patricia Lopes made the *New York Times* for performing CPR on a 13-year-old greyhound who collapsed in her salon. The dog survived, although it was probably not the most enjoyable experience for Lopes, who declared to the newspaper that she "would rather not perform [dog] mouth-to-mouth again."

Beach Boy Carl Wilson loved his dog, and when it got killed by a car, friend and songwriter Henry Gross wrote a song in honor of the Golden Retriever. He offered it to the Beach Boys, who refused to record it because, they reasoned, no one would want a song about a dog. So Gross recorded it himself, and it went gold immediately, selling 1.5 million copies. No listeners knew "Shannon" was a dog. They all thought the song was about a girl.

In ancient China, dogs were considered good-luck charms, able to ward off demons. (That's why you see so many porcelain dogs in Chinese homes today.) Their power was considered so strong that the men guarding the Imperial Court would dress in dog outfits and bark to chase away demons.

Is Fido Psychic?

Many people claim their pets have ESP, and a Russian experiment proved it. Scientists did 1,278 trials with dogs to test their mind-reading ability (measured by their response to unspoken commands.) They had a success rate of over 50 percent. The odds of this being mere chance, claims the author of *Psychic Animals*, are billions to one.

Author Robert Caras had a shy, psychic cat. Or at least it seemed that way—cat Tom only came into the house when his college-aged daughter Pamela was about to come home from school for a visit. The rest

of the time Tom was nowhere to be found. But whenever Pamela was about to arrive, Tom came out of hiding, only to disappear as soon as Pamela left again.

A couple named Irma and Gianni lived in a village near Mt. Vesuvius with their cat. One evening in 1944, the cat became agitated and tried to get the couple out of bed by jumping on them, scratching, and chasing the husband around the room. Gianni was enraged and wanted to throw the cat outside. Irma, however, felt that the cat was trying to tell them to leave. She insisted that they pack some clothes and get out. Soon after, Vesuvius erupted, covering their village in lava and killing many people. But not Irma and Gianni; their cat had saved them from that fate.

When Henry VIII had Anne Boleyn beheaded for witchcraft and adultery, he had her dog beheaded as well.

As recently as the late nineteenth century, women accused of adultery in Turkey were tied in bags with live cats and thrown into the ocean.

Starting in the Middle Ages, there grew a strong relationship between cats and "fallen" women, both witches and adulteresses. Witches were often killed with their cats, and cats were often found guilty of witchcraft on their own and killed. That's because it was believed that witches could turn into cats and

back again whenever it suited them. So a cat could be a witch in disguise.

A different cat transformation story can be found in one of Aesop's fables. A man fell in love with a cat and begged the goddess of love, Venus, to help him. So Venus turned the cat into a beautiful woman, and the two wed. The evening of the wedding, a mouse ran across their bedroom floor, and the woman jumped out of bed to try and catch it. This offended Venus, who thought she should have been otherwise occupied, and the goddess turned the woman back into a cat.

During the War of 1812, when the British burned down Washington, Dolley Madison, the first lady at the time, left carrying only 2 things. Of all the treasures in the White House, what did she choose to save? The original Declaration of Independence and her pet, the first parrot.

It was dangerous to get Catherine the Great peeved. She would send you to an anteroom where you had to sit for days, mewing like a cat and eating food from the floor until she decided you could come into her presence again.

One of the world's most talkative birds was Sparkie, a budgie owned by Mattie Williams of Newcastle, England. She entered Sparkie in a budgie-speaking contest in which he won hands-down by

uttering 531 words, 383 sentences, and 8 nursery rhymes. On his deathbed in 1962, his final words to Williams were, "I love you, Mama." She had him stuffed and donated him to a Newcastle museum.

I love you, Mama...

The world's most famous nurse, Florence Nightingale, always carried her pet owl with her in a pocket. (By the way, Ms. Nightingale achieved her fame with only 2 years of actual nursing of soldiers. She herself got so sick in the Crimean War that she was an invalid for the rest of her life—50 years.)

8

Entertaining Women

Shining Stars, Audacious Artists,
and Daring Divas

Lights, Camera, Action

Madonna wins the prize for changing her clothes more times than any other person in a movie. In *Evita*, she wore 85 different outfits, all based on Eva Peron's actual clothes, which are stored in a bank vault in Argentina.

Changing your name for fame is quite common. Here are some of the most outrageous real names of well-known stars:

★ Ariane Munker: **Jodie Foster**

★ Maria Magdalene von Losch: **Marlene Dietrich**

★ Frances Gumm: **Judy Garland**

- ⭐ Tula Finklea: **Cyd Charisse**

- ⭐ Alexandra Zuck: **Sandra Dee**

- ⭐ Margarita Cansino: **Rita Hayward**

- ⭐ Susan Tomaling: **Susan Sarandon**

- ⭐ Betty Joan Perske: **Lauren Bacall**

- ⭐ Doris von Kappelhoff: **Doris Day**

- ⭐ Etta van Heemstra: **Audrey Hepburn**

- ⭐ Sarah Jane Fulks: **Jane Wyman**

Carol Lombard changed her name too—from Carol Jane Peters. She took her name from a New York City drugstore.

Performing in *The Wizard of Oz* was dangerous. Buddy Edsen, the original Tin Man, nearly died from the aluminum powder used in his costume and had to be replaced. Among the female casualties: The Wicked Witch of the East, Margaret Hamilton, got third-degree burns when a stunt went bad, and her stand-in got hurt when her flying broom exploded. Weeks after the movie was completed, Hamilton was complaining that her skin was still green from the makeup they had used.

209

Having It Their Way

Women directors are a relatively recent phenome-
non. Here are the top 10 grossing movies directed
by women:

1. *Look Who's Talking*, directed by Amy
 Hecherling

2. *Sleepless in Seattle*, directed by Nora Ephron

3. *Wayne's World*, directed by Penelope Spheeris

4. *Big*, directed by Penny Marshall

5. *A League of Their Own*, directed by Penny
 Marshall

6. *The Prince of Tides*, directed by Barbra
 Streisand

7. *Pet Sematary*, directed by Mary Lambert

8. *Clueless*, directed by Amy Hecherling

9. *Michael*, directed by Nora Ephron

10. *National Lampoon's European Adventure*,
 directed by Amy Heckerling

However, if you look at a list of the top grossing
films of all time, not one by a woman makes the cut.

Penny Marshall was the first woman movie direc-
tor to have a film gross more than $100 million. The
film was *Big*.

And while we're on women directors, no woman has ever won the Academy Award for Best Director. But, unlike the men, every nominated woman director or woman who directed a Best Picture nominee also had actors or actresses nominated for best acting. I guess that means female directors are very good at getting great performances from their stars.

Mad for Marilyn

♥ We all know a lot about Marilyn Monroe. But did you know that in 1946 she was the world's first Artichoke Queen?

♥ MM has the distinction of being the most popular poster subject in the world.

♥ The blonde bombshell was the model for Tinker Bell in the animated *Peter Pan*.

♥ Did you know that in 1952 Ms. M starred in a film called *O. Henry's Full House*, an adaptation of 5 of O. Henry's short stories?

♥ When *Playboy* debuted in 1953, it was with Marilyn as the first nude centerfold.

♥ Apparently Marilyn wasn't the easiest person to work with. When asked to make a third film with her, director Billy Wilder, who made *The Seven Year Itch* and *Some Like It Hot* with her, quipped,

"I have discussed this project with my doctor and my psychiatrist and they tell me I'm too old and too rich to go through this again."

Oh So Naughty

Annette Kellerman, star of *Million Dollar Mermaid* was the very first aquatic glamour girl. In 1909 she was arrested for indecent exposure. Her offense was wearing a one-piece bathing suit that had just been created for her. The offensive suit covered her legs all the way down to her calves.

A woman is responsible for naming Hollywood. It was 1887, and Mr. and Mrs. Horace Wilcot had just moved to the area. One day, Mr. Wilcot took it upon himself to plant holly bushes in his yard, his wife began calling the area "Hollywood," and the name stuck.

Oscar and the "Fairer" Sex

ঽ The Oscar is named after Oscar Pierce, a wealthy Texas farmer who had no connection to the movies whatsoever. How did that happen? Pierce's niece was working as the secretary of the Academy of Motion Picture Arts and Sciences when she happened to remark, while a newspaper columnist was present, that the unnamed award looked like her Uncle Oscar. The columnist wrote about it, and it took hold.

The youngest person to ever receive an Oscar was Shirley Temple. When the curly mophead was 5 years old, she received a special miniature statuette "in grateful recognition of her outstanding contributions to screen entertainment...." The youngest person to win in a regular category was Tatum O'Neal, who, at age 10, won Best Supporting Actress for *Paper Moon*.

The only actress to win 4 Academy Awards for best actress was Katherine Hepburn, in a career that spanned more than 50 years of fame. She got the statuettes for *Morning Glory* (1933), *Guess Who's Coming to Dinner* (1967), *The Lion in Winter* (1968), tied with Barbra Streisand in *Funny Girl*, (1968), and *On Golden Pond* (1981). She's also the only woman who won 2 Best Actress awards consecutively.

Geraldine Page received 8 Oscar nominations before winning, in 1985, for T*he Trip to Bountiful*, setting a record for number of nominations received before a win.

In 1955, Dorothy Dandridge became the first black woman to be nominated for an Oscar, for her role in *Carmen Jones*. She didn't win. She's known for another first—in 1957, she appeared in *Island in the Sun*, the first movie to deal with the theme of interracial love.

- When Oprah Winfrey and Margaret Avery were both nominated for Best Supporting Actress for *The Color Purple*, it was the first time 2 African American women were ever nominated at the same time for the same category.

- The oldest Best Actress winner was Jessica Tandy, who at age 81 got the statuette for *Driving Miss Daisy*. The oldest woman ever nominated was Gloria Stuart, who was 87, for *Titanic*.

- We all know that women love to outdo one another fashion-wise on Oscar night. Some, like Barbra Streisand and Cameron Diaz, have appeared in peek-a-boo. Others, like Kim Basinger, have been ridiculed for appearing in a homemade number. But one woman goes down in history as having the most unique dress ever seen on the Academy Award stage. When Lizzy Gardiner picked up her Oscar for Best Costume Design in 1994, she wore a dress made completely of American Express gold cards.

- For 4 years running, the best supporting actress award was won by women with the initials M. S.: Maggie Smith in 1978, Meryl Streep in 1979, Mary Steenburgen in 1980, and Maureen Stapleton in 1981.

- In 1941, sisters Olivia de Havilland and Joan Fontaine competed for the Best Actress award.

Fontaine won, for *Suspicion*, which probably didn't help in the sibling rivalry department. Then, in 1966, sisters Vanessa and Lynn Redgrave were both nominated. They both lost.

ॐ Poor Loser? When Shirley Maclaine lost Best Actress to a critically ill Elizabeth Taylor for *Butterfield 8* (which many pundits say was not an award-winning performance, but was given the award because of the sympathy vote), she cracked, "I lost to a tracheotomy." And Debbie Reynolds, who lost husband Eddie Fisher to Liz, agreed, saying, "Hell, even I voted for her."

ॐ The Academy Awards ceremony used to have no time limit. That changed in 1943, after Greer Garson spoke for 5 1/2 minutes upon winning the Best Actress award for *Mrs. Miniver*. Enough is enough, said the show's producers.

ॐ When designer Edith Head won the Best Costume Oscar for *Roman Holiday*, she said, "I'm going to take it home and design a dress for it."

ॐ In 1978, Miss Piggy ("*moi*," as she liked to say) received 20,000 write-in votes for Best Actress from the viewing public. Since the average person can't vote, their opinions were ignored.

Bond girls Ursula Andress,
Shirley Eaton, Eunice Gayson, and

Claudine Auger may have looked like sex goddesses, but they didn't have the voices to go along with the looks. For the James Bond films, each one of them had to have voiceovers done by golden-toned Nikki van der Zyl, an aspiring actress who also did the sexy grunting for Raquel Welch in *One Million Years B.C.* Nikki eventually gave up hope of making it on her own and took up law.

Marnie Nixon was in a similar boat. She was the voice of Audrey Hepburn in *My Fair Lady*, Natalie Wood in *West Side Story*, and Deborah Kerr in *The King and I*. She was finally allowed to appear on screen in *The Sound of Music* as Sister Sophia.

Actress Michele Yeoh is one brave female. She's renowned for doing all her own stunts in Jackie Chan movies, including riding a motorcycle on a moving train without any protection. Her job is not without hazards—she did land in the hospital once for 3 months after she vaulted off a 265-foot bridge. The star of 18 movies, she's best known in the West for *Tomorrow Never Dies*.

The very first woman to be considered a film sex symbol was Theda Bara, who was famous between the two world wars. Her image was carefully self-constructed, and her outfits rivaled Madonna's at her

most daring. Theda was fond of wearing chains and even had one outfit made of loosely spun spider webs that barely covered only the essentials.

Silent film star Mary Pickford, also known as "*America's Sweetheart*," had the longest childhood on record. She was so baby-faced that she was still playing young girls (and even a few boys) well into her twenties. She *was* small in stature, but the studio enhanced the effect by filming her in oversized rooms and furniture; even doorknobs were placed higher to make her appear smaller. Pickford became so popular that fans would mob her wherever she went. When she was visiting the open-air market in Paris, butchers had to lock her in a meat cage to keep fans from mobbing her. In Egypt, her car was almost destroyed by dockhands wanting her to autograph their ears, which they then planned to have tattooed. To keep her happy, United Artists was forced to agree that she could destroy any movie of herself she didn't like, a contract term that no other star had.

When young Jodie Foster was scheduled to appear as the teen prostitute in *Taxi Driver*, the California Labor Board insisted on a psychiatric evaluation to make sure she was psychologically able to play the part.

In the old days of the studio system, stars were often signed to long-term contracts, and at least one, Olivia deHavilland, had to invoke the 13th

Amendment (you know, the one against slavery) to get out of hers. DeHavilland's lawyers argued successfully that it was slavery when Warner Brothers extended her 7-year contract every time they suspended her for refusing a particular role.

Marvelous Mae

❀ Mae West has the distinction of being the oldest woman ever to become a sex symbol in the United States. She was over 40 when she arrived in Hollywood to begin her career in film.

❀ West was renowned for her racy bons mots. Here's a sample:

> "I do all my best work in bed."

> "Marriage is a great institution, but I'm not ready for an institution."

> "A man in the house is worth two in the street."

❀ She titled her autobiography *Goodness Had Nothing to Do with It*.

❀ Did you know that she was actually arrested and jailed for penning obscene plays? In 1927, West's plays—one about a Canadian prostitute and one about transvestites—were shut down after the

New York theaters that were showing them were raided. West was sent to the slammer for 10 days.

❀ After serving 8 days of her 10-day sentence, Mae was let out of jail, quipping to reporters that this was the only time she ever got anything for good behavior.

❀ West was so buxom that sailors named their inflatable life jackets after her. They are still called Mae Wests.

❀ When Marilyn Monroe died, Ms. West commented, "She photographed well, but of course, she copied me."

The Raw End of the Deal

The unnamed girlfriend of screenwriter Shane Black came up with a great idea for a movie script. On the spot, he wrote her a check for $20,000 for the idea. When he finished the script for *The Long Kiss Goodnight*, he sold it to New Line Cinema for $4 million.

At the height of her popularity during WWII, screen star Betty Grable had her legs insured for $250,000. To put the matter into perspective, Fred Astaire's feet were insured for $650,000.

On the Good Ship Lollipop

❀ Shirley Temple was so beloved that she received 135,000 presents on her eighth birthday.

❀ And she was so popular that, during the worst of the Depression, when millions were starving, Shirley commanded $300,000 per film.

❀ She's also the only female star to have a drink—non-alcoholic, of course—named after her. A Shirley Temple is ginger ale mixed with grenadine (cherry juice) and served with a maraschino cherry. For girls only—boys get Roy Rogers, the same drink but with a masculine moniker.

❀ It wasn't all fun and games being America's Little Sweetheart. As an adult, Shirley reported that she stopped believing in Santa Claus when "my mother took me to see him in a department store and he asked me for my autograph."

The most-married female movie stars are Zsa Zsa Gabor, Lana Turner, and Georgia Holt, each with 8 husbands. Liz Taylor doesn't make the list because, although she has been married 8 times, she has had only 7 husbands (marrying Richard Burton twice.)

Elizabeth Taylor does have the distinction, though, of appearing more times (11) on the cover of *Life* than any other movie star, and of being the first actress ever to be paid $1 million (for *Cleopatra*).

Lovely Liz is also responsible for raising the most money for charity at a birthday party. Her sixty-fifth was an AIDS fundraiser that featured such stars as Michael Jackson, Shirley MacLaine, Roseanne, and Madonna netted more than $1 million.

Oh, How Things Have Changed

The actress who has brought in the highest gross box office receipts is Julia Roberts; but her dollar figure (around $1 billion) is only half that of Harrison Ford.

Julia Roberts now holds the distinction of being the current highest priced actress, asking $20 million per film.

A Girl Has to Eat

Here are the jobs some well-known stars performed before hitting it big:

★ **Julia Roberts:** Soda jerk

★ **Michelle Pfeiffer:** Grocery store cashier

★ **Lauren Bacall:** Theater usher

★ **Geena Davis:** Window dress model

Who was the Lady in Black? No one knows to this day, although there are rumors that she was nothing more than a publicity stunt. Starting in 1931, five years after the great screen lover Rudolph

Valentino died at the age of 31, a woman dressed all in black began to lay flowers on his grave on the anniversary of his death. This went on for many years until, presumably, she too died.

Baring All

Many renowned actresses have appeared topless on screen. Some, like Sharon Stone and Madonna, are not surprising. But this list of women who bared all might shock you:

❀ Julie Andrews, in *S.O.B.* and *Duet for One*

❀ Kirstie Alley, in *Blind Date*

❀ Kathy Bates, in *At Play in the Fields of the Lord*

❀ Candice Bergen, in *Starting Over*

❀ Tyne Daly, in *The Adulteress*

❀ Sally Field, in *Stay Hungry*

Lena Horne was the first black actress signed to a long-term Hollywood contract. The year was 1942.

All *Gone*, All the Time

★ Finding the right Scarlett O'Hara was no piece of cake. More than 1,400 women were considered before Vivien Leigh got the part. Even Bette Davis wanted the role.

★ There's a legend that Hollywood folks swear is true about how Leigh got the job. David O. Selnick was having such trouble casting Scarlett that he started filming the burning of Atlanta first. Many people came to see the fire, which cleared out a number of old buildings in the studio's back lot. One of the visitors was Selnick's brother Myron, who was an agent. Myron brought a new client and introduced her to David during the burning. "David, I want you to meet your Scarlett," he said, pointing to Vivien Leigh.

★ Scarlett is so famous they even modeled a Barbie after her. The 1994 *Gone with the Wind* Barbie came in 4 outfits: the white and green barbecue dress, the green velvet drapery dress, the red velveteen gown with beads and feathers, and the black and white honeymoon outfit. And of course, there was Ken as Rhett all decked out in a tuxedo and cape.

★ British actress Vivien Leigh was too proper to gag during the garden scene when Scarlett chokes on a radish. Olivia de Havilland, who played Melanie, had no such scruples, so her voice was dubbed in.

No woman has been number 1 at the movie box office since 1967, when Julie Andrews held the top spot. Since 1932, only 5 women have held the honor in addition to Andrews: Shirley Temple (4 times), Doris Day (twice), Betty Grable (once), and Elizabeth Taylor (once).

Myrna Loy, who portrayed Nora Charles in *The Thin Man* series of films, became so popular with the French that women spent hours at the beauty parlor having fake freckles put on in imitation of her beauty.

The tradition of putting your footprints in cement at Grauman's Chinese Theatre in Hollywood got started by accident in 1927. That's when actress Norma Talmadge accidentally tripped onto the still-wet sidewalk outside the theater, and the resulting footprints captured the imagination of star-crazed fans.

Jacqueline Susann, the author of *Valley of the Dolls*, had a bit part when the movie version was made. Watch for her as the first reporter.

The very first movie star was a German silent film actress, known only as the Messter Girl, who starred in

a number of films directed by Oskar Messter. Messter was finally forced to reveal her name when she appeared in the smash hit *The Love of the Blind Girl,* and fans were clamoring for her identity: Henny Porten. Cashing in on her newfound fame, Porten quickly demanded more money per film.

Poor Veronica Lake. She was a huge movie star in the early '40s, but her career crashed to the ground due to her patriotism. How's that? She was renowned for her spectacularly long hairdo, which swooped over one eye and which women all across the country imitated. That would have been fine, except that women were leaving their homes and working in factories to support the war effort, and were getting that hairdo caught in dangerous machinery. Someone from the government asked Lake, for the safety of American women, to change her hairdo. She did, and her popularity immediately plummeted. She ended her years as a cocktail waitress.

A GOOD LINE IS HARD TO FIND

Howard Hawks directed 3 films in which the same line was used: "**I'M HARD TO GET—ALL YOU HAVE TO DO IS ASK ME.**" Jean Arthur said it first to Cary Grant in *Only Angels Have Wings;* then Lauren Bacall used it in *To Have and Have Not;* and Angie Dickinson said the very same thing to John Wayne in *Rio Bravo.*

Sing It Again, Gal

According to *The Odd Index,* in the past 8 decades there have been hundreds of popular songs that have been named after girls, but very few for boys.

I bet you've been dying to know the original name of the primo girl group, the Supremes. It was the Primettes. Now there's a name that would have gone nowhere.

The Supremes remain the only American singing group to have 12 straight number 1 singles. According to the Popular Music Database, they are the number 1 female group of all time in the United States. In second place are the Pointer Sisters.

Cole Porter penned a tune called "True Love," which Princess Grace of Monaco recorded with Bing Crosby in 1956 for the movie *High Society.* It became a smash hit, selling a million copies and making her the only princess ever to have a bestselling record.

Success Is the Best Revenge

Forced to give up her throne as Miss America when nude photos of her surfaced, Vanessa Williams went on to become the only Miss America who has ever had a hit record, despite all their warbling. Her hit, in 1992, was "Save the Best for Last."

Donna Summers got the idea for her hit song "She Works Hard for the Money" while in the ladies' room of a snazzy hotel. It came to her after noticing the bathroom attendant; she immediately closed herself into a stall and wrote the lyrics on the spot.

Nobody Does It Better Than Babs

Barbra Streisand is the only solo recording artist to have a song or album in the top 5 in four decades— the '60s, '70s, '80s, and '90s.

Who are the women who have had the most top 10 hits in the United States?

1. Madonna, with 32

2. Janet Jackson, with 23

3. Whitney Houston, with 18

4.–5. Tie between Aretha Franklin and Mariah Carey

6. Connie Francis

7. Olivia Newton-John

8. Donna Summer

9.–10. A 3-way tie among Brenda Lee,
Diana Ross, and Dionne Warwick

Remember the "Singing Nun," the Belgian religious woman whose song "Dominque" hit number 1 in 1963, as did her subsequent album? Sister Mary Luc-Gabrielle experienced instant fame, appearing on TV around the world and becoming the subject of a 1966 movie starring Debbie Reynolds. The call of fame proved stronger than her vows. She left the convent to pursue her music career, but it was all downhill from there. As Jeanine Deckers, she was never able to achieve the level of fame she'd known as the Singing Nun. In 1985, poor and hungry, she and a female companion killed themselves.

A recent female rock star has the distinction of being the only woman whose work made the list of the top 10 bestselling albums or CDs of all time in the United States: Alanis Morissette, who made the number 10 spot with "Jagged Little Pill." It sold 16 million copies.

Dolly Parton and Crystal Gayle were the very first women country recording artists to have songs go platinum, for, respectively, "Here You Come Again" and "Don't It Make My Brown Eyes Blue." And it was actually Dolly who wrote the song for

which Whitney Houston won a Grammy in 1993: "I Will Always Love You."

Speaking of Dolly, she's the only woman in the world to have her own theme park: Dollywood. The 88-acre amusement park in Pigeon Forge, Tennessee, is now that state's most popular tourist attraction. And she also has had a highway named for her in Sevierville, Tennessee.

Dollyisms

"I patterned my look after Cinderella, Mother Goose, and the local hooker."

"I have to keep a little money back because it costs a little to make me look so cheap."
—*Ms. Parton*, upon donating $7 million to the Imagination Library, the charity she created to promote literacy

"Lots of women buy just as many wigs and makeup as I do. They just don't wear them all at the same time."

"It's a good thing that I was born a woman, or I'd have been a drag queen."

"I should open my next theme park in Silicon Valley."

The famous piano piece "Chopsticks" was created by a 16-year-old girl named Eupemia Allen. She wrote it in 1877 under the pseudonym Arthur de Lulli, presumably because she thought no one would take it seriously if they knew a female composed it.

Aretha Franklin is the only woman among the top 10 winners of Grammy Awards. She squeaked in with 15 Grammys, tied for tenth with Itzhak Perlman.

Every time you sing "Happy Birthday," you are supposed to pay a royalty to the estate of the Hill sisters. This duo, in 1893, wrote a tune called "Good Morning to All." During the 1920s, someone changed the words to "Happy Birthday to You" and published it without the sisters' permission. When the song was featured in a play on Broadway, a third Hill sister sued and won. Now, the Hill family still receives royalties every time the song is sung professionally (which is why, I am told, certain chain restaurants sing their own ditties—they don't want to pay up).

Tammy Wynette, who died at age 55, was the very first woman country singer to sell 1 million records.

EARLY BLOOMER
Loretta Lynn was only 29 when she became a grandmother.

Talk about staying power. At 52, Cher became the oldest woman to have a number 1 hit single in

the United States. She beat out Tina Turner by 7 years. Tina had a number one at age 45, and Bette Midler at 44. The next oldest women are all in their thirties.

Elizabeth Taylor Greenfield, also known as "The Black Swan," was one of the most well-known artists of the 1850s and '60s. She was the first black concert singer and the first black singer to give a command performance to the queen.

Blues rocker Bonnie Raitt is known for her gutsy voice and her political outspokenness. She has always lived life on her own terms, saying once, "If I had to be a woman before men and women were more equal, I would've shot somebody and been in jail."

Women and the Boob Tube

Who is the person most mentioned on the Internet? Why, it's Pamela Anderson of *Baywatch* fame. On Yahoo alone, there are approximately 170,000 hits on her name—per day. Pam is also the most watched woman on TV—over 1 billion folks in 142 countries tune into *Baywatch* each week.

Anderson is now primed to take advantage of some of those Internet hits herself, what Web-savvy

folks call "monetize traffic." As of this writing, she is launching her own Web site, *PamTV.com*. To construct it, she's asking fans what it should include.

Do you know who Mrs. Miller is? You would if you had been a fan of the Merv Griffin show in the '60s. An elderly woman who loved to come to the theater where Griffin did his TV show, she was considered his good luck charm. He gave her front row seats and would say hello to her on camera every day she was there.

Remember all those old shows where married couples slept in twin beds? The duo that finally broke the double bed barrier was Ozzie and Harriet Nelson of *Ozzie and Harriet*. Maybe because they were married in real life the censors figured it wasn't as racy.

X-Filer Gillian Anderson kicked up a ruckus when she discovered that she was being paid only half the amount that co-star David Duchovny was making to chase aliens. She's still with the show, so she and the producers must have come to some agreement over the matter.

For Love of Lucy

♥ Before she hit it big on *The Lucy Show*, Lucille Ball was the star of a radio program called *My Favorite Husband*. Her wacky housewife on that show was the prototype for her TV persona.

♥ Lucy made sure her sidekick remained just that. It was stipulated in Vivian Vance's contract that she remain overweight and only appear in frumpy dresses so that the redheaded star would always shine brighter.

♥ When she was 15, Lucy was kicked out of drama school for being too shy and reserved.

♥ The birth of Little Ricky consumed the TV-viewing public for the entire 1952–1953 season as Lucy's belly grew and grew. But censors didn't allow the cast to use the word *pregnant* even once—too risqué.

♥ When Ugandan dictator Idi Amin was deposed, folks rummaging through his palace found a case of old *I Love Lucy* film reels.

In the days when *Charlie's Angels* was big, Farrah Fawcett was so famous she had a plumbing fixture named for her: the "Farrah faucet."

An Australian TV show called *Check It* is now offering free breast enhancements. Interested women send in a photo of themselves along with a few sentences on why they want to be bigger. The winner will be chosen by viewers. "There'll be only one winner, but of course two silicone implants," explained the program's editor-in-chief to Reuters.

All Oprah, All the Time

⭐ Oprah Winfrey is the first African American woman and only the third woman ever to own a film and TV production studio. (The other 2 were Mary Pickford and Lucille Ball.) In 2000, she added a magazine to her list of media venues. *O* debuted at 385 pages.

⭐ Talking about Oprah is a no-no for employees and former employees. She recently won a lawsuit upholding a confidentiality agreement she requires all those who work for her to sign. In order to get hired, they have to agree never to discuss her personal or business life for as long as they live—and no, they can't change their minds when they quit.

⭐ She is the richest TV star in the world with, according to Forbes, a fortune estimated at $201 million.

The average house has the TV and radio on for a whopping 11 hours a day combined, and half of us like the viewing choices we're being given.

Who is most TV-addicted? Not kids, it turns out, but women 55 years and older. As a group, they watch more than 25 hours per week, with women 25–54 coming in a close second at 21 1/2 hours. (Kids log only about 10.)

In 1994, Minnie Pearl (real name Sarah Ophelia Colley Cannon) was the first woman to be inducted into the Comedy Hall of Fame.

Before she got married, Wilma Flintstone's name was Wilma Slaghoopal.

Across the Cultural Divide

Concerned that the behavior of the women in the TV show were incomprehensible to their audience, when *Laverne and Shirley* was broadcast in Thailand in the '70s, it was preceded by this announcement: "The two women depicted in the following episode are from an insane asylum."

Joan Collins was 50 when she posed, semi-nude, for *Playboy*. The issue proved so popular that it sold out.

Don't Get Joan Mad . . .

Joan Rivers was feuding with Victoria Principal when she was hosting *The Late Show with Joan Rivers*. So to really get Principal's goat, Rivers gave out her unlisted home phone number on the air.

Talk about Chutzpah!

When her film *The Prince of Tides* was first shown on TV, Barbra Streisand called the network airing it—NBC—and demanded that they lower the volume of the commercials.

Ladies of Literature

I bet you didn't know that the first known writer was a woman. Her name was Enheduanna, and she lived in Southern Mesopotamia around 2700 B.C. Clay tablets bearing her name have been discovered, along with fragments of poems.

Humor writer Erma Bombeck wants to keep us laughing even from the grave. She's requested that her epitaph read, "**BIG DEAL!** I'm used to dust."

The Lowdown on Mother Goose

There was a real woman in Boston named Elizabeth Foster Vergoose, who had 16 children, 10 of whom were adopted. But whether she actually penned the well-known rhymes is in dispute. Her son-in-law, a Boston printer, in 1719 supposedly published a book called *Mother Goose's Melodies for Children*, although no copy of it has ever been found and many people doubt it actually existed. A book published in 1790 called *Mother Goose Stories and Rhymes* is the one we know of today. Regardless of who wrote them, many of the rhymes were based on true events. "Little Jack Horner" was derived from an incident involving the Bishop of Glastonbury in England. As a gift to Henry VIII, he sent the deeds to 12 properties baked into a pie. The deliveryman was Jack Horner, who was said to have lifted off the top crust of the pie and

made off with one of the deeds. And "Little Miss Muffet" was written by entomologist Dr. Thomas Muffet for his little girl. Most of the tales have origins in England, but the United States gained at least one famous addition when Sara Josepha Hale (1788–1879) wrote "Mary Had a Little Lamb" to commemorate her school days. It has become one of the most popular nursery rhymes of all time.

Book 'Em

- Virginia Woolf wrote all of her novels standing up.

- There was no such name as Wendy before the *Peter Pan* book. James Barrie made it up for the story.

- One of the best-loved novels of all time, *Little Women* was written solely for the money. Louisa May Alcott hated young girls but was desperate for cash. Ms. Alcott is also known for spearheading a campaign to ban *Huckleberry Finn* from libraries, claiming it was inappropriate for children.

- Women are 4 times more likely than men to turn to the last page of a book and read it first, and are twice as likely to skip pages to find out what's going to happen.

- The reclusive Emily Dickinson wrote nearly 1,000 poems in her lifetime, but only 4 of them were

published while she was alive. She was so reclusive that she went on a trip only once—from her home in Massachusetts to visit her father, a member of the House of Representatives, in Washington. As she grew older, when she allowed guests at all, she would not meet them face to face, but would speak to them from another room.

- ❧ Jane Austen's novel *Pride and Prejudice* was originally titled *First Impressions*.

- ❧ Remember the story of "The Princess and the Pea"? She slept on top of 20 mattresses and 20 featherbeds.

- ❧ The bestselling novel of the 1800s was *Uncle Tom's Cabin* by Harriet Beecher Stowe. It was such a powerful testament against slavery that none other than Abraham Lincoln claimed it to be the impetus for the Civil War, saying of Stowe, "Is this the little lady whose book made such a war?" Said this independent woman, thinking of herself apropos of something else, "I won't be any properer than I have a mind to be."

- ❧ Stowe's book was so influential, it brought 2 new expressions into the English language: "Simon Legree," a cruel boss, and "Uncle Tom," a black person who kisses up to whites.

- ❧ The bestselling novelist of all time is Agatha Christie. Her 78 mysteries have sold more than 2

billion copies. Christie gained her knowledge of the poisons that figure so prominently in her books working in a hospital pharmacy during WWI. Christie, who had a good sense of humor, was married to an archeologist. When asked how that was, she replied, "It's wonderful. *The older I get, the better he likes me.*"

❧ What young girl hasn't enjoyed the adventures of Eloise, the spirited girl who lives in the Plaza Hotel in New York? Author Kay Thompson modeled Eloise after her goddaughter—singer Liza Minnelli.

FRANKENSTEIN'S MOTHER

Mary Shelley was the 19-year-old bride of the poet Percy Bysshe Shelley when she created a whole new genre in writing—the science fiction novel. She didn't set out to do such a thing. She and her husband were houseguests, along with the poet Byron, in a villa in Switzerland during the summer of 1816. Trapped inside due to bad weather, Byron decided to read of a book of old ghost stories to the group. Thus inspired, he suggested they each try their hand at writing one. They all tried, but it was Mary who took the challenge the most seriously. Two years later, her story of science gone mad was published to great acclaim. Poor Mary's personal life was not as successful. All 3 of her children

died at birth or when very young, and the love of her life, Shelley, drowned when Mary was only 25. She never remarried, and died at age 53, having written nothing else.

Not Yet Gone

❀ How popular is the book *Gone with the Wind?* Well, it's sold over 20 million copies and has been translated into 27 languages. But it almost didn't have that title. The author, Margaret Mitchell, wanted to call it *Tomorrow Is Another Day*, but the publisher changed it. They also changed the main character's name from Pansy to Scarlett.

❀ When, in 1988, Alexandra Ripley agreed to write *Scarlett*, the sequel to *Gone with the Wind*, she received an advance of $4.94 million. Margaret Mitchell was only paid a $500 advance.

❀ Apparently Margaret Mitchell didn't worry about a timeline in her novel. If you count, Melanie is pregnant for 21 months. When someone pointed out that fact to Mitchell, she replied that a Southerner moves slower than a Yankee.

❀ All these many years later, interest in Mitchell, the movie, and the book remains high. Indeed, attendance at the Margaret Mitchell House and Museum continues to grow. Founded in 1995, it

had 45,000 visitors that year; by 1999, the number had jumped to 65,000.

The first known full-length novel was written by a woman, Lady Murasaki Shikibu, a noblewoman in eleventh-century Japan. Apparently her feat wasn't that incredible; many Japanese women writers wrote around this time, but only Lady Shikibu's manuscript survived.

In 1773, Phillis Wheatley, a slave born on the west coast of Africa, published the first book of poetry by a black person and the second by a woman of any race in America. When she was about 7 or 8, she was bought by a man in Boston who taught her to read and supported her writing. She traveled to Europe with her master's son when she was in her late teens, and in England she attracted a great deal of attention as a poet. She was subsequently freed, but the rest of her life was difficult. She married a freeman, and her first 2 children died. Forced to work as a maid to support herself, she died in her early thirties, the same day as her third child.

We May Not Have the Critics, but We've Got the Bucks

★ While not one woman has made it to any of the top 10 lists compiled at the end of the twentieth century of the greatest novels, novelists,

and writers, women do hold top spots in one distinctive writing category: the bestselling children's books of all times. Of the top 10 paperback bestsellers, women have written 5 and co-written 1. Janette Lowrey, author of *The Poky Little Puppy*, which she wrote in 1942, is number 1, with 14 million copies in print. *The Tale of Peter Rabbit* by Beatrix Potter is a distant second at 9 million–plus. (But don't feel bad for Potter. She also goes into history as the first person to understand the true nature of lichen, but because she was a woman and a writer, the director of the London Botanical Garden shamefully ignored her discovery.)

★ A woman has also made it into the list of the 10 bestselling books of all time. Can you guess who? Jacqueline Susann, whose *Valley of the Dolls* has sold more than 30 million copies.

★ Popular until the Civil War, chapbooks were small illustrated books that were very inexpensive, sort of like comic books but with more words. One of the most popular chapbooks of all times was written in 1682 by a woman colonist who had been captured by Indians. Titled *Mary Rowlandson's Captivity*, it sold 5 million copies—mostly in England, I presume because the colonies did not have that many English-speaking residents.

★ The very first bestselling novelist was Susanna Haswell Rowson. Her novel *Charlotte Temple*, written in 1791, went through 200 editions.

★ The writer who has the highest earnings of all times is Mary Higgins Clark, who in 1996 signed a contract for $12 million for each of her next three books. That's almost twice as much as what Stephen King and John Grisham get.

Romance writer Barbara Cartland (a relative of Princess Diana, by the way) was no slouch when it came to productivity—she wrote 623 books and sold more than 650 million copies of her novels around the world. Yes, that is more than any other human being, according to *The Guinness Book of World Records*.

As most any writer can tell you, writing is not the most lucrative of professions. Most authors have to toil at other work and write on the side. Here are some of the professions of our most-beloved authors:

- **Anne and Charlotte Brontë:** Governesses

- **Willa Cather:** Teacher, journalist

- **Toni Morrison:** Editor

- **Dorothy Parker:** Pianist

- **Katherine Ann Porter:** Actress

- **Eudora Welty:** Photographer

- **Virginia Woolf:** Publisher

A dear friend of John Adams, Mercy Otis Warren was a writer who labored for 30 years on a 3-volume history of the American Revolution. In the end, it cost her her friendship with Adams. He didn't like the way he was depicted, saying, "History is not the Province of Ladies." They didn't speak for 7 years, then somehow made up and, as a symbol of their care for one another, exchanged locks of hair that Adams' wife had made into jewelry.

The Nobel Nine

Nine women have been awarded the Nobel Prize in Literature:

1. Selma Ottilia Lovisa Lagerlof, 1909

2. Deledda Grazia, 1926

3. Sigrid Undset, 1928

4. Pearl Buck, 1938; the only women writer in the world to win both the Pulitzer and the Nobel Prize in literature

5. Gabriela Mistral, 1945

6. Nelly Sachs, 1966

7. Nadine Gordimer, 1991

8. Toni Morrison, 1993

9. Wislawa Szymborska, 1996

It was a book by a woman that is credited with launching the entire environmental movement— *Silent Spring*, written by Rachel Carson in 1962.

There really was an Alice. Her name was Alice Liddell, and her father was an Oxford dean who was friends with an Oxford professor named Charles Dodgson. In 1862, when Alice was 10, Dodgson took her and her 2 sisters on a boating trip and told them a fantastic story to occupy them. Alice begged him to write it down, which he did and then published *Alice in Wonderland* using the pseudonym Lewis Carroll.

In his *Book of Facts*, Isaac Asimov analyzes the male and female characters in 200 tales of the Brothers Grimm. What he came up with is no surprise to women: "There are 16 wicked mothers or stepmothers and only 3 wicked fathers or stepfathers. There are 23 evil female witches and only 2 evil male witches. There are 13 young women who kill or endanger the men who love them, but only 1 man who harms his bride."

It wasn't always easy to be a woman writer. That's why a number of very successful authors used male

pseudonyms. These ladies figured if you can't beat them, join them. And it worked!

↔ George Sands: Amandine Lucie Aurore Dupin

↔ George Eliot: Mary Ann Evans

↔ Acton, Currer, and Ellis Bell: Ann, Charlotte, and Emily Brontë

↔ Lee Chapman, John Dexter, Morgan Ives: Marion Zimmer Bradley, author of, among other works, *The Mists of Avalon*

↔ Ralph Iron: Olive Scheiner, author of *The Story of My African Farm*

All about Artists

You know those Hummel figurines of cherubic children so many women like to collect? There's a female artist behind them. German Berta Hummel was a Franciscan nun at the beginning of the twentieth century; she held a degree in fine arts and loved to draw happy children and give them to her sister nuns as gifts. The mother superior was so taken with Sister

Hummel's work that she contracted with a German company to turn them into figurines. The artist continued to draw until her death in 1946.

Madame Claude Latour was such a talented art forger that her copies of Utrillo fooled even Utrillo himself.

Bucking Convention

❖ Women artists have had a particularly rough time. Before the nineteenth century, only 3 women artists were famous: painters Rosalba Carriera (1675–1757), Angelica Kauffman (1740–1807), and Marie Anne Elizabeth Vigee-Lebrun (1755–1842).

❖ Swiss painter Angelica Kauffman was so talented that she was famous by the time she was 11 years old. Her paintings can been seen throughout Europe.

❖ To study anatomy, nineteenth-century painter Rosa Bonheur kept monkeys, goats, deer, gazelles, and even lions in her backyard.

❖ Anna Mary Robertson, better known as Grandma Moses, didn't even touch a paintbrush until she was in her seventh decade. But the famous American painter who lived from 1860 to 1961

quickly made up for lost time: when she died at 101, she had painted more than 1,800 paintings. By the way, she began to paint because her fingers had gotten too stiff from arthritis to embroider, and she was looking for something else to do.

❖ The most expensive painting by a woman went, at auction, for more than $4 million. It was Mary Cassatt's *The Conversation*. Cassatt rules—7 of the 10 highest prices ever paid for a painting by a woman are for her works. Sexism still rules in the art world, though; the most expensive painting by a man was Vincent Van Gogh's *Portrait of Dr. Gachet,* which in 1990 sold at auction for a staggering $75 million.

❖ When asked at 8 years old what she was going to be when she grew up, Georgia O'Keeffe proclaimed, "I am going to be an **ARTIST!**"

French sculptor Camille Claudel, born in 1864, suffered a fate common to pre-twentieth-century women artists. A student of Rodin, she quickly became his model and mistress, and her work was eclipsed by his. Disowned for her scandalous behavior by all her family except her brother, she fell completely apart when her stormy relationship with Rodin ended in 1898, and her brother abandoned her as well. By 1913, she was institutionalized for hysteria and depression, a common female fate, and spent the rest of her life—30 years—in a mental hospital. In

the 1980s a play and a movie about Claudel shed new attention on this talented woman, who many say was more of a true artist than Rodin. Some folks go so far as to say that not only did she give him her creative ideas, but that she also actually helped sculpt a number of works for which he is credited.

But Is It Art?

Ripley's Believe It or Not wants you to know that Mrs. Mabel C. Wood, who resides in Horseheads, New York, is an oil painter who uses cobwebs instead of canvas.

Marie Grosholtz was a 2-year-old Swiss girl in 1762 when her uncle took her and her mother to Paris to live with him. There he became famous as a wax portrait sculptor, attracting business from people such as Benjamin Franklin and Voltaire and teaching the art to Marie as well. As a teenager, Marie became friends with Louis XVI's sister. When the French Revolution came, she was jailed as a royal sympathizer and was only allowed to leave when she promised to sculpt the likenesses of the revolutionary heroes. By the time she was in her thirties, she had married and divorced and moved to London, where she continued her art form under her married name—Madame Tussaud. Her wax museum continues to this day.

The very first American sculptor was Patience Lovell Wright. Like Madame Tussaud, she worked in

wax. Famous in her day, she sculpted many of the luminaries of her time, but wax is not the most permanent of media. Only one of her works—a likeness of Lord Chatham that she completed in 1779—is known to exist. It is on view in Westminster Abbey.

INTENSE ICONOCLAST

The beautiful painter Frieda Kahlo has lately gotten her share of fame. But that certainly didn't happen while she was alive. Her surrealistically tortured self-portraits and dreamscapes were a bit too much for the early twentieth century. And, like so many other women artists, she was eclipsed while she was alive by her husband, the famous Mexican muralist and painter Diego Rivera. Her life wasn't easy on any count, although she managed nonetheless to live and work on her own terms. As a child, she suffered from polio. Then at 15, she was in a horrible streetcar accident that crushed her pelvis, spine, and right foot, leaving her crippled for life and unable to bear a child, the pain of which she expressed in her paintings. She underwent 35 operations, including the amputation of her foot, and spent extended periods of time bedridden in body casts. But that didn't stop this passionate painter—some of her greatest works were done with a special easel that allowed her to pain while lying flat on her back.

For Woman, All the World's a Stage

In England, before the late 1600s women did not appear on stage. Men in drag played all the female parts. Finally, in 1660, a director of *Othello* decided to use real women, as theaters had been doing in the rest of Europe. But the director couldn't find any respectable women to perform. So he recruited his actresses from a brothel.

Indirectly, it is Catherine de Medici who is responsible for the development of ballet. Here's how the story goes: It was 1581. In honor of the marriage of the sister of the French queen Louise to the Duke de Joyeuse, Catherine, the queen mother, commissioned an entertainment from dance master Baltazarini di Belgioioso. He wanted to do something different; using the story of Odysseus' escape from Circe and ending up with a tribute to the current queen, Louise—he was a smart court follower—he developed a number of choreographed steps of geometrical arrangement set to music. Catherine loved the

spectacle and sent illustrated accounts of it to all her royal friends throughout Europe, which encouraged the further development of this new art form.

One of the world's very first operas was penned by a woman, Italian Francesca Caccini. Performed in 1625 in honor of the visit of the Polish prince to the Medicis, it even included a ballet performed by horses.

Prima donna (as in, "She's *such* a prima donna") was not originally a derogatory term. It refers to the principal female singer in an opera.

Modern dance has many roots, but free spirit Isadora Duncan is credited as one of its main influences. Basing her ideas on Greek ideals, she strove for the "good, true, and beautiful" and appeared in flowing robes at a time—the late 1800s—when women were still totally laced up. She once declared of her work, "If my art is symbolic of any one thing, it is symbolic of the freedom of woman and her emancipation."

To be a Ziegfeld showgirl, your measurements had to be 36–26–38; it is estimated that between 1907 and the 1930s, when the *Ziegfeld Follies* ended, only 3,000 of the more than 200,000 women who tried out had bodies that fit the bill.

Look out Ziegfeld, make room for the Fabulous Palm Springs Follies. These fit females range in age from 53 to 85 and perform 10 shows a week, 7

months a year, making them the oldest professional chorus line in the world.

No Stopping This Stage Queen

The famed stage actress Sarah Bernhardt was a real character. Supposedly the very first actress to don pants, she owned her own railroad car, and, after she lost her leg, appeared on stage with a wooden one. She was such a fabulous actress, though, that none of that mattered. She once played the lead role in *Hamlet*, appeared as Prince Charming in the play *The Sleeping Beauty* when she was 62, and wowed audiences as teenager Juliet when she was 70! Bernhardt distrusted banks and forced theater producers to pay her in gold, which she kept in an old bag and carted everywhere with her. Obsessed with death from a very young age, she convinced her mother to buy her a coffin with a white lining, which she slept in occasionally and when she died at age 79 was buried in.

Hello, Dolly was written for Ethel Merman, but she didn't star in the title role until many other women had, including Carol Channing, Betty Grable, Pearl Bailey, and even Phyllis Diller.

Actress Diane Keaton has always gone her own way. When she starred in the rock musical *Hair*, she was the only member of the cast who refused to take off her clothes at the end of the play.

Julie Harris has won more Tony Awards than any other actor, male or female—she has 5 in all.

Speaking of the Tonys, the annual awards given to Broadway plays were named for Antoinette Perry. Perry was a well-known actress, director, and theater producer who in 1941 helped found the American Theater Wing (ATW), a professional acting school in New York that also raised money for the British World War II effort. She died at age 58, and members of the ATW, looking for a way to honor her, hit on the idea of annual theater awards.

Before ballerina Marie Taglioni, no ballerina had ever appeared in a tutu or danced on her toes.

The Japanese form of dance known as *kabuki* was created at the beginning of the seventeenth century by a woman named Okami of Izumo and starred an all-women cast. By 1620, women were banned from performing it; it was considered too risqué.

In 1955, singer Marion Anderson caused a nationwide scandal by becoming the first black woman to sing with the Metropolitan Opera Company in New York.

In 1959, the first play written by a black woman to be performed on Broadway debuted. *Raisin in the Sun* earned the 29-year-old playwright Lorraine Hansberry a New York Drama Critics' Circle Award,

making her the youngest person and the first African American to have that distinction. The play went on to be made into a very successful movie. Tragically, Hansberry died of cancer only 5 years later, at 34.

Female opera singers have the reputation of having egos as large as their forms. Singer Geraldine Farrar was once in a sparring match with conductor Arturo Toscanni. To put him in his place, she declared, "Remember, the audience is here to see my face, not your backside."

Liberated Luce

Clare Booth Luce was a brilliant writer who, during her husband Henry's lifetime, was not allowed to help him run his company, Time, Inc., or *Life* magazine, even though the idea for the magazine was hers. Clare got her revenge, though. She turned to playwriting and penned the very successful *The Women*, which ran on Broadway for 657 performances and was made into a smash hit movie. Then she must have turned Henry around, for her next incarnation was as a war correspondent in Asia for *Life* during WWII. A staunch Republican, she later served as a representative in the Connecticut Congress and then became the Ambassador to Italy (where she convinced the prime minister to give Italian women the vote). She took her role as a groundbreaking woman seriously, saying, "Because I am a woman, I must

make unusual efforts to succeed. If I fail, no one will say, 'She doesn't have what it takes.' They will say, 'Women don't have what it takes.'"

Helena Modjeska was a nineteenth-century Pole reputed to be one of the greatest actors of all time. She once did a dramatic reading in Polish to an audience who spoke no Polish. By the end, the entire crowd was in tears. She later revealed that she had simply recited the Polish alphabet.

Marvelous Miscellany

The top women magazines in the United States are called the Seven Sisters. They are *Better Homes and Gardens, Family Circle, Good Housekeeping, Ladies' Home Journal, McCall's, Redbook,* and *Woman's Day.*

The first celebrity stalker of all time was an unnamed woman who was obsessed with baseball player Eddie Waitkus. Reportedly she would set a place for him at the table each evening, in spite of the fact that they had never met. She gunned him down one day in 1949 in his hotel room.

The nine Muses were beautiful goddesses in Greek mythology. The daughters of Mnemosyne, goddess of memory, they represented the nine Greek arts:

1. **Calliope:** Muse of epic poetry

2. **Clio:** Muse of history

3. **Erato:** Muse of lyric and love poetry

4. **Euterpe:** Muse of music

5. **Melpomene:** Muse of tragedy

6. **Polyhymnia:** Muse of sacred song

7. **Terpsichore:** Muse of dancing

8. **Thalia:** Muse of comedy

9. **Urania:** Muse of astronomy

In Norse mythology, the Valkyries were 9 warrior women who fought beside the god of war Odin. Known for their ferocity, they are

1. Gerhilde

2. Helmwige

3. Waltrute

4. Schwertleite

5. Ortlinde

6. Grimgerde

7. Rossweisse

8. Siegrune

9. Brunnhilde, made famous by Richard Wagner in his Ring cycle operas

Five women have won the "Grand Slam" of Entertainment—picking up an Oscar, a Grammy, a Tony, and an Emmy. They are Julie Andrews, Rita Moreno, Helen Hayes, Barbra Streisand, and Audrey Hepburn. (Three men have done it too, by the way: John Gielgud, Peter Ustinov, and Marvin Hamlisch.) Moreno, Streisand, and Hepburn also each have a Golden Globe to their name.

Barbie's World

❀ She is the most popular toy ever invented.

❀ Barbie's full name is Barbara Millicent Roberts. She lives in Willows, Wisconsin, and was named after Barbara, the daughter of Barbie's creator, Ruth Handler. Ruth and her husband Elliot were two of the three founders of Mattel.

❀ Ruth got the idea for Barbie by watching her daughter and her friends play with paper dolls. They loved the adult dolls, and Ruth realized that all the 3-dimensional dolls in the world were baby dolls or children.

❀ Ken's full name is Ken Carson, and he was named for the Handlers' son Kenneth.

❀ Barbie's and Ken's last names come from Mattel's ad agency, Carson/Roberts.

❀ Not all Barbies have boyfriends—Barbie outsells Ken 3 to 1.

❀ "You're So Vain": Her birthday is October 15, 1959, but Barbie is not aging gracefully. As soon as she hit 25, she stopped counting birthdays and started celebrating anniversaries, in order to keep her youthful image intact.

❀ Over the years Barbie's clothes have been designed by many famous fashion designers, including Bob Mackie, Oscar de la Renta, and Mary Quant (who was, by the way, the first to put Barbie in a miniskirt).

❀ Of course, Barbie's favorite color is pink, and she has her own shade that is required for use by anyone making Barbie products.

❀ Don't Mess with Barbie: Many folks have found out the hard way that to parody this most delicious target is to take on the wrath of Mattel. Those who found out the hard way include an artist in San Francisco who was creating social satire by creating dolls such as Drag Queen Barbie, a psychic who professed to channel messages from Barbie, and magazines that showed Barbie and Ken in compromising positions. Each was slapped with a lawsuit.

❀ Barbie isn't all proms and frills. There are military Barbies from each branch of the service. In the Army, for instance, Barbie is a captain dressed in

evening uniform. And yes, she and Ken participated in Operation Desert Storm, Barbie as a medic and Ken as a staff sergeant.

❀ Naturally, there is a Barbie Hall of Fame—in Palo Alto, California—that contains more than 17,000 Barbies worth over $2 million.

❀ Mattel created over 6,000 different Barbie outfits in the first 30 years of her existence and annually sells 20 million outfits a year, making Mattel the largest manufacturer of clothes in the world.

❀ In real life, Barbie's measurements would be 36–18–33. The probability of a woman having those dimensions is 1 in 100,000. Ken's measurements are more down-to-earth; men have a 1 in 50 chance of having his build in real life.

❀ Ever wonder why Barbie has realistic hair and Ken only painted plastic? The answer is that playing with Barbie's hair is the number 1 Barbie activity for young girls, but they take no interest at all in Ken's hair. So Mattel opts for the cheaper Ken 'do. Hair is such the Barbie allure that the bestselling version of all time is "Totally Hair" Barbie, who boasts 10 1/2-inch long hair on her 11 1/2-inch frame.

9

Shattering the Ceiling
Fabulous First and Other Fantastic Female Feats

*I*n 1958, a Kansas tornado ripped a woman out of her house and deposited her, unharmed, 60 feet away, next to a record of "Stormy Weather." Honest.

The first ever women's boxing match took place in 1876. The winner got a silver butter dish.

The days of the week are named mostly after Anglo-Saxon gods. The only day named for a woman is Friday. It is from the Anglo-Saxon "Friegg-daeg," in honor of Frigg, the goddess of marriage and love, and wife of the god that Wednesday is named for, Woden.

As far as the months go, April is named for Aphrodite, Roman goddess of love and beauty; May for Maia, goddess of fertility; and June for Juno, wife of Jupiter.

Wendy Wall of Australia holds the record as the fastest person to make a bed solo. Her time: 28.2 seconds. Two British nurses, Sharon Stringer and Michelle Benkel, hold the team record: 14 seconds.

THEY CAN'T GET NO RESPECT

A team of 5 Sherpa women recently climbed Mount Everest to prove that "they are as good as male Nepalese mountaineers, who have discouraged them from climbing," according to the BBC. Before their climb, only 1 female Sherpa had ever reached the peak of Everest, and she died on the way down.

According to the National Association of Women Business Owners, women are starting up businesses at a rate of 2 to 1 over men. They now own 9 million businesses, employ 25 million workers, and do $3.6 billion in annual sales. The majority of female businesses (53.7 percent) are in the service sector, as are men's, but at a lower percentage (45.1 percent).

Where in the United States are the most women-owned companies? Denver and West Palm Beach. Indeed, the West and the South in general are the best spots for women entrepreneurs; the East and the Midwest are at the bottom of the list, with Buffalo dead last.

Avon did a study of 450 women entrepreneurs and discovered that only 12 percent of those responding considered profits as the major indicator of their companies' success. The vast majority of women ranked self-fulfillment, being challenged, and helping others higher.

THE UPDATED CEILING

More women than ever are making it to the top of the career ladder. According to the Census Bureau, there were over 7.1 million women in full-time executive, administrative, or managerial positions in 1998, a 29 percent increase from

1993. During the same time period, the increase for men was only 19 percent. But the salary gap is still there; executive women earn about $17,000 less annually than men in the same positions.

According to studies, women are less likely to lie than are men (or at least to own up to it), but we are more likely to lie about our weight, how old we are, and our real hair color. We're also more likely to pad our expense accounts and pad an insurance bill to cover our deductible (perhaps, I speculate, because we make less money than men). But women are less likely to try to avoid jury duty, so we're not all bad.

THE NOT SO FRIENDLY SKIES

When stewardesses were first being hired in the 1930s, women had to be single, weigh no more than 115 pounds, and be certified nurses. The criteria were established after nurse Ellen Church, the first flight attendant, convinced Boeing that she would be good in emergencies. (The requirement was dropped 12 years later.) The route Church and the 7 other young nurses she recruited flew—from San Francisco to Chicago—took 20 hours in good weather, and the plane made 13 stops to refuel.

Approximately 18 percent of women ages 65 to 69 are still working, at least part-time.

All the Presidents' Wives

★ It was no picnic being the first lady in the White House. Abigail Adams moved in with husband John, the country's second president, when the building was still under construction. Not one room was completely finished. She had to shout for the servants and hang her laundry in the audience room.

★ Eleanor Roosevelt was the only first lady to pack a pistol in her purse. She did so at the request of the Secret Service; it was a response to many death threats.

★ Mrs. R was the most admired woman in America for 13 years running. At the time her husband became president, she was editing a magazine called *Babies*, a job she gave up for a life of diplomacy, public policy, and good works.

★ If you like the cherry trees that bloom all over Washington, D.C., in the spring, then thank First Lady Helen Taft. She was the one who introduced them after seeing the trees on a visit to Japan.

★ The only woman ever to appear on paper money in the United States was

Martha Washington. Her face graced one of the Silver Certificates when bills were first minted.

★ Mrs. Washington also has the distinction—which didn't happen until 1901—of being the first woman to appear on a postage stamp in the United States. She's actually been on four—an 8-cent, a 2-cent prepaid postcard, a 4-cent, and a 1 1/2 cent.

★ According to historians, the United States has had a woman president, at least unofficially—Edith Wilson. In 1919, while Woodrow Wilson was president, he suffered a stroke, which he and his wife decided to keep secret. For months before he died, Edith took charge, deciding what to consult Woodrow on and making many decisions on her own.

★ The press is always alerting us to presidential wives who are considered to have too much power. But what of poor Mrs. Calvin Coolidge? Her husband did not even let her attend to those things that are considered wifely duties. He picked out all White House menus and even her wardrobe.

★ Did Florence Harding kill her husband while he was still in office? Rumors persist. It all started with allegations of an affair. While he was president, there were rumors that Harding had

fathered a child with a much younger woman. Mrs. Harding put the FBI on the case to put the rumor to rest. They discovered it was true, which peeved Florence to no end. She then inquired of the FBI about killing someone by putting an undetectable white powder in their food. What was it? she asked. They refused to tell her. Soon after, the president got sick with what was believed to be food poisoning—no one else got sick, although they all ate the same thing—and died. Mrs. Harding refused to allow an autopsy, and the death was officially regarded as a stroke.

★ Mrs. Ulysses S. Grant was cross-eyed. Her husband refused to let her have her eyes fixed because he liked her like that.

It pays to be a Scout. Forty percent of American women were Girl Scouts at one point in their lives. But two-thirds of the women listed in *Who's Who* were Scouts. (By the way, the woman who founded the Girl Scouts in the United States, Juliette Low, was deaf.)

And a Brownie Smile to You
Do you remember the Three Brownie Bs, the principles all Brownies (Girl Scouts ages 5–8) are taught to memorize?

1. Be Discoverers

2. Be Ready Helpers

3. Be Friend-Makers

In Japan, women are still not allowed to enter a Sumo wrestling ring. The inequity came to light recently when Fusae Ota became Japan's first female governor and requested the privilege.

It's the Guilt That's the Worst

Okay, working moms everywhere: Stop feeling guilty. A new study by the University of Maryland has found that women spend as much time (actually slightly more) with their kids as moms did in 1965—5.8 waking hours per day compared with 5.6. And this even though three-quarters of all mothers now work outside the home! How do we do it? By stealing time from ourselves. The study revealed that working moms sleep 5 to 6 hours per week less than nonemployed mothers and have 12 hours per week less of free time.

Working mothers are unevenly distributed around the United States. The highest percentages are found in the Midwest: more than 80 percent; the lowest in the South: around 50 percent. Overall, approximately 70 percent of women with kids under 18 are employed.

California has always been known for being ahead of trends, and this is no exception. It ranks first in number of women mayors, with 24.7 percent in 1995. However it doesn't even rank in the top 10 states with the highest percent of women in the legislature.

Washington heads that list, with almost 40 percent! States with the fewest women are almost all Southern, with New Jersey and Pennsylvania the two exceptions.

"In politics, if you want anything said, ask a man. **If you want anything done, ASK A WOMAN.**"
—*Margaret Thatcher*

The first woman pharaoh was Hatshepsut, who, to make her subjects more comfortable about her gender, had herself depicted breastless, with a beard, and dressed in male clothing. It's amazing that we even know about her, for her successor so despised Hatshepsut that he had every statue of her destroyed and her name chiseled off every public building. He missed a few, though.

Hypatia was the only known woman scholar of Alexandria circa A.D. 400. She was beautiful and brilliant, helping to prove Euclid's ideas about geometry and teaching Neoplatonism. A pagan, she was killed by early Christian monks who sliced her body to ribbons with oyster shells gathered from the harbor.

A Sporting Chance

❖ No woman had ever appeared on the Wheaties "Breakfast of Champions" commercial until 1984, when Mary Lou Retton broke the gender barrier after her Olympic gold medal in gymnastics.

❖ Women first began playing base-
ball in college in the 1860s,
about 50 years after men.

❖ The fastest woman on
Earth, based on her time in the
100-meter race, was Florence
Griffith-Joyner. Her 1988 records
in both the 100- and 200-meter
dashes are yet to be broken.

❖ The first woman to race in the Indianapolis 500
was Janet Guthrie in 1976.

❖ Susan Butcher is the only woman to have ever
won the Iditarod Dog Sled race—and she did it
twice, in 1987 and 1990.

❖ Austrian Annemarie Moser-Proll is the woman
who has won more Alpine skiing World Cup
titles than anyone else: 6. She did it in the 1970s,
and the closest anyone else has gotten before or
since is 3 titles.

❖ Gertrude Ederle was no teenage slouch. Not only
was the 19year-old, in 1926, the first woman to
swim across the English Channel, but she also
did it faster than any man had done.

❖ Tennis star Martina Hingis is the youngest
woman in sports to earn $1 million. She did it at
16. Since then, she's had years in which she's
made more than $4 million in prize money, and

her sponsorships add another $5 million to her pocket per year. She's also the youngest person, at 15, ever to win Wimbledon.

❖ Kimberley Ames rode 283 miles in 24 hours on her in-line skates to win the world's record for fastest 24-hour time for a man or a woman in 1994.

❖ Dorothy Hamill was so talented she even has a skating move named after her—the Hamill's camel, named for her distinctive spin.

Tobacco was a male-only thing, until Catherine de Medici came along. She blended it with snuff and inhaled.

The first journalist to use a quoted interview was crusader Anne Royall. Extremely well-known in her day, she interviewed presidents from John Quincey Adams to Franklin Pierce and exposed corruption and incompetence at all levels of government. Royall was not afraid to do what it takes to get a good story—she was horsewhipped, ridden out of town by a mob, and had a leg broken by an irate would-be interviewee.

The Virgin Mary holds the record for the woman who has appeared on the cover of *Time* magazine the most: 10 times.

Women in Africa grow the majority of food there, but own only 1 percent of land. Those involved in famine relief believe the decline in food

production in Africa is due to the marginalization of women, so they recently launched an initiative to offer credit to women farmers to purchase land.

Nobel Women of Science and Peace

★ Marie Curie is the only woman (and the first person) to have won 2 Nobel Prizes—one in physics in 1903 that she shared with her husband and one in chemistry in 1911 for the discovery of radium and polonium. Despite winning 2 Nobels, Marie was once denied membership in the French Academy because she was a woman.

★ Curie was truly a noble sort. She and her husband refused to take out a patent on radium, although it would have made them—and their heirs—wealthy. Their discovery belonged to the world, they felt.

★ Marie was the first person in the world to die of radiation poisoning. Before she got sick, no one knew that it was deadly.

★ Science obviously ran in the Curies' blood. Their daughter Irene also won a Nobel Prize in chemistry for synthesizing radio-active elements.

★ Hailed as the greatest geneticist of the twentieth century, Barbara McClintock not only became the first woman head of the Genetics Society of America, but she was also the very first woman to be given an unshared Nobel Prize in physiology and medicine. What did she have to say of such honors? "It might seem unfair to reward a person for having **SO MUCH FUN** over the years."

★ Ten women have won the Nobel Peace Prize, out of a total of 97 awards:

1. Baroness Bertha von Suttner, the peace activist who wrote *Lay Down Your Arms*, 1905

2. Social crusader Jane Addams, who founded the International League for Peace and Freedom, 1931

3. Emily Greene Balch, a compatriot of Addams, who was cited for her solution-oriented approach to peace around the world, including obtaining the U.S. withdrawal of troops from Haiti in 1926 after a 10-year occupation, 1935

4. & 5. Betty Williams and Mairead Corrigan, leaders in the peace crusade in Northern Ireland, cited for "what ordinary people can do to promote peace," 1976

6. Mother Teresa, founder of the Missionaries of Charity, for work with the poorest of the poor in India, 1979

7. Mexico's Alvar Myrdal, for her work in the disarmament movement, 1982

8. Aung San Suu Kyi, a Burmese Buddhist and political prisoner who advocates the peaceful transition of her country from dictatorship, 1991

9. Mayan Indian Rigobertu Menchu Tum, a worker for peace and justice in her homeland of Guatamala, 1992

10. American Jody Williams, for her work with the International Campaign to Ban Landmines, 1997

Who is Agnes Gonxha Bojaxhin? The birth name of **MOTHER TERESA!**

The very first American woman doctor was Elizabeth Blackwell, who got into medical school in 1845 by applying as E. Blackwell after being rejected many times. When the school discovered he was a she, the student body voted to let her stay as a joke. Despite such treatment, she did graduate and ended up practicing with her sister, a British doctor, during the Civil War. Later she helped found the Women's Medical

College in New York, then moved to England and continued her crusade for female medical opportunities.

The list of the first 10 people to orbit the Earth in a spaceship includes 1 woman: Valentina Tereshkova, the very first woman in space. The Russian took flight in June 1963.

What are college women's favorite sports these days? Basketball, then volleyball and tennis.

Going for the Gold

* Ice skater Peggy Fleming was the only American woman to win a gold medal in any sport in the 1968 Winter Olympics.

* The woman who won the most gold medals as a figure skater, though, was Norwegian Sonja Henie, who came home with three, in 1928, 1932, and 1936. Sonja really shone on the ice—in 9 years, from 1927 to 1936, she also won 10 world figure-skating championships.

* You can never be too careful: To make sure that women were truly women and men, men, 1976 Olympic officials gave everyone a sex test. Everyone, that is, except for Princess Anne of England, who was competing in the equestrian events. Her gender was apparently above scrutiny.

* Discus thrower Danuta Rosani goes down in
 sports history books as the first person to be dis-
 qualified from the Olympics for using drugs. She
 was taking steroids to beef up for her events.

* Track star Merlene Ottey has the distinction of
 being the person who holds the most bronze and
 silver Olympic medals without ever winning a gold.

* The original Olympics in Greece didn't have
 events for women. Women had their own event,
 called the Heraean Games (after the goddess
 Hera). Athletes wore an above-knee-length dress
 with a bare right shoulder and breast. In modern
 times, women were first allowed to join the 1900
 Games in just one sport—tennis.

* Then There's the Woman Who Wasn't: After
 World War II, a German man named Hermann
 Ratjen revealed that the Nazis had forced him to
 pretend to be a woman and compete as "Dora
 Ratjen" in the 1936 Olympic high jump. Even
 so, he only came in fourth.

In 1975, UCLA spent only $180,000 of its
$3 million sports budget on women. No, no, said
the Supreme Court, in a landmark decision that
resulted in much greater funding for females and
changed the face of women's sports forever.

Babe Didrikson was one of the top athletes, male
or female, who ever lived, excelling at every sport

she tried her hand at—jumping, running, javelin throwing, swimming, golf, basketball, and baseball, to name just some. She set records at the Olympics in 1932 for the 80-meter hurdles and the javelin throw. She would have won the gold in the high jump too, but her method of throwing herself over the pole headfirst was deemed illegal. And that year the Olympics committee had imposed a 3-event limit per athlete or she would have taken even more events. Post-Olympics, she turned to golf to make a living, winning 17 tournaments in a row and helping found the Ladies' Professional Golf Association. Her golf advice for women? "It's not enough to swing at the ball. You've got to **loosen your girdle** and really **let the ball have it**."

In 1954, a Mrs. Hewlatt Hodges from Syracuse, Alabama, was almost hit by a meteorite, becoming the only known person to have been so. The 9-pound object crashed through the roof of her house, happily avoiding Mrs. Hodges.

A 4-year-old Lithuanian girl, Kristina Stragauskaite, holds the record for the youngest person ever to receive an award for bravery. She saved her younger brother and sister when a fire broke out in their house and their parents were gone.

Holidays Created by Women

❊ Mother's Day was conceived of by Anna Jarvis in 1907, after the death of her own mother. Through her perseverance, it became official in 1914, when Woodrow Wilson signed a presidential proclamation. Originally, the day was marked by the wearing of carnations—red if your mother was alive; white if she had passed on. Anna, who never became a mother herself, eventually came to detest the commercialization of this annual holiday.

❊ It's not surprising that Wilson was the president to make Mother's Day a national holiday. He was known as a "mama's boy" who changed his first name from Thomas to his mother's maiden name. "I clung to her until I was a great big fellow," he once said of his mom.

❊ In the mid-1800s, magazine editor Sarah Josepha Hale launched a crusade to create a national day of thanksgiving. In 1863, President Lincoln made it official. Hale had quite an impact on American culture. She's also the creator of "Mary Had a Little Lamb."

❊ Father's Day was also a woman's idea. Mrs. Sonora Smart Dodd was sitting in church on Mother's

Day in 1910 when she decided that fathers deserved a similar honor. She proposed June 5, her father's birthday, but it wasn't until 62 years later that it was made into a holiday. The all-male Congress kept feeling that making it official would be interpreted as a self-congratulatory pat on the back. Richard Nixon had no such qualms and declared it official in 1972.

The first American woman killed in World War II was the actress Carol Lombard, wife of Clark Gable, who was on tour to boost troop morale.

Forcing women into slavery continues around the world to this day. According to Shewire, nearly 1,000 Russian women per year who respond to ads promising work abroad as waitresses and dancers are shipped to Israel, sold to pimps, and forced to work as prostitutes. There, they are made to service 15 to 20 men each day—earning at least $1,000 a day for their "owner." And according to the BBC, in Asia alone, 250,000 people—mostly women and girls—are sold into prostitution or sweatshop labor yearly. Lest you think the United States is above such actions, unofficial estimates claim that between 50,000 and 100,000 women and children are sold into slavery annually here too.

Where does the word *Easter* come from? From the Anglo-Saxon goddess of Spring, Eostre.

Famous Female Executions

❖ The great WWI German spy Mata Hari was born in Holland. Her real name was Margaretha Geertuida Zelle McLeod (she married a Scotsman). Her cover was as an exotic dancer, and her German code name was H-21. She met her death at Vincennes in 1917 at the hands of the French. Legend has it that she donned an expensive tailored suit for the event and a pair of immaculately white gloves, then smiled and winked as the firing squad aimed at her. Those in the know say she died unnecessarily because she was a truly lousy spy who was remarkably unsuccessful.

❖ Just before her head was cut off, Marie Antoinette allowed her breasts to be used for a mold to make drinking glasses.

❖ As she was being led to the guillotine to be beheaded, Marie Antoinette accidentally stepped on the executioner's toes. "I beg your pardon," the well-bred royal remarked. "I did not do it on purpose." Those were her last words.

❖ Before the guillotine was invented, people tended to be executed via ax. If you had money, you would tip the executioner so that he would cut off your head in one blow. Poor Mary, Queen of Scots must not have paid enough. It took 15 blows before her head and body were separated.

❖ Catherine Howard, the fifth wife of Henry VIII, actually practiced getting her head chopped off. When the date of the deed was confirmed, she asked that the block and ax be sent to her cell, which they were, so that she could rehearse a few times.

Golda Meir was so tough that Israeli president David Ben-Gurion once proclaimed her "**THE ONLY MAN IN MY CABINET.**"

According to Greek mythology, the very first mortal woman was Pandora—you know, the one who opened the box when she was told not to and released the Furies into the world.

The very first American saint was Mother Frances Xavier Cabrini. She was canonized in 1946.

Rule Britannia

❀ Queen Victoria reigned Great Britain for 64 years, from 1837 to 1901, which makes her one of the top 5 rulers for length of reign, the only woman in the group. (The United States had 18 presidents during the same time.) What's most interesting about her reign is that she spent 40 years of it in seclusion, in mourning over the death of her beloved husband Albert. During that huge stretch

of time, she only wore black, had servants lay out Albert's evening clothes on his bed as if he were alive, and rarely appeared in public except to attend memorials to Albert. Nevertheless, she put her mark on many aspects of life from morals and geography.

❀ There are 8 places in the world named for this Queen: Victoria, Australia; Victoria Falls, bordering Zambia and Zimbabwe; Lake Victoria, bordering Uganda and Tanzania; Victoria Nile, Uganda; and 3 in Canada: Victoria, British Columbia; Victoria Island; and Victoriaville, Quebec.

❀ No wonder Victoria had such a stiff upper lip. As a little girl, she was trained to keep her chin up by having a sprig of holly tied to her collar. Any time she put her head down, **ouch!**

❀ When she was made queen, the very first thing Victoria did was have her bed moved from her mother's room into a room of her own.

I didn't count personally, but those in the know tell us that of the 2,200 persons quoted in *Bartlett's Familiar Quotations*, only 164 are women.

Lady Godiva was real. She was the wife of the Lord of Coventry, who, in 1040, agreed to stop taxing the people of Coventry if his wife rode naked through the streets. (Why this was his condition is

unclear.) The modest lady didn't want to do it, but she took pity on the poor townsfolks and agreed—as long as they all promised to close their eyes. They all did, except one man named Tom, who saw all Ms. Godiva's wares. And that, dear reader, is where the expression "Peeping Tom" comes from.

Typhoid Mary was a cook named Mary Mallon who was personally responsible for spreading typhoid from house to house in New York City in the early 1900s. At least 51 cases and 3 deaths were attributed to her before she was caught mixing up gelatin for a friend and locked up in an isolation ward until her death 23 years later.

Pocahantas' real name was Mataoka. Despite all the fictionalizing of her life, Pocahantas *was* actually her nickname. It means "playful." The many-named Native American changed her moniker again in later life. When she married John Rolfe and converted to Christianity, she took the name Rebecca Rolfe.

Royal Rumors

- ❦ Unlucky Name: Supposedly every queen ever named Jane has either been murdered, dethroned, gone mad, died young, or was imprisoned.

- ❦ Anne Boleyn, Henry VIII's second wife, had extra body parts. One source claims that one of her

hands had six fingers. She always wore custom-made gloves to cover this up. Another says that in addition to her extra fingers, she had six toes on one foot and three breasts.

❦ Louis XIV was married at one point to Marie-Therese. Supposedly, each morning when they awakened and the servants came in, Marie-Therese would sit up and clap her hands if Louis had performed his husbandly duties the night before.

❦ Poor Louis the XIV. His second wife, Madame de Montespan, liked to gamble a bit too much. She once lost 4 million francs in half an hour.

❦ When Queen Austrichildia, wife of the Frankish king Guntram got sick, she believed her 2 doctors weren't trying very hard to fix her. So she made her husband promise that if she died, he would have them executed on her grave. She did, and he did—with all the other court doctors in attendance. (I bet they all worked really hard after that!)

❦ During her reign, Elizabeth I outlawed wife beating—after 10 P.M., that is.

❦ Elizabeth I suffered from an unusual psychological disorder—anthophobia. What is it? A fear of roses.

❦ That same Elizabeth was known as "The Virgin Queen." And so it is for her that the state of Virginia is named.

- Catherine II of Russia didn't want anyone to know that she had to wear wigs. So she kept her wigmaker locked in an iron cage in her bedroom for more than 3 years.

- Mary, Queen of Scots was over 6 feet tall.

- June 2, 1953, was picked as the date for the coronation of Queen Elizabeth II. That's because meteorologists did a weather analysis and discovered that in England, that day is the most consistently sunny day in the whole year. It rained.

- Someone analyzed all the rumors in the French press about Queen Elizabeth II for the period 1958–1972. Here's what they came up with, according to *Mind-Bogglers:* "The Queen was pregnant 92 times, had 149 accidents, 19 miscarriages, and took the pill 11 times. She abdicated 63 times and was on the point of breaking up with Prince Philip 73 times. She was said to be fed up 112 times and on the verge of a nervous breakdown 32 times. She had 43 unhappy nights, 27 nightmares, and her life was threatened 29 times. She was rude to the Queen of Persia 11 times and to Princess Grace of Monaco 6 times." Can you imagine what the tally on Fergie and Diana would be?

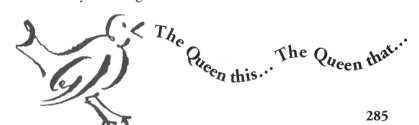

The Queen this... The Queen that...

When Princess Diana was killed in 1997, 5 million bouquets of flowers were placed in her honor in front of Buckingham Palace in a 1-week period. Experts estimate the total weighed between 10,000 and 15,000 tons!

In 1956, the office of Health, Education, and Welfare was established, and a woman, Oveta Culp Hobby, became the head, proving, it seems, that even at the highest levels, these areas were seen as "women's" issues.

In 1963, JFK revealed that there was discrimination against women in the United States. He knew, because he had just convened the first Commission on the Status of Women, and they told him.

Those Swiss! They were the last Western country to give women the vote. The year? **1971!**

Three young girls from Bayside, New York, made it into *Ripley's Believe it or Not* by constructing a gum wrapper chain 500 feet long, using 12,500 wrappers.

Mary Baker Eddy is the only woman in the world known to have started a religion—Christian Scientist, in 1866.

Hereford, Texas, is home of the only museum dedicated to those wrasling gals—cowgirls. It's the National Cowgirl Hall of Fame and Western Heritage Center.

REAL CLASS

Sharpshooter Annie Oakley, a.k.a. "Little Miss Sure Shot," won a great number of gold medals for her prowess. What did she do with them? Melted them down, sold the gold, and gave the money to charity.

In the War Between the States, Barbara Fritchie was on the Union side, and no one could stop her from declaring it. So when General Stonewall Jackson marched through her hometown of Frederick, Maryland, the 95-old Fritchie defied Confederacy orders and waved a Union flag right in old Stonewall's face. To this day, her house remains a memorial to this defiant female. Some folks refute the story, saying that Fritchie was too feeble to wave anything at anybody that day.

Saint Mary-Magdalen dei Pazzi, who lived in the 1500s, was a mystic who was so prone to talkative trances that the Carmelites provided 6 women to take down what she said during her religious ecstasies, which could go on for days.

Women in ancient Egypt (3500–2500 B.C.) were allowed to hold all the same kinds of jobs as men. With one exception—they were not allowed to be judges.

In ancient Rome, around 400 B.C., only women were allowed to drive around the city in carriages; men had to walk. This privilege had been granted by the emperor as a reward to the women of Rome for

their incredible fund-raising during the invasion of Rome by the Gauls. It was supposed to be a perpetual perk, but when Julius Caesar came to power, he immediately rescinded it, forcing everyone, male and female, to walk.

Money Makes the World Go Round

$ Despite all the gains women have made, we still make less money than men. For white women in 2000, it's 73 cents for every dollar earned by white men; for black women, that figure drops to 63 cents; and for Latinas, it's only 53 cents.

$ Women tend to have less retirement money, are older when they stop working, and are more worried about retirement than men, according to a Cornell University study. (No wonder, given our lower salaries!)

$ The youngest billionaire in the world is Athina Onassis Roussel, who inherited the $5 billion estate of Aristotle Onassis when she was 3. When she turns 18, in 2003, she will be given control of the fortune.

$ The richest self-made woman is reputed to be Pam Lopker, founder of QAD. She's worth around $425 million.

$ The richest woman of her day (the late 1800s) was Baroness Angela Burdett-Coutts. A friend of Charles Dickens, she gave away most of her fortune, not only on the usual things like endowments for schools, but also on all manner of unusual charities. She sent cotton gins to Nigeria, supported peasants in Turkey and aborigines in Australia, funded a survey of Jerusalem, paid for the bells in St. Paul's Cathedral, and even created drinking fountains for dogs. In 1871, Queen Victoria granted her a peerage for her good works, one of the only times a woman has ever received such an honor in her own right rather than because she was a mistress of a king.

$ *U.S. News and World Report* tells us that women slightly outnumber men (50.4 to 49.6) in millionaire status. It's not only because of our increased earning power, but also because we live longer than men, we end up inheriting their wealth too.

$ Just Lucky I Guess: Suzanne Henley "just had a feeling" about a one-armed bandit in Las Vegas one night and waited over an hour to play it. Her hunch proved right, and she became the person to win the largest slot machine jackpot in the world—$12.5 million!

$ Just who the first black woman millionaire was is open to dispute. But we know that she made her

fortune in hair-care products. The leading contender is Madame C. J. Walker, an illiterate Southerner who started her company with $1.05 in savings and amassed great wealth at the end of the nineteenth century with a line of black-hair products. She was against hair straightening and preached pride in black women's natural beauty. Her renowned hair loss formula came to her in a dream, she said, in which "a big black man appeared and told me what to mix up for my hair." Other folks claim it was Annie Turnbo Malone, who hit $1 million first, and that Walker had actually worked for Malone and learned Malone's tricks of the trade before striking out on her own.

Talk about Chutzpah!

A woman robbing a bank demanded her note back because it was taking too long for the teller to get the money. She then went to a nearby competitor where she got better service—and their money.

Edith Stein was an amazing woman. Born into a Jewish family in 1891, as an adult she converted to Catholicism and became a nun teaching and writing philosophy at German universities until the Nazis began rounding up the Jews. Stein promptly identified herself to the authorities as a Jew and a Catholic, and was murdered at Auschwitz in 1942 wearing the star of David on her Carmelite nun's habit.

The weirdest house in the world is in San Jose, California, and belonged to Sara Winchester, heir to the Winchester rifle fortune. A psychic told her that if she ever stopped building onto it, she would die. When she did finally die, at 84, the mansion had 160 rooms and 8 stories, 48 fireplaces, 2,000 doors, and 10,000 windows. Many staircases go nowhere, and many windows open onto walls. It is now a museum.

Missourian Phoebe Snetsinger made it into the *Guinness Book of World Records* for spotting more varieties of birds than any other human being. Since 1965, she's seen 8,040 of the world's 9,700 known species.

But Does She Keep Them on the Fridge?
Nevada resident Louise Greenfarb is the proud owner of over 21,500 refrigerator magnets.

Hieldegarde Ferrera was 99 years old when she jumped out of an airplane, making her the oldest parachutist in the world.

Talk about Beauty Treatments!
The most prolific murderer of all times in the West was one Elizabeth Bathori, who lived in the 1600s in Translyvania. She is reputed to have killed more than 600 women and girls to drink and bathe in their blood, which she believed would keep her young.

The niece of the king of Poland, she was not killed when the murders were discovered, but was walled up in her castle until her death.

One of the bloodiest mass murders of the nineteenth century was instigated by a woman, Burmese Queen Supayalat. Trying to ensure her husband's rule, she ordered followers to club to death about 100 of his relatives in a 3-day death orgy. To cover up the screams, she had loud music played. Her plan backfired though; horrified, the British forced the royal duo out of the country for their nefariousness.

An examination of records shows that women accused of murder are given more leniency than men throughout the entire legal process and are much more likely than men to be granted clemency in death penalty cases.

Do you use SOS pads? The name comes from the wife of the inventor, Edwin Cox. She suggested SOS, for Save Our Saucepans, a play on the SOS of Morse Code. Actually, however, the Morse SOS doesn't stand for anything, even though most of us think it means Save Our Ships. It was just the easiest thing to broadcast.

Everyone knows that girls are inferior in math and science, right? To prove that wrong, Emma Hart Willard founded the Troy Female Seminary for girls—in 1821.

If you love the world of high tech, check out *GirlGeeks.com*, a tech career site for women and girls that offers mentorship groups and techie chats.

Who Says Women Aren't Mechanical?

❊ When patents began to be granted in the early 1800s, women quickly jumped to register their inventions. Here are some of the first by females: a corset; carbonated liquid; foot stove; sheet-iron shovel; a machine that manufacturers moccasins.

❊ You Can't Keep a Good Woman Down: Gail Turner, who lives in Belmont, California, built her own airplane from scratch and flew it to Wisconsin. She stores the parts in her living room. When she wants to fly, she assembles the plane in a nearby vacant lot.

❊ Did you know that the dishwasher was invented by a socialite discouraged about the job her hired help was doing on her dishes? That's right. Josephine Cochrane was so upset about her broken dishes that she decided to make a machine that would do a better job than her maids. And she did—patenting it in 1886 and winning an award at the 1893 Chicago World's Fair.

* Then there's Anna Bissell. She and her husband invented the carpet sweeper in the 1890s, which proved so popular that it became a verb: to "Bissell" a carpet.

* The Johnny Mop, which is a disposable toilet bowl cleaner on a stick, was invented by none other than Dorothy Rogers, wife of composer Richard Rogers (of Rogers and Hammerstein).

* Gloria Swanson maintained several times, including in her autobiography, that she had invented the precursor to the pager. (There's no objective evidence of this, however; a man, Jack Scantlin, is generally credited with the invention.)

* The very first solar heating system was invented by Dr. Maria Telkes and installed in a house in Massachusetts. The year was 1948.

* The first bomb shelter was also built by a woman. In 1951, a Mrs. Ruth Colhoun spent $1,500 (a large sum at the time) to build a deluxe shelter at her Los Angeles home. Soon folks across the country were following suit in their basements and backyards.

The very first woman to be admitted to the American Academy of Arts and Sciences was Maria Mitchell, an astronomer who discovered a comet in 1847. Schooled at home by her father, she discovered

the comet while working as a librarian. Later she became the first professor of astronomy at Vassar.

Naughty Know-How

One of the most famous American counterfeiters was Mary Butterworth (1686–1775) who used her Massachusetts kitchen to manufacture 8 kinds of bills. Getting the bogus bills into circulation was no problem for this enterprising female. Her "gang" included the justice of the county court and the town clerk. They were caught in 1723 and ultimately acquitted. Why? No hard evidence—Mary had figured out how to forge without copper plates.

One of the first blows against segregation came in 1948, when Ada Loisa Fisher, who had been barred from entering Oklahoma Law School, sued, and the U.S. Supreme Court ruled that Oklahoma must provide her the same education as white students. The State of Oklahoma responded by ruling that it would establish a separate but equal law school for Ms. Fisher, which, of course, was absurd and which helped lead to the end of the concept of separate but equal.

Researchers asked women in 1979, 1987, and 1998 to agree or disagree with the statement: "I am concerned about what others think of me." In 1979, 45 percent of women agreed; by 1998, that figure had gone down to only 24 percent. Better self-esteem

among women accounts for the difference, say scientists, which comes from being out in the work world.

DESPERATION BREEDS FOOLHARDINESS

The first person to go over Niagara Falls in a barrel and survive was widow Annie Edison Taylor, who, in 1901, at the age of 50, did it to raise money for herself.

Sharon McClelland is one tough cookie. She was learning to parachute one day, when her chute failed to open. As luck would have it, she landed in a marshy bog, thus avoiding the hard ground that would have inevitably killed her. She got up, cleaned herself off, apologized to her instructor for failing to follow procedure for a no-chute landing, then went and jumped again.

When you get a *bug* in your computer, blame Grace Hopper. She's the Navy computer pioneer whose team first coined the term for something going wrong in a computer's hardware or software. It was 1945, and a moth got caught in one of the world's first computers.

Actually many of the basic principles for computer programming come from Augusta Ada Byron, Lord Byron's daughter and a brilliant mathematician. As the Countess of Lovelace, Byron worked with Charles Babbage, the designer of the ideas behind the first digital computer.

When her husband died while Louis IX's Crusaders were trying to conquer Egypt, Shajar-al-Durr, the sultan's wife, pretended he was just sick and giving her orders. She then led the Egyptian troops on a successful mission to cut off the Crusaders' supplies (her own idea, by the way), won the battle, and even captured Louis!

The first woman ordained by any major denomination in the United States, the Presbyterians, was Reverend Margaret Towner, in 1955.

Who was Britain's longest-serving prime minister of the twentieth century? Margaret Thatcher, of course.

In 1992, Carol Moseley-Braun became the very first African American woman to serve in the Senate.

The woman most credited with launching the modern feminist movement is Betty Friedan, the former housewife who decided to talk to women about the malaise they were feeling about being stay-at-home moms, which turned into that classic of the women's movement, *The Feminine Mystique*.

The U.S. Small Business Administration now has a Web site to encourage young women and girls to start their own businesses. Discover Bu$iness! includes an interactive "manage your own business" game, facts about starting your own business, and a

glossary of business terms. To visit Discover Bu$iness! Web Site, go to *www.discoverbusiness.com*.

Where did the poor U.S. government get the silver to mint its first coins? From melting down Martha Washington's silver service.

In the 1700s, South Carolina prospered due to the export of indigo, a blue dye, to Europe. And it was a woman who introduced the dye, one Eliza Lucas Pinckney, who at 21 was running her father's farm. She thought she would give the crop a try, and it proved so successful that the following year she gave neighboring farmers her excess seeds. Only 3 years later, the colony was exporting over 100,000 of the stuff to England, and Miss Eliza soon grew quite wealthy.

Margaret Mead was a born anthropologist. By the age of 9, she had recorded and analyzed the speech patterns of her sisters.

A female archeologist discovered a temple of Aphrodite, the Greek goddess of love. The archeologist's name? Iris C. Love.

Bombs Away!
Hanna Reitsch was a pilot who was the first woman to test a rocket, helping the Germans develop the Messerschmitt Me163, the V1, and V2 rockets during World War II. She crashed so many times that she

claimed there wasn't a bone in her body that had not been broken. A loyal Nazi to the end, she was the only pilot willing to fly into Berlin during the siege of the city to try and rescue Adolph Hitler. She found him, but he insisted on staying behind. While she flew to safety, he killed himself and his wife.

Lady Mary Whortley Montagu is responsible for the first smallpox vaccinations being given in England. An Englishwoman married to the British ambassador to Turkey in the early 1700s, she got smallpox herself and was horribly disfigured. Her plight got her interested in the subject, and she began researching the way the Turks dealt with this disease. When she found out they did inoculations, she wrote to doctors in London, who began imitating the Turks in 1721.

Let's set the record straight. Betsy Ross did *not* design the first American flag. In fact, the story that she did was concocted by a grandson 30 years after she died. What she did was sew the flag designed by one of the signers of the Declaration of Independence, Francis Hopkinson.

In Java, at one of the country's most deluxe hotels, a room with a bath is always reserved for Njai Loro Kidul, goddess of the sea.

Eliza Hart Spalding and Narcissa Prentiss Whitman were the first 2 white women to cross the

continental United States. The success of their journey to Oregon with a party of men in 1836 spurred mass migration to the Pacific Northwest.

Arlene Blum is a professor with a doctorate in chemistry who also happens to love to climb mountains. So when she was turned down as part of a team about to climb in Afghanistan as well as one headed for Alaska because she was a woman, she decided to put together an all-women's climbing team to tackle Mount Denali. Blum and her 6 cohorts all made it in 1970. Then she decided to take on Annapurna, the world's tenth largest peak. At the time, 1978, only 4 teams had ever done the trek successfully. Again, Blum and her gals made it, financing the jaunt through corporate sponsorships and by selling T-shirts that can still be seen today: **"A WOMAN'S PLACE IS ON TOP... Annapurna!"**

Heart-Warming Helpers

Women volunteers do so much good in the world, often very much behind the scenes. Here are 2 stories I recently came across that really lifted my heart:

♥ A 71-year-old Michigan woman has been visiting women in prison for the past 10 years. Two years ago, 4 prisoners asked if they could do some cro-

cheting. So the elderly woman, who doesn't cro-
chet herself, rounded up some plastic crochet
hooks (metal not allowed) and yarn. From that
small beginning came a program that now
involves one-third of the prisoners—300
women—crocheting items for people in need.
This past year, for instance, they made 1,000
blankets and thousands of hats, mittens, and
scarves for homeless people. Nowadays, the
woman who started the program spends her days
collecting yarn from donations from all over the
world and delivering it to the prison. And of
course she's also the one responsible for distribut-
ing the finished goods.

♥ The Lutheran World Relief is a consortium of
3,000 church groups around the country that sew
quilts for needy folks. One of the groups of
women, who live in Olympia, Washington, call
themselves the Piece Corps. Every year these
women together sew 1/2 million quilts. Last year
alone, they sent 127 tons of handmade quilts,
clothing, and health kits to Kosovo.

Sources

absolutetrivia.com

Stevens W. Anderson, ed. *The Great American Bathroom Book.* Salt Lake City, Utah: Compact Classics, Inc., 1991.

Russell Ash. *The Top 10 of Everything 2000.* New York: DK Publishing, 1999.

Isaac Asimov. *Isaac Asimov's Book of Facts.* New York: Wing Books, 1979.

The Bathroom Readers' Institute. *Uncle John's Absolutely Absorbing Bathroom Reader.* Ashland, Ore: Bathroom Readers' Press, 1999.

Barbara Berliner. *The Book of Answers.* New York: Fireside, 1992.

Patricia Braus. "Sex and the Single Spender." *American Demographics,* November 1993.

Wesley D. Camp, ed. *World Lover's Book of Unfamiliar Quotations.* Upper Saddle River, N.J: Prentice Hall Press, 1990.

Tim Cavanaugh. "Mall Crawl Palls." *American Demographics,* September 1996.

David Comfort. *The First Pet History of the World.* New York: Simon and Schuster, 1994.

cooking.com.

Gerard and Patricia Del Re. *The Only Book.* New York: Ballantine, 1994.

Paul Dickinson. *From Elvis to E-Mail.* Springfield, Mass.: Federal Street Press, 1999.

Rachael Dickinson. "Why True Love Is Like Puppy Chow." *American Demographics,* January 1996.

Heather Dickson, ed. *Mind-Bogglers.* London: Lagoon Books, 1996.

Paula B. Doress-Worters and Diana Laskin Siegal. *The New Ourselves, Growing Older.* New York: Touchstone, 1994.

Shannon Dortch. "Women at the Cosmetic Counter." *American Demographics,* March 1997.

Brad Edmondson. "Five Steps Before They Buy." *American Demographics,* July 1997.

———. "Aging Plus Spices Equals Antacids." *American Demographics,* May 1997.

———. "A Decade of Change in Household Spending." *American Demographics,* March 1997.

Brad Edmondson and Josh Galper. "Pet Places." *American Demographics,* September 1998.

Eugene Ehrlich. *What's in a Name?* New York: Henry Holt and Company, 1999.

Cris Evatt. *Opposite Sides of the Bed.* Berkeley, Calif.: Conari Press, 1992.

David Feldman. *How Does Aspirin Find a Headache?* New York: HarperPerennial, 1993.

———. *Do Penguins Have Knees?* New York: HarperPerennial, 1991.

John Fetto. "Pets *Can* Drive." *American Demographics,* March 2000.

Mike Flynn. *The Best Book of Bizarre But True Stories...Ever!* London: Carlton, 1999.

Gwen Foss. *The Book of Numbered Lists.* New York: Perigee, 1998.

Jo Foxworth. *The Bordello Cookbook.* Wakefield, R. I.: Moyer Bell, 1999.

Peter Francese. "Doggone!" *American Demographics,* November/December 1996.

Jennifer Fulkerson. "The Demographics of Bad Habits." *American Demographics,* April 1995.

Andrea Alban Gosline, Lisa Burnett Bossi, and Ame Mahler Beanland, ed. *Mother's Nature.* Berkeley, Calif.: Conari Press, 1999.

The Guinness Book of World Records 1999. New York: Bantam Books, 1999.

Cheryl Hanlon and Bonnie Speer. *Barbie Doll Trivia Trail.* Norman, Okla.: Reliance Press, 1998.

Arnold Wayne Jones. *The Envelope, Please.* New York: Avon Books, 1999.

Bernice Kanner. "Are You a Normal Guy?" *American Demographics,* March 1999.

———. *Are You Normal?* New York: St. Martins, 1995.

Sean Kelly and Rosemary Rogers. *Saints Preserve Us.* New York: Random House, 1993.

Paula Kephart. "Money Can't Buy Them Love." *American Demographics,* February 1996.

Daphne Rose Kingma. *Weddings from the Heart.* Berkeley, Calif.: Conari Press, 1995.

Matthew Klein. "Mars, Venus and Shopping." *American Demographics,* September 1998.

———. "He Shops, She Shops." *American Demographics,* March 1998.

———. "Looking Out for Fido." *American Demographics,* March 1998.

Brenda Knight. *Women Who Love Books Too Much.* Berkeley, Calif.: Conari Press, 2000.

Marsha Kranes, Fred Worth, and Steve Tamerius. *5087 Trivia Questions and Answers.* New York: Black Dog and Leventhal, 1998.

Les Krantz. *The Definitive Guide to the Best and Worst of Everything.* Paramus, N.J.: Prentice Hall, 1997.

Stephanie Laland. *Animal Angels.* Berkeley, Calif.: Conari Press, 1998.

————. *Peaceful Kingdom.* Berkeley, Calif.: Conari Press, 1997.

J. Stephen Lang. *Another Big Book of American Trivia.* Wheaton, Ill.: Tyndale House Publishers, 1997.

————. *The Big Book of American Trivia.* Wheaton, Ill.: Tyndale House Publishers, 1997.

Margie Lapanja. *The Goddess' Guide to Love.* Berkeley, Calif.: Conari Press, 1999.

————. *Goddess in the Kitchen.* Berkeley, Calif.: Conari Press, 1998.

Laura Lee. *The Name's Familiar.* Gretna, La.: Pelican Publishing, 1999.

David Louis. *2201 Fascinating Facts.* New York: Random House Value Publishing, Inc., 1983.

Howard Loxton. *99 Lives.* San Francisco: Chronicle Books, 1998.

Jim Marbles. *The College of Obscure Knowledge.* Tulsa, Okla.: Trade Life Books, 1998.

Doreen Massey, ed. *The Lovers' Guide Encyclopedia.* New York: Thunder's Mouth, 1996.

Bill McLain. *Do Fish Drink Water?* New York: William Morrow and Company, 1999.

Marcia Mogelonsky. "Reigning Cats and Dogs." *American Demographics,* April 1995.

————. "The Geography of Junk Food." *American Demographics,* July 1994.

Shane Mooney. *Useless Sexual Trivia.* New York: Simon and Schuster, 2000.

Charles Panati. *Sexy Origins and Intimate Things.* New York: Penguin, 1998.

————. *Panati's Extraordinary Origins of Everyday Things.* New York: Harper and Row, 1987.

————. *The Browser's Book of Beginnings.* New York: Penguin, 1984.

Tom Parker. *Never Trust a Calm Dog and Other Rules of Thumb.* New York: HarperPerennial, 1990.

William Poundstone. *Big Secrets.* New York: Quill, 1983.

————. *Bigger Secrets.* Boston: Houghton-Mifflin Company, 1986.

David Pryce-Jones. *You Can't Be Too Careful.* New York: Workman, 1992.

Shelly Reese. "Selling More than Prescriptions." *American Demographics,* January 1998.

Charles Reichblum. *Knowledge in a Nutshell.* Pittsburgh, Pa.: arpr, inc., 1994.

Louis D. Rubin Jr., ed. *A Writer's Companion.* New York: Harper-Perennial, 1995.

Jow Schwartz. "My Child, the Schanuzer." *American Demographics,* July 1996.

Nat Segaloff. *The Everything Trivia Book.* Holbrook, Mass.: Adams Media, 1999.

Fred R. Shapiro, ed. *Stumpers!* New York: Random House, 1998.

Geoff Simons. *The Book of Sexual Records.* London: Virgin Publishing, 1998.

Stephen J. Spignesi. *The Odd Index.* New York: Penguin, 1994.

Vince Statten. *Can You Trust a Tomato in January?* New York: Simon and Schuster, 1993.

Autumn Stephens. *Wild Women in the White House.* Berkeley, Calif.: Conari Press, 1997.

John Student. "No Sex, Please . . . We're College Graduates." *American Demographics,* February 1998.

Nancy Ten Kate. "Women Restaurateurs." *American Demographics,* October 1996.

Scott Thomas. "Women-Owned Businesses." *bizjournals.com,* April 1, 1996.

————. "Consumer Spending." *bizjournals.com,* March 11, 1996.

James Thornton. *Chore Wars.* Berkeley, Calif.: Conari Press, 1997.

Richard Torregrossa. *Fun Facts about Dogs.* Deerfield Beach, Fla.: Health Communications, 1998.

Paco Underhill. *Why We Buy.* New York: Simon and Schuster, 1999.

uselessknowledge.com

Varla Ventura. *Sheroes.* Berkeley, Calif.: Conari Press, 1998.

vintagevixen.com

Don Voorhees. *The Book of Totally Useless Information.* New York: Carol Publishing, 1994.

Judith Waldrop. "When Tulsa Burps, McDonald's Apologizes." *American Demographics,* July 1993.

Deanna Washington. *The Language of Gifts.* Berkeley, Calif.: Conari Press, 2000.

The Wild Women Association. *Wild Women in the Kitchen.* Berkeley, Calif.: Conari Press, 1996.

womenswire.com

Howard Zimmerman and Elizabeth Henderson, ed. *Ripley's Believe It or Not: Great and Strange Works of Man.* New York: Tor, 1992.

If you enjoyed *The Ladies' Room Reader* you
might enjoy:

*Hell's Belles: A Tribute to the Spitfires, Bad Seeds & Steel Magnolias
of the New and Old South*
 by SEALE BALLENGER

Loose Cannons: Devastating Dish from the World's Wildest Women
 by AUTUMN STEPHENS

Sheroes: Bold, Brash (and Absolutely Unabashed) Superwomen
 by VARLA VENTURA

Uppity Women of Ancient Times
Uppity Women of Medieval Times
Uppity Women of the Renaissance
 by VICKI LEON

*Wild Women: Crusaders, Curmudgeons and Completely Corsetless
Ladies in the Otherwise Virtuous Victorian Era*
 by AUTUMN STEPHENS

*Wild Women in the White House: The Formidable Females Behind
the Throne, On the Phone, and (Sometimes) Under the Bed*
 by AUTUMN STEPHENS

Wild Women in the Kitchen
101 Rambunctious Recipes & 99 Tasty Tales
 by THE WILD WOMEN ASSOCIATION

*Wild Words from Wild Women: An Unbridled Collection of Candid
Observations & Extremely Opinionated Bon Mots*
 by AUTUMN STEPHENS

Drama Queens: Wild Women of the Silver Screen
 by AUTUMN STEPHENS

To Our Readers

onari Press publishes books on topics ranging from spirituality, personal growth, and relationships to women's issues, parenting, and social issues. Our mission is to publish quality books that will make a difference in people's lives—how we feel about ourselves and how we relate to one another. We value integrity, compassion, and receptivity, both in the books we publish and in the way we do business.

As a member of the community, we sponsor the Random Acts of Kindness™ Foundation, the guiding force behind Random Acts of Kindness™ Week. We donate our damaged books to nonprofit organizations, dedicate a portion of our proceeds from certain books to charitable causes, and continually look for new ways to use natural resources as wisely as possible.

Our readers are our most important resource, and we value your input, suggestions, and ideas about what you would like to see published. Please feel free to contact us, to request our latest book catalog, or to be added to our mailing list.

2550 Ninth Street, Suite 101
Berkeley, California 94710-2551
800-685-9595 510-649-7175
fax: 510-649-7190
e-mail: conari@conari.com
http://www.conari.com